Developing glazes

Greg Daly

D1341646

Bloomsbury Visual Arts
An imprint of Bloomsbury Publishing Plc

BLOOMSBURY

LONDON · OXFORD · NEW YORK · NEW DELHI · SYDNEY

Bloomsbury Visual Arts
An imprint of Bloomsbury Publishing Plc

Imprint previously known as A&C Black Visual Arts

50 Bedford Square	1385 Broadway
London	New York
WC1B 3DP	NY 10018
UK	USA

www.bloomsbury.com

First published in 2013 by Bloomsbury Publishing Plc
Reprinted by Bloomsbury Visual Arts 2014, 2017

Published simultaneously in the US in 2013 and 2014 by
The American Ceramic Society
600 N. Cleveland Ave., Suite 210
Westerville, Ohio, 43082, USA
http://ceramicartsdaily.org

British Library Cataloguing-in-Publication Data
A catalogue record for this book is available from the
British Library and the US Library of Congress.

ISBN: PB: 978-1-4081-3495-5
US edition PB: 978-1-5749-8331-9

Series: New Ceramics

Typeset in 10 on 13pt Rotis Semi Sans
Book design by Susan McIntyre
Cover design by Sutchinda Thompson
Edited by Kate Sherington

Printed and bound in India.

To find out more about our authors and books visit
www.bloomsbury.com. Here you will find extracts,
author interviews, details of forthcoming events
and the option to sign up for our newsletters.

TITLE PAGE Greg Daly, etched
lustred bowl, see p. 11.

CONTENTS PAGE Two glazes
applied in four different
ways, see p. 27.

Contents

1 Introduction to glazes .. 5

2 Getting started .. 28

3 Systems for glaze testing .. 35

4 Fluxes and colour .. 75

5 Developing colour .. 78

6 Glaze recipes .. 91

 Ingredient conversions 126

 Suppliers 127

 Index 128

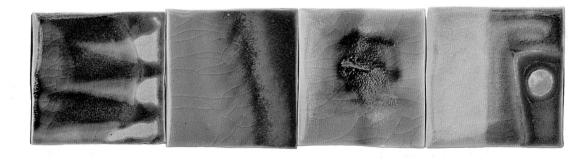

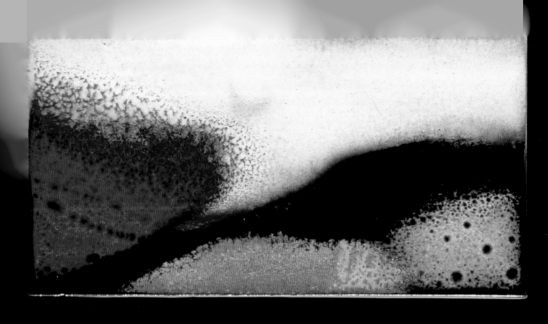

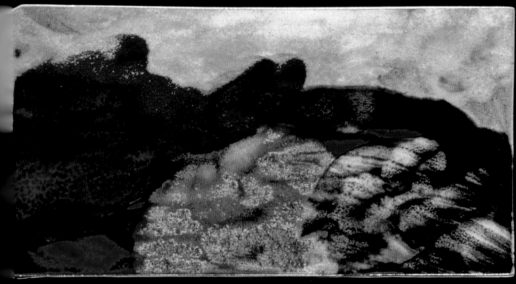

Introduction to glazes

The personal discovery of glazes is a journey that can take many paths. As with any journey undertaken to distant places, the first impressions are the lasting ones, and knowledge is gained from first-hand experience. You can choose to arrive at the destination by using motorways (i.e. using recipes from books) or you can wander the back roads, taking longer but being enriched by what you come across along the way. Theories and techniques can be learned, but what do these recipes mean and why do they produce such varied surface finishes? The real interaction between potter and glaze may never take place if, as with the images of a country never visited, you never experience for yourself the thrill of creating your own glazes.

In 1967, after a mere two weeks of potting, I was lucky to be taken to an exhibition of ceramics, a national pottery prize at Potter's Cottage in Warrandyte, Australia. There I was to see, for the first time, earthenware and stoneware glazes of many types and finishes. At the age of fourteen it left its mark; the work created an impact. I understood then that no matter how beautiful a glazed surface may be – matt, satin, glossy, coloured or not – it requires a good form to put it on.

That exhibition showed the variety that is possible in glazes, so I set out to collect glaze recipes. Soon I had hundreds, collected from many sources, but where would I begin? That was the obvious question, which soon led to another: what did I want in a glaze? Iron glazes interested me – reduced stoneware iron reds and tea dusts, and iron yellows. From that, I had a starting point, and by finding the factors that created and controlled those glazes, I began to understand what glazes were about. The aim of this book is to start you, the potter, on your own journey of exploration – of your materials, equipment and self.

Such a journey should begin with the *materials* that go to make up the glaze and how these materials control surface finish and colour. First, a few items to equip you for the road ahead:

1. Be thorough in your *recording* of materials, tests and firings. Without a reference to what was in a test firing, all you are left with is a glazed tile, with no information to enable you to explore it further.

2. Closely *observe* the fired tests; in the firing, many important pieces of information are often overlooked. Don't throw out a test for at least a month, or even up to a year. The test result may not be what you are looking for at the time, but it may turn out to be just right later on. Even sitting with the tests in full natural light, you may see something of interest, right at the edge of a glaze where it thins out. Don't keep tests locked away; I put them on windowsills, on a desk, anywhere I will constantly see them, and I swap them periodically.

Five glazes applied by spraying, painting and pouring, respectively.

3. Keep an *open mind at all times*. We can develop such tight concepts of what a glaze is and should do that we miss the big picture, as well as the immediate evidence of what we are holding in our hands. As a student researching copper-red glazes, I had a firm idea of what they should look like in colour, tone and surface – an ox blood or peach bloom – having seen them depicted in books. But I was liberated when seeing copper-red glazes en masse at the Victoria & Albert Musum: in a room full of copper reds, the colours were qualitatively different from each other in shade, intensity, surface depth and colour. This freed me of my expectations of how a glaze should look. Glazes have families – copper reds, iron, lustre glazes, shino, etc. – but within any family there is also diversity.

4. Be *playful*. If it occurs to you to try one material with another, and others say it will not work, do it anyway. You will always learn and extend your understanding. In Chapter 3 (p. 39) I have outlined a way of testing materials for fun, called 'random glazes'. Taking any four materials and any four numbers between 5 and 55, you will find you have a workable surface at cones 8 to 10. I have repeated this countless times in workshops. Many potters dismiss this odd way of creating a glaze, but are then surprised when they see the results.

5. Have a *quick way of testing*. Testing is what puts most people off, so they turn to the last page for recipes (the answers). But when you simplify the process and results come back, there is nothing more rewarding. Systems for ease of testing will be covered in Chapter 3.

Before we explore the testing process and the factors that can change the way in which a glaze emerges from a kiln, we need to understand what a glaze is and what happens to develop a balanced glaze.

What is a glaze?

A glaze is a thin layer of glass that has been fused onto a ceramic surface. A clear gloss glaze is a good example, but a clay matt glaze (in which there is not enough flux to melt the silica) or a high flux satin or matt glaze (in which there is an excess of flux, with no silica left to melt) will also have varying degrees of fused glass. In simple terms a glaze, is composed of three parts:

1. Silica (SiO_2), which forms a glass when melted. Silica melts at about 1710°C (3110°F), whereas stoneware glazes melt at 1280–1300°C (2336–2372°F) and earthenware at 1060–1100°C (1940–2012°F). Without the addition of flux in a glaze, silica would remain an unmelted powder at these temperatures.

2. A flux, used to lower the melting temperature of the silica, as explained in point 1.

3. Alumina (Al_2O_3), which is used to increase the viscosity of the glaze and give it stability on the pot (i.e. to stop the glaze running). This allows the glaze to have a broader firing range. One may liken it to flour in gravy.

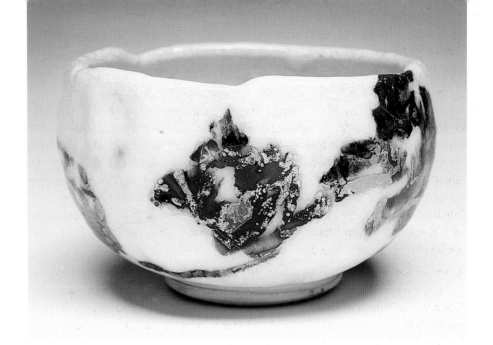

Figure 1.1. Greg Daly, bowl, 1986. Glazed with potash feldspar, poured, with iron brushwork. *Photo: Stewart Hay.*

What makes a glaze different from window glass is that it contains a higher amount of alumina.

In traditional glaze calculations, the Seger formula represents these three components as columns of oxides: RO, R_2O_3 and RO_2. This area of glaze formulation is well documented in other sources. Instead, this book is about an empirical way of approaching glaze.

Consider how few materials are used to create a multitude of surface finishes. Silica is added in its 'pure' form or as part of another material like ball clay or kaolin, which is composed of silica and alumina. Kaolin, known also as china clay, has the chemical composition $Al_2O_3 \cdot 2SiO \cdot 2H_2O$. Alumina is rarely added in its oxide form, but as a component of another material, e.g. kaolin, feldspar or ball clay. The most commonly used fluxes are added in their oxide or carbonate forms (lead, boric acid, borax, soda, potassium, lithium, calcium, magnesium, barium, zinc, strontium), along with the common metal oxides that colour glazes (iron, copper, cobalt, chrome, nickel, manganese, tin, titanium) and a group of lesser-used oxides (antimony, vanadium, selenium, gold, cadmium, uranium). The combinations, permutations and variations of these few substances are infinite.

The list of materials used in glazes is actually much longer than this, because they are also found in combination with each other. Take potash feldspar, for instance, which is composed of potassium (a flux), silica and alumina. All three are components that make up a glaze. If you have never glazed a pot in feldspar before, let this be your first test. Feldspars, if applied on their own to a pot and fired, will result in a glaze surface, as in the bowl depicted above. They are considered a natural frit or glaze. There are many different feldspars, the fluxes within them differing: soda feldspar, calcium feldspar, lithium feldspars, etc. Nepheline syenite is a feldspar that has soda and potash as the fluxes, but is lower in silica (called a felspathoid), whereas Cornish stone is a feldspar that is high in silca and lower in the fluxes (see Figure 1.6, p. 14, and note the melt in the different feldspars). Other natural glazes worth investigating are basalt, slate and wood ash, all of which contain the three basic glaze components.

Let us consider a glaze that melts to a clear, shiny surface. Temperature is unimportant for this exercise, but consider a stoneware glaze as the example. The materials that make up this glaze perform a balancing act; if one is out of balance then the glaze will no longer be clear and shiny, but milky, opaque, or even matt. Imagine the three components of the glaze: silica, alumina and flux. When combined to create this clear glaze they are in balance, with the right proportion of flux to melt the silica and alumina; but if we introduce more of either of these materials, we upset this balance and the glaze is no longer clear.

If the flux is increased there will be insufficient silica to combine with the extra flux and thus it is not taken into the solution. As the flux increases the glaze becomes first opaque then matt. The same applies for silica and alumina: increase the silica or clay (silica/alumina) content of a glaze and the same effect will be created. It may be likened to dissolving salt in water: you reach a point where the water can absorb no more salt and the salt remains as undissolved particles; whereas if you warm the water, more salt will be taken into solution. It is the same for a glaze: increase the firing temperature and you will again have a clear glaze. Imagine the beam balance in the diagram (Figure 1.2) with silica and alumina on one side and flux/fluxes (a glaze can and usually does have more than one flux) on the other side. Add more silica and an imbalance occurs; increase the flux and it tips the scales the other way, upsetting the melt of the glaze again.

Figure 1.3 illustrates these responses. A stoneware glaze was used (potash feldspar 40, whiting 20, silica 30, kaolin 10). Whiting, as the major flux, was initially left out and then line-blended back into the glaze of potash feldpar 40, silica 30 and kaolin 10 in 10g increments (see pp. 49–64, for more on line blends). This way, the effect of the flux could be observed on the melt of the glaze, from no whiting at all up to an excess of 60g. The second line was repeated with silica, blended with potash feldspar 40, whiting 20, kaolin 10 as the base. Silica is line-blended in 10g increments, starting at zero silica up to an excess of 60g. In each line blend, a material has been left out of the original recipe and blended back in.

It is important to note that the recipe will not equal 100 when a material is left out, as it is easier this way to see the effect of the addition back into the glaze base. You can calculate a result later to add to 100, as described on pp. 12–3.

You can clearly see in both the whiting and silica addition line blends opposite that the surface moves from opaque to milky to clear, then back to milky opaque again. Try this with a glaze you use. Leave out the main flux and blend back in up to double the original amount of the flux. Then leave out the silica and blend it back in up to double the amount. Satin and matt glazes (flux matts and clay matts) contain high amounts of fluxes or silica. A third type of opaque glaze is the result of crystallisation on cooling, creating an opaque/matt surface.

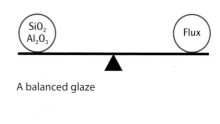

A balanced glaze

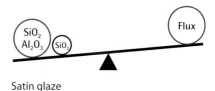

Satin glaze

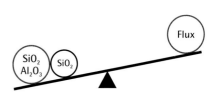

Matt glaze

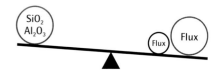

Satin flux glaze e.g. Dolomite glaze

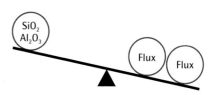

Matt glaze
e.g. Dry barium matt (80% barium)

Figure 1.2. Balanced and unbalanced glazes – showing a balanced, clear glaze being unbalanced by the addition of silica and flux.

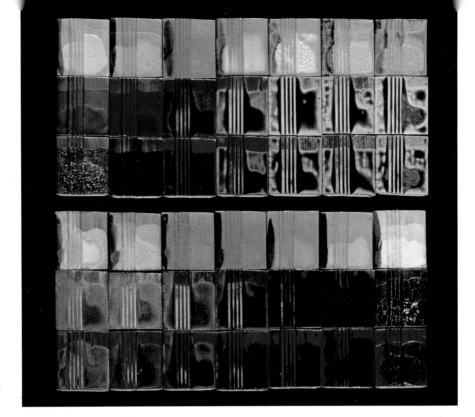

Figure 1.3. Top: Whiting, line blended. Top row reduced, lower rows oxidised. Bottom: Silica, line blended. Top row reduced, lower rows oxidised. Fired to 1280°C (2336°F).

In the balancing act of flux and silica in the line blends, other results can be seen. As either whiting (being calcium, the flux) or silica (glass former) is blended into the glaze it goes from matt to satin, then to glossy-clear and back to satin, then matt. What you are observing is the *eutectic* of the materials in the glaze. A eutectic is the lowest melting point of two or more materials when blended together. If you take two materials like lead oxide and silica in a line blend, you might expect that as the proportion of silica increased, the melting temperature of the mix would increase. However, the melting point for lead oxide is 880°C (1616°F) and the melting point for silica is 1710°C (3110°F), while the eutectic for lead and silica together is only 510°C (950°F), substantially lower than lead's melting point. This eutectic is reached at approximately 90% lead oxide, 10% silica. Other eutectics are given in Figure 1.4, over the page. A glaze can have two or more euctectics as the ratio of the materials changes and the final firing temperature.

The whiting and silica line-blend ends are on either side of the eutectic. The eutectic for this glaze can be found at around test 3 in the whiting test and test 3–4 in the silica test. The majority of glazes are on the silica side; increasing the flux will lower the melting point of the glaze. If the glaze were a flux matt, increasing the silica would lower the melting point by providing more silica for the flux to react with. This needs to be borne in mind, as the normal practice when a glaze is moving on a pot is to add silica, or clay as silica/alumina, to limit the glaze's viscosity. If the glaze still runs, then it was on the flux side of the eutectic and a larger percentage of a stiffener may need to be added, though this may also change the character of the glaze, moving it to the other side of the eutectic curve. Adding more of the flux may be the answer. The use of a line-blend test quickly gives a picture of the glaze and the direction in which to

Single material	Melting point °C (°F)	Combined materials	%	Eutectic °C (°F)
Lead oxide (litharge)	880 (1616)	Lead oxide	92.1	510 (950)
Silica	1710 (3110)	Silica	7.9	
Albite	1170 (2138)	Albite	58	1160 (2120)
Orthoclase feldspars (soda, potash)	1200 (2192)	Orthoclase	42	
Barium carbonate	1450 (2642)	Barium carbonate	35	1200 (2192)
Alumina	2050 (3722)	Silica	55	
Silica	1710 (3110)	Alumina	10	
Lead oxide	880 (1616)	Lead oxide	77.8	485 (905)
Boric oxide	700 (1292)	Boric oxide	5.8	
Silica	1710 (3110)	Silica	16.4	
Soda	900 (1652)	Soda	24.2	720 (1328)
Boric oxide	700 (1292)	Boric oxide	35.2	
Silica	1710 (3110)	Silica	40.6	
Lead oxide	800 (1472)	Lead oxide	84	484 (903.2)
Boric oxide	700 (1292)	Boric oxide	12	
Silica	1710 (3110)	Silica	4	

Figure 1.4. Eutectics of combinations of some materials, compared with the melting points of single materials, the eutectic being the lowest melting point of two or more materials combined.

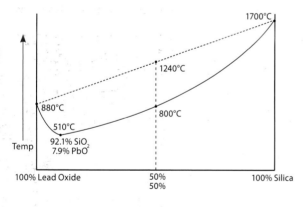

The eutectic point in the melt of lead and silica.

correct the problem. A glaze can have a number of eutectic points, just to add to the complexity and interest.

Eutectics is an interesting word but doesn't mean much until something takes place to give it clarity. In my case, I had a glaze that I wanted to fire to a higher temperature, but it ran. I line-blended silica into the glaze – from 5, 10, 15 and 20grams to 100grams of the glaze. (Adding clay would have altered the nature of the glaze.) At 5 the glaze really ran, at 10 it still ran, but somewhat less, and at 15 the glaze was what I wanted. It was odd, I thought, that 5 and 10 made it run more.

Then I remembered about eutectics: as my glaze had a high flux content, adding more silica allowed the silica to combine with the excess flux, with the result that at 10, the glaze was tipping back the other way. Lesson learnt, but in a practical way. Try line-blending silica into a satin glaze made from excess flux, e.g. a talc-white glaze, to see the results for yourself.

Before we venture further into the composition of glazes and the materials that go into making them, I would like to tell you a story that has happened or will happen to most of us at some time or another. You see a glaze on a pot – not just any glaze, but the most wondrous glaze surface you have ever seen. You obtain the recipe for that fantastic mottled green and purple glaze with yellow crystals, red stripes breaking on the top rim of the pot to blue and gold, and at the bottom of the pot, a jet black edge. What a disappointment when you mix and fire the glaze and the colour is a frosted white! But in these instances, it is worth stopping to think about the result: the white may be what you always wanted, but are too blind to see because the pot isn't as expected. You may not have achieved the original results you set out to achieve, but you have found a peaceful, understated glaze that enhances the shape of your pot. When your work emerges from the kiln, take time to view it – we are often too quick to make a judgement. The work may not be how we conceived it, but by taking time to consider an unexpected result, our initial disappointment may turn to pleasure.

Figure 1.5. Greg Daly, etched lustred bowl, 1990. Stoneware with copper glaze, half reduced and half oxidised in the same firing, lustre and acid-etched decoration, diameter: 43 cm (17 in.). *Photo: Russel Baarder.*

This has happened to me more than once and often leads to new directions in my work. For example, I had a number of works glazed in a copper red that, when fired in oxidation to cone 9, gave a light-green aqua. On this particular firing a piece of wadding (fireclay used between props and shelf for stability) had fallen down into a burner. The kiln was fired with four burners positioned from under the base of the kiln, pointing directly up into the kiln. The wadding produced a reducing flame from

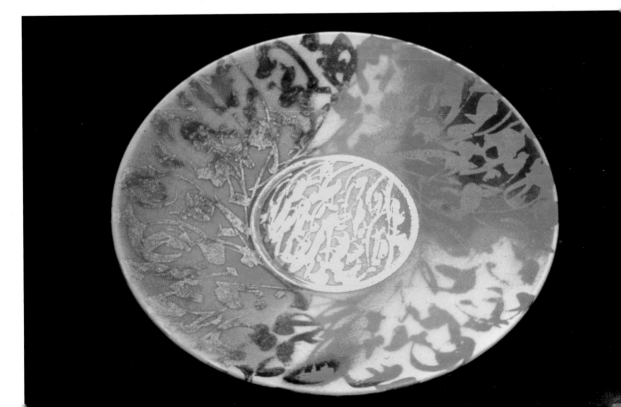

the burner at the back of the kiln that did not show during the firing (all the evidence at the time showed it to be an oxidising firing). When the kiln was opened, the pots in line with that burner had partly reduced to the copper red. My initial reaction was one of annoyance, as these pieces were for an exhibition, and were meant to be further decorated in a particular way. But by the end of the day I was excited by the possibilities offered by this 'faulty' firing (see Figure 1.5, previous page). This incident also gave me insights into the firing of copper reds. More recently I have taken this knowledge further when firing copper reds, setting burners at different degrees of reduction and oxidation, resulting in varying colours of copper red throughout the kiln and on the work from just one glaze.

Back to the story of the glaze and the recipe. There are hundreds and thousands of recipes for glazes obtainable from books, the internet and our friends. Recipes are not like manna from heaven, coming to us fully formed and unable to be changed. Indeed, the fun part is in changing them to suit your needs, as I hope you will see in the chapters that follow.

A recipe is only a recipe; it can only tell you some of the information that goes into creating the glaze. By looking at a number of recipes for copper reds, you can see what amounts of the different materials are needed to make up these glazes. Comparison of recipes is important to see which factors are similar or different. To compare recipes accurately, the ingredients of the base glaze must be converted so that the whole base adds up to 100g, in order for the colourants to be added in proportion. You may have a batch recipe for making up a bucket or bin of glaze to compare with a small quantity, but this is pointless, as accurate comparisons cannot be made if the quantities are not equal.

To compare glazes, list the materials in the same order, as shown in the table below:

Recipe	A	B	C	D
Nepheline syenite	40	133	4800	250
Whiting	20	66.6	2400	100
Silica	30	100	3600	125
Kaolin	10	33.3	1200	25
+ Iron oxide	9	30	1080	45

As you can see, it is difficult to compare recipes A, B, C and D with each other in this form. In fact, three of them are the same glaze, B and C being batch recipes of A. D is the only different recipe (it has nepheline syenite 50, whiting 20, silica 25, kaolin 5, and iron 9). Instead, always convert *base* glazes to 100 for comparison. **Don't include the colourant oxides you add as part of the total 100.** If you do, you will not be able to compare the base glazes with each other. Here is an example of comparisons, using a different group of recipes:

Recipe	A	B	C	D
Nepheline syenite	44	37	63	40
Whiting	14	10	6	20
Soft borosilicate frit	14	10	10	
Barium carbonate		10		
Bone ash			6	
Silica	25	28	10	30
Kaolin	3	5	5	10
+ Tin oxide	3	5	5	1
+ Copper carbonate	0.5	0.5	0.5	0.5

A clear comparison can be made between these recipes – you can see how the amounts of materials differ.

Factors affecting a glaze

There are many variables that go into changing the way the same glaze recipe will come out of the kiln each time. These include the source and mesh size of the raw materials; the clay body on which the glaze is fired; the duration of the firing; the work done by the heat of the kiln; the kiln type; the atmosphere (oxidised or reduced); the method used to apply the glaze; and yourself – how you work with and react to these factors. All of these can alter the glaze result that emerges from the kiln. The starting recipe is important, but can be overridden by any of these factors.

The materials

To make up a glaze recipe we need the raw materials that consitute a glaze. These might include a mixture of feldspar, cobalt oxide/carbonate, kaolin, lead bisilicate (frit), zinc oxide, whiting, silica, iron oxide, talc, borosilicate (frit), copper oxide/carbonate, amblygonite, barium carbonate, rutile, bone ash, lithium, nepheline syenite, chrome oxide, ball clay, wood ash, titanium dioxide, basalt – just a few from a long list. A number of these are natural, mined materials; feldspar, kaolin and ball clay are three of the most commonly used. As is the case with any mined, natural material, their composition will vary. Thus their flux, silica and alumina ratios will change slightly from one sample to the next, so bear in mind that any additional trace materials may affect the glaze melt.

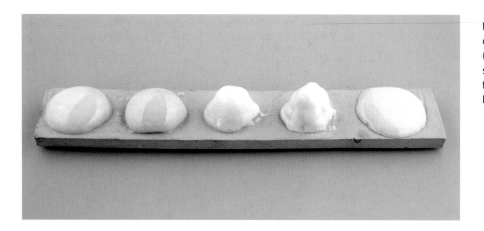

Figure 1.6. A melt test for different feldspars at 1280°C (2336°F): nepheline syenite, soda feldpsar, potash feldspar, Cornish stone, lepidolite.

If we take feldspar as an example, we find that mineral suppliers usually blend materials from two, three or more pits to give a more uniform product. As feldspar is a major ingredient (30–60%) of stoneware/porcelain glazes, so it is very important to do a melt test on each batch you buy. This can be done by parallel-testing new and old feldspars. Each sample is mixed with water to a thick paste and applied to a tile to create separate cone shapes at least 3 cm (1¼ in.) high (see Figure 1.6). Firing these in your next stoneware firing is the quickest and easiest way to make a comparison of both melt and colour.

There is another important comparison test you can carry out – a flow test. On a tile, apply a 1 cm (½ in.) thick dome of glaze of the the new and old batches, then fire the tile in a near-vertical position (see Figure 1.7). The flow of the new glaze down the tile can be compared to the old. As can be seen in the top left tile (copper red), and bottom right (Jun glaze), there is a difference between the old and new materials. The tile on the top right tests the same soft borosilicate frits, but three different batches. The left is from the USA, and the other two are from Australia, from different batches made two years apart.

In Australia in recent years, and I imagine other countries, various mines have closed and mining companies have changed hands. Along with this, the feldspar available for my glazes also changed. It became more refractory – glazes lost their edge, their life, and looked underfired. As all my glazes were based on this feldspar, the easiest solution was to fire a cone higher.

The other solution would be to recalculate the glaze recipe. If you know how to recalculate using the Seger formula, this is straightforward. Here I must add a warning, however: while the Seger formula is an excellent and informative means of glaze calculation, it depends upon the analysis of all your materials being accurate. If you are unable to obtain an analysis of the feldspar you are using, for example, and instead use a standard analysis from a book, this approach can lead to miscalculation because feldspars will differ in composition. This applies to all materials. Kaolin (and the trace elements it contains) is another important material that can change a glaze's silica/alumina ratio. Doing comparison tests with different kaolins in a given glaze will give you feedback as to how important that material is in the glaze.

Figure 1.7. Flow test. Top left: two different batches of copper-red glaze; top right: three different soft borosilicate frits; bottom left: 1 cm (½ in.) thick application before firing; bottom right: change of feldspar in a Jun glaze.

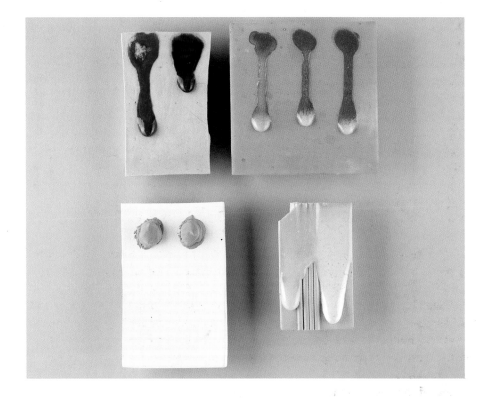

Another factor to note when buying materials is the mesh size – the size the material has been ground to. For example, I have tried a different source of whiting (calcium carbonate) with smaller/bigger mesh sizes than I normally use, and most of the glazes emerged totally different, especially the satin glazes, which came out glossy. In Figure 1.8 (below), in the test on the right, the whiting was of a very fine mesh which promoted a better melt, lowering the maturing temperature. I have experienced this with a very fine-mesh feldspar too. Take a note of the mesh size on your bag or ask your supplier. They usually carry more than one mesh size and source. If your glaze has changed recently for no apparent reason, an unnoticed change in mesh size may be why.

Figure 1.8. The two glazes applied here demonstrate the results from different whiting mesh sizes – coarser-mesh whiting was used in the glaze on the left, extra-fine mesh in the glaze on the right. The extra-fine mesh prompted a lower temperature melt.

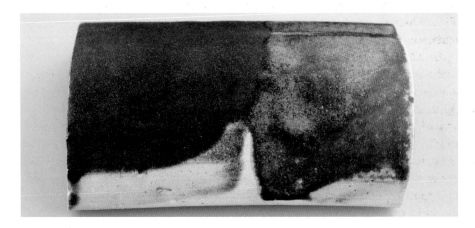

To find out how important a particular material is in your glaze, substitute another kaolin, ball clay, grade of feldspar, whiting, talc, and so on. You may be surprised at the result. In my own studio I have a number of feldspars, whitings (from different suppliers) and kaolins that I can use for testing. It is important to understand the material you are using. Can you name the kaolin you use, the grade of feldspar, the talc, the silica mesh? One suggestion is to purchase enough of this type of material to last for at least a year. If, in the last year or so, any of your glazes changed for no apparent reason, it may have been due to a new batch of a material which, along with the kiln, can make for a big difference in the final result.

In Figure 1.9, only one recipe was used; the variations in the result come from using different feldspars, talcs and bone ash (natural and synthetic). The recipe is:

Feldspar	60
Whiting	6
Talc	9
Bone ash	11
Silica	9
Kaolin	5
+ Iron oxide	12

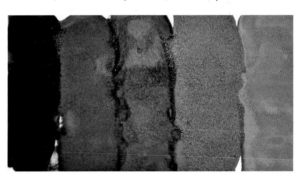

Figure 1.9. Differences in a glaze recipe when varying materials are used.

The clay body

The clay body on which you choose to fire the glaze has an important part to play in the finished glaze's quality, colour and appearance. Consider what type of clay body will give your glaze the best surface. An iron-bearing clay can give depth, and the extra iron in the body can alter the colour of a glaze. Using a transparent, coloured glaze over such a body would be like putting a watercolour wash over dark brown paper. If the wash was a gouache, like an opaque glaze, it would bleed through where thinly applied. A porcelain body is like a good watercolour paper: it makes the glaze glow, whereas on a grey, stony-coloured clay, it can look dull.

Some clays will take the life out of a glaze, like blotting paper. These clays tend to be more refractory in nature. Over a porcelain-type clay, the glaze will tend to have a quality of depth and life. Matt glazes are less affected. Figure 1.10, opposite, illustrates the effect of eight different clay bases on various glazes.

Choice of body also affects the glaze–body fit, that is, whether the glaze will craze or not. If crazing occurs, the glaze can be adjusted by increasing its silica content, decreasing the silica in the body, or by adding flux to the body. It is simpler to increase silica in the glaze by additions of silica *not* in the form of clay; adding silica by using kaolin or ball clay can have a major effect on the glaze. If you encounter the problem of a glaze running and crazing, test by line-blending silica or kaolin, or try adding a silica/kaolin blend (3:1 ratio) in the problem glaze.

Figure 1.10. Clay bodies test with glazes

Column headers: Fireclay · Iron-bearing stoneware clay · Porcellaneous clay · Terracotta clay fired to stoneware · White stoneware clay · Low iron-bearing stoneware clay · Porcelain clay · White stoneware clay

E
stoneware base glaze

+ cobalt carbonate 4

F
stoneware base glaze

+ copper carbonate 0.5
+ tin oxide 4

C
stoneware base glaze

+ zinc oxide 10
+ rutile 10

D
stoneware base glaze

+ iron oxide 1

B
stoneware base glaze

+ cobalt carbonate 0.5
+ rutile 8

E		F		C		D		B	
Nepheline syenite	55	Nepheline syenite	36	Barium carbonate	60	Potash feldspar	63	Potash feldspar	33.3
Whiting	16	Whiting	9	Kaolin	40	Whiting	6	Whiting	33.3
Talc	13	Barium carbonate	9			Talc	10	Kaolin	33.3
Kaolin	16	Soft borosilicate frit	9			Bone ash	6		
		Talc	4			Silica	10		
		Silica	28			Kaolin	5		
		Kaolin	5						

Heat

The heat of the kiln can have a dramatic effect on a glaze. In my own studio I usually have two or three kilns at my disposal, so I only obtain results pertaining to these kilns. If it were possible to farm out glaze tests to kilns of all types and sizes, people would be surprised at the varied results obtainable from one glaze. You may have experienced the dilemma of having a large kiln and being unable to try different firing cycles because of the time lag between firings, with the result that test firings never seem to get anywhere. In this case, you might wish to build a small test kiln for developing glazes, and use your large kiln for firing on ware. But why don't the final glazes on ware always look the same as the tes results? This is because of the differing heat work on glaze materials during the melt and then the cooling of the glaze.

I once saw three stoneware pots glazed in the same feldspathic iron glaze. When removed from the kiln, the first was a honey colour, the second a black, and the third an opaque, satin olive green known as a tea dust (as it resembles green tea in colour and surface). What was interesting about these pots was that, while they had all been glazed in the same glaze, each had been fired in a different chamber of a three-chamber climbing kiln. The first pot was in chamber one, which was fired on a normal firing cycle but crash-cooled, i.e. as air was pulled through the first chamber into the next, it rapidly cooled the first chamber. As chamber two reached temperature, preheated air was pulled through to help the third chamber reach temperature. By this method, the black pot in chamber two experienced a slower firing but also a slower cooling than the first, which, because the kiln was built out of dense firebrick, wasn't as rapid as it would have been in a fibre kiln. The tea-dust pot came from the third chamber. Cooled slowly, allowing crystalline growth in the glaze and the development of a satin green.

When potters shifted from using brick kilns to fibre-insulated kilns, glazes on the whole were no longer the same. In time, glazes were adapted to the new firing schedule. Firings were quicker, both in the time taken to reach the required temperature and in the cooling. Initially, glazes lacked the same depth and the quality was glossier, but it was discovered that by firing a little higher or by increasing the flux content, the finished quality could be improved. Glazes developed for fibre kilns will also take on a different character when fired in a brick kiln. In Figure 1.11, the two tiles are glazed with the same glaze recipe (previously described in Figure 1.9). The upper glaze uses nepheline syenite (a lower melting point than potash feldspar), while the lower uses potash feldspar. The left tile was fired in a brick kiln, so cooled more slowly than the right tile, which was fired in a fibre kiln. The slower cooling prompted iron crystals to form.

The effect of heat on glaze materials can easily be seen through the use of pyroscopes, commonly known as pyrometric cones or Buller's rings. While a pyrometer measures air temperature within a kiln, cones measure the work done by heat. Not surprisingly, this is called 'heat work', a term denoting the combined effect of time and temperature on ceramic material. For example, prolonged heating of a ceramic body at a lower temperature may result in the same degree of vitrification as a shorter period at a higher temperature. On most cone boxes you will note two or more columns informing the user of the temperature at which the cones will bend,

Figure 1.11. The same glaze (recipe described in Figure 1.9) fired in different kilns. The left tile cooled more slowly.

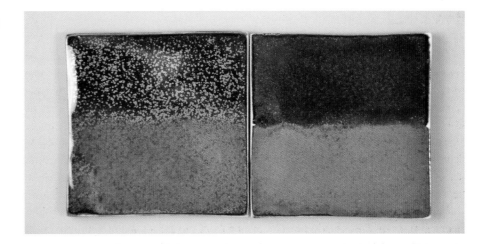

based on degrees per hour of heat input. The table below refers to cone-bending temperatures for Orton cones.

Cone-bending temperature for Orton cones

Cone number	Temperature rise of 60°C (108°F) per hour	Temperature rise of 150°C (270°F) per hour
03	1080°C (1976°F)	1001°C (1834°F)
5	1177°C (2151°F)	1196°C (2185°F)
9	1260°C (2300°F)	1280°C (2336°F)
10	1285°C (2345°F)	1305°C (2381°F)

If you were firing to cone 9 at 150°C (270°F) per hour, the pyrometer would read 1280°C (2336°F) when the cone bends; if the kiln was fired at 60°C (108°F) per hour, the pyrometer would read 1260°C (2300°F). Cone 03 at 150°C (270°F) per hour bends at 1101°C (2014°F); at 60°C (108°F) per hour it bends at 1086°C (1987°F). As you can see, the faster you fire the kiln, the higher in temperature you will need to go. You just have to fire to a higher temperature to get the same amount of 'heat work' acting on the ceramic material. Additionally, materials melting in a reduction atmosphere will have a lower melting point than those fired in oxidation. This brings us to how important cones are in every firing; it is the cones, not the pyrometer, by which you should judge whether or not the firing is completed.

Be aware of the heat work in firing. Potters who reach cone 9 will soak their kilns for 30 minutes. The reading on the pyrometer may stay at 1280°C (2336°F), not increasing or decreasing in its temperature, but will see cone 10 bend. Soaking for a period of time allows the heat to continue working on the glazes and cones and this extra heat work causes the next cone to bend. This is a good example of heat work acting on the cones, glazes and clay. If you do not have cones in the firing, you will not realise that you have fired to cone 10, and this will affect the glaze. Pyrometers

are excellent at recording the temperature's rate of climb in a firing, but should not be the final guide.

All these factors go into altering the fired glaze recipe we started with. Some glazes, such as high-feldspar glazes, respond to a slower firing in the melting of the glaze. The cooling of the kiln can be critical in the case of crystalline glazes, which require slow cooling through the temperature zone in which the crystals develop; the temperature will need to be held at the critical point. It is worth putting the glazes you use most frequently into kilns of different sizes and types, to see how important the firing cycle is to them.

Another way to look at a glaze melt is to examine an oil-spot glaze. This is a high-iron glaze (fired in oxidation) which, as the glaze begins to melt, creates bubbles, similar to sugar melting. In the top left tile in Figure 1.12, you can see the craters in the glaze that occur from bubbling at around 1240°C (2264°F). As the temperature is increased, the surface heals over, leaving the iron dots of concentrate that give the glaze its name. The glaze on the bottom left test has been applied 2 mm thick, while the right test was applied around 5 mm thick, and fired to cone 7–8 oxidised. If fired to a high temperature, the iron is taken back into the glaze melt, and the result is black.

Oil-spot recipe

Potash feldspar	40
Whiting	10
Talc	10
Silica	30
Kaolin	10
+ Iron oxide	10

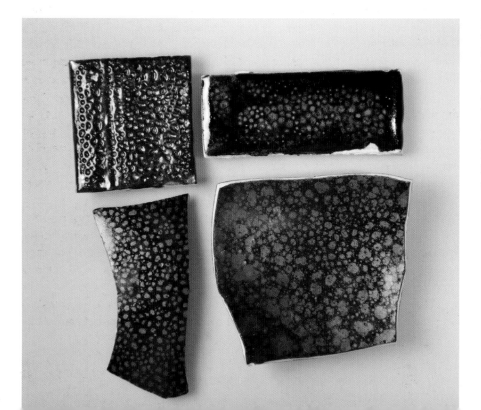

Figure 1.12. Oil-spot glaze test, showing glaze melt. Note the top left tile has not fully reached its maturing temperature. The glaze still shows signs of the bubbles that form the oil spot look, and the thickness of the glaze application. If fired higher, the iron spots will be taken back into the glaze and the effect lost.

Kiln type and fuels

The thermal properties of a kiln vary depending on the amount of fuel used, while the fuels themselves will affect the outcome of the glaze. Wood, when used as a fuel, contributes directly to the quality of the fired glaze, as the 'flux fly ash' – ash from the firebox that is taken through the kiln by flame and draught – impinges upon the surface of the glaze and affects different areas depending on the surface's exposure to the flame path and the glaze used. Wood kilns packed with unglazed pots, in which there is a build-up of ash over long firings of 40–100 hours, will produce a glazed surface. Glazed work can be fired very quickly for 6–8 hours, but longer firings of 20–30 hours lend a different quality to glazes by providing a slow melt in conjunction with ash from the fire. The amount of ash deposited will depend on the type of firebox used and the wood chosen. A bourry style firebox will give less ash deposit than a Dutch oven-style firebox or an anagama kiln.

As a fuel, oil can give different glaze qualities, but is not popular these days. Sump oil, if fired incorrectly, will produce black smoke, which neighbours and the Clean Air Acts do not appreciate. However, impurities in the oil may react with the glaze to give subtle results. Potters who have used oil as fuel usually have fond memories of the surfaces achieved; when they switched to gas, many felt their glazes lost something. Gas is clean in comparison with oil. It is also efficient and easily fired and does not affect or react with the glaze as wood or oil can.

While it is possible to fire a kiln using wood, oil or gas in oxidising or reducing atmospheres, with electricity the atmosphere can only be oxidising. An electric kiln can be reduced using gas or wood; a small gas burner can be connected to an electric kiln, which is not used for heating, but just to provide gas to create a reducing atmosphere. Some electric kilns are designed with their own side chamber for reducing with wood, but damage to the elements will result if oxidation firings don't take place regularly.

Kiln atmosphere

The kiln atmosphere may also change the finished glaze. Take, for example, the glaze called copper red. In reduction, it will fire red in colour, but in oxidation it can be light green to turquoise. In an oxidising atmosphere, oxygen is present throughout the firing, while a reducing atmosphere is produced by the presence of unburnt fuel which uses up the oxygen available. The unburnt gases are thus starved of oxygen and so take it from materials in the glaze. When the glaze is deprived of some of its oxygen content, it is said to be reduced, and this may affect the colour of the glaze. A feldspathic iron glaze with 1–3% iron in an oxidation firing will be a light honey brown with the iron appearing as ferric Fe_2O_3 (red iron oxide). In a reduction firing, the colour will be a green known as celadon, the iron having lost some oxygen, and so appearing as the ferrous form FeO. Iron and copper are the oxides that will give the most varied colour palette, while cobalt gives the same blue colour in either oxidation or reduction, changing colour only in response to other materials (with titanium a blue-green can result, and with magnesium, a mauve-pink).

Historically, kilns were fired with wood, and later coal, fuels which produced a reduction atmosphere with relative ease. In the firing of earthenware and bone china,

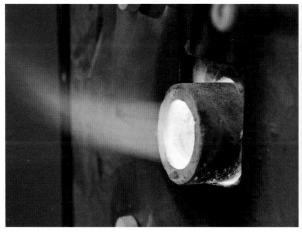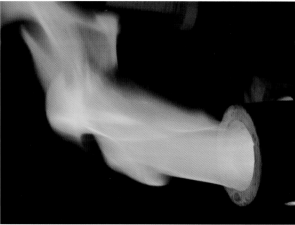

Figure 1.13. Two flames operating in one kiln: a light reduction (light yellow) and a heavy reduction dense flame (yellow-orange).

the protection of ware from fuel impurities and reduction, which could lead to body and glaze defects, was essential. Saggars were used to protect the ware; they would be sealed by clay and stacked on top of each other up to 20 high, each base forming the top of the next. A kiln could hold as many as two to three thousand saggars in a firing. Today, saggar firing means exactly the opposite, with sealed saggars containing combustible materials to create special surface effects – using a supposed defect to create a wanted effect.

When firing glazes with a higher temperature range, such as copper reds, iron greens, blacks, reds and Jun glazes, reduction is essential. A number of years ago, potters who were firing stoneware for the first time took it as read that any firing had to be reduction. You will observe that, in fact, oxidised stoneware firings on the whole produce brighter, clearer glaze colours, the main exceptions being copper reds, celadons, shinos and Jun glazes. Jun glazes develop an opalescent blue colour, but do not rely on an oxide as a colourant, depending instead upon bubbles (new research identifies the formation of small crystals as the cause) in the glaze. When light enters the glaze, violet to blue light is reflected back, with the rest of the light spectrum being absorbed by a dark, underlying body. Jun colour effects may be achieved in oxidation, using titanium and borax frit in a feldspar glaze, with small amounts of iron intensifying the blue. More detail about reduction will be covered later, such as when to reduce, for how long and how intensely (light/heavy).

Wood, the traditional source of kiln fuel, readily produces a reduction atmosphere. By choking the firebox with wood and providing insufficient primary or secondary air and/or closing the damper to restict the draw of the kiln, the fuel will fail to burn properly due to lack of oxygen. Here again we have our scales of balance – oxygen on one side, fuel on the other. The fuel can be either wood, coal, oil or gas; if more fuel is present than oxygen available for its complete combustion, a reducing atmosphere will be produced. The right amount of oxygen for complete combustion will produce a neutral atmosphere. When more oxygen is present than is needed by the burning fuel, an oxidation atmosphere is present; an atmosphere with too much oxygen can cause the kiln to lose temperature or slow down its temperature climb. In Figure 1.14 you can see

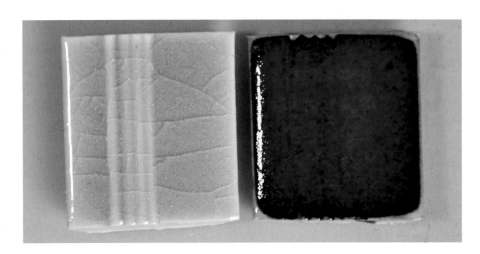

Figure 1.14. A copper glaze, oxidised and reduced.

the effect that an oxidising and reduction firing has on the same glaze, oxidation giving a green/blue, and reduction a copper red. (Copper-red recipes are given in Chapter 6.)

This temperature variation may also occur with reduction. When reduction begins, the kiln will initially lose temperature before beginning to rise again, though usually not as quickly as before reduction began. All kilns behave differently: with some it is a slow, agonising rise, while others don't seem to miss a beat. Experiment with your kiln and the amount or intensity of reduction to see how your glazes are altered, if at all. Keep a record of changes to the firing cycle, and the changes you make to, for example, gas pressure, the primary air setting on the burners, or the damper setting. When you know your kiln, you might just be able to turn up the gas pressure. Having set the damper, you can use primary air from the beginning. One point to note is how densely packed the kiln is; a light packing of two or three large pots on a single shelf will need damper adjustment, compared with a dense packing of five to six shelves, each supporting lots of small pots. The shelves and pots act as baffles, restricting the flow, so you may need to open the damper slightly and go a little slower. The flow of the gases through a kiln is like water in a stream: add more boulders and the water pressure will increase, taking more time to work its way around the boulders, finding the path of least resistance. If you have a cooler spot in your kiln, open that part up by placing the shelves higher than the cool spot and allowing a larger space between shelves, or between wall and shelf. I find kiln shelves are too big for gas kilns; you can go close to the wall in an electric, but in a gas kiln you need space for the gases to flow. Reducing the size of the shelf by 2.5 cm (1 in.) or more on both sides greatly improves the heat circulation in the kiln.

It is worth experimenting with the variables that can affect your kiln. As gas is the favoured fuel for reduction firings, we will begin here. The kiln's burners will each have a primary air input, which on most burners can be adjusted for the flow of air to mix with the gas. The flame can be adjusted by closing the primary air control, in a manner similar to a Bunsen burner, creating an orange flame that may give off black smoke; open the air control slowly and the flame will change from a blue flame with an orange tip to a hot, blue flame.

Varying the air and gas ratios is one means of controlling reduction, while increasing gas pressure is another. By increasing the pressure, you introduce more gas into the kiln, until the point is reached where there is insufficient oxygen to burn all the fuel; this is reduction. The damper is used to reduce the flow of gases through the kiln. The back pressure is created by closing the flue, holding back the flow of gas/heat through the kiln, which creates a positive pressure. It can also have the effect of helping to achieve even heat distribution throughout the kiln. Lowering gas pressure and closing the damper may also result in more even heat distribution within the kiln.

As previously explained, the packing of the kiln will alter the way it fires, so the damper and fuel pressure will have to be adjusted accordingly. When making a change to the damper setting or pressure, or to primary air on burners, always allow at least five to 10 minutes for the kiln to rebalance itself. Beginners tend to fiddle with the controls without allowing the kiln to settle.

Keep a logbook noting the increase in temperature per hour, the damper settings, gas pressure, length of firing and so on. This will allow you to refer to previous firings and makes it much easier to build up a picture of your kiln, and learn its limits, capabilities and foibles. To find these limits, try firing your kiln as fast as you can and turning up the pressure to see what happens. When does the kiln start to reduce? When it does, can you change it back to oxidation by altering the damper or primary air? Any changes to shift the kiln from reduction to oxidation should be incremental. A 1 cm (½ in.) change on the damper may be all it needs. You might also try firing on the lowest pressure, closing down the damper, then altering the primary and secondary air. In this way you will learn how to control the firing conditions of the kiln for your glazes. As you learn to read your kiln, you'll find that many glaze effects and qualities will fall into place.

Reduction

When do you begin reduction for a glaze? For me, it is when the first material in the glaze begins to fuse. In a stoneware feldspathic glaze made up of potash feldspar 25, whiting 25, silica 25 and kaolin 25, for example, the first material to begin to melt is potash feldspar at 1120°C (2048°F), so reduction would begin around 1080°C (1976°F). Why 40°C (72°F) lower? This is because you need to reduce the materials before they begin to melt. In a gas or wood-fired kiln especially, the pots exposed directly to the flames are usually hotter than the pyrometer reading indicates, as the pyrometer is not in the flame path. If the recipe has a frit as a component, reduction would need to begin just lower than the temperature at which the frit melts, in some cases as low as 800°C (1472°F), the reason being that as it begins to melt and form a glaze, the material cannot then be reduced easily, if at all. So a copper-red glaze that contains a frit, when reduced at 1100°C (2012°F), may emerge from the kiln green or clear instead of copper red, because the frit began melting under 1000°C (1832°F) and fused the copper in the forming glass, preventing the reduction atmosphere from reducing the copper.

In Figure 1.15, reduction began at 800°C (1472°F) for 15 different copper-red glaze recipes and continued through to the end of the firing. In Figure 1.16, the reduction began at 1050°C (1922°F). Glazes with a high percentage of frit will fire either green, clear or patchy.

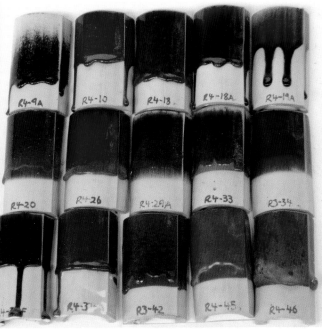

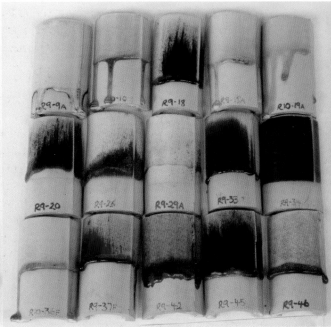

LEFT **Figure 1.15.** 15 different copper-red glazes reduced from 800°C (1472°F).

RIGHT **Figure 1.16.** The same 15 copper-red glazes reduced from 1000°C (1832°F).

Reduction can continue for the entire firing, but a period of oxidation (5–20 minutes, as a general rule) will lift some of the colours in the glaze. There is no set rule for the reduction cycle. Some glazes respond to a lighter reduction than that required by a copper red, so it is important to be able to gauge the reduction, knowing when to begin and how heavy it should be. The presence of flame exiting a spy-hole or flue doesn't necessarily mean that the reduction is heavy. Many kilns, especially after 1200°C (2192°F), can exhibit a gentle flame from the top spy-hole, caused by the back pressure. The colour of the flame and how fiercely it comes out is a better guide: a yellow-orange flame, sometimes with smoke, is reducing, while a blue flame is oxidising to very light reduction. Remember to compare the flame colour when you adjust the primary air on the burner or increase the gas pressure.

It is important to note that if you are going to begin reduction below 1000°C (1832°F), the bisque firing needs to be higher than 1000°C (1832°F) to ensure that all organic carbon material has burnt out. Without this precaution, reduction may cause the pot to bloat at stoneware temperatures. In addition, reducing a clay body before the glaze melt takes place will create different effects. For example, a high iron-bearing body with a talc glaze over the iron will bleed through with a more pronounced effect.

This discussion of reduction has so far been confined to stoneware glazes, but the same principle applies to any temperature you intend to fire to start reduction before the melting point of the materials. In the case of earthenware glazes this will be before the melting point of any frit. It is not common practice to reduce these glazes but the technique should not be overlooked, especially for copper glazes or copper glazes in combination with other oxides (see Figure 3.13, p. 54, for reduced copper earthenware

and mid-fire glazes). More care is required when reducing with earthenware glazes, as carbon trapping can occur, causing bubbling and pin-holing.

When a glaze that has been oxidised or reduced can produce two effects or colours that are as dissimilar as chalk and cheese, neither firing can be said to be 'better'; it is a matter of personal choice.

Glaze application

The next factor in determining how the glaze will emerge from the kiln is how the glaze is applied to the work. Different glaze application techniques include dipping, pouring, spraying and painting. Mixing water with the glaze and painting it onto a pot, rather than using a painting medium like CMC (carboxymethyl cellulose), gives an uneven surface resulting in varying thicknesses of glaze. With some glazes this can be a bonus, giving a variety of colours and surface effects, while with others the surface will be patchy and unpleasing. Similar variations can be observed when spraying the glaze onto a surface.

Applying with a spray gun normally results in an even surface and the desired thickness of glaze. With reduced air pressure the spray gun will splatter, creating an uneven glaze application, which with some glazes will create interesting finishes.

When you dip a pot into a glaze, a controlled thickness and covering of glaze can be obtained; as you lift the pot out of the glaze, try running your fingers or a comb/tool over the still wet surface to create a pattern. In the variation of thickness, another decorative effect is obtained.

Glaze application variables include the porosity of the bisqued work, firing bisque ware to varying temperatures, or using a number of clay bodies that have different porosities. Even when dipping in the same glaze, different thicknesses of glaze will in most cases result in different surface qualities. If a group of potters were given a glaze recipe and asked to mix it up with water, they would each add a different amount, a variation that could affect the finished thickness of glaze and the finished surface colour.

There is no set rule as to how much water to add to your glaze, but a glaze with a high clay content will require more water than one with a small amount. A high-clay glaze will take longer to dry on the pot. Some glazes, when mixed up, have the consistency of water and must be applied thinly to obtain the best results, while others need to be thick like cream and applied thickly. Sometimes one glaze recipe can be made at varying consistencies, giving a palette of colours. One such example is tenmoku, an iron stoneware glaze that when thin is a rust brown and when thick, a black. Using a small number of glazes, applying them using a range of techniques and mixing them to differing consistencies multiplies the variables, giving many different surface effects and colours. This is sometimes overlooked by potters trying to achieve a particular glaze surface.

In Figure 1.17, two glazes have been used, and applied in four different ways: dipped, painted, poured and sprayed. Note the variation of colours with the overlap from thickness variation.

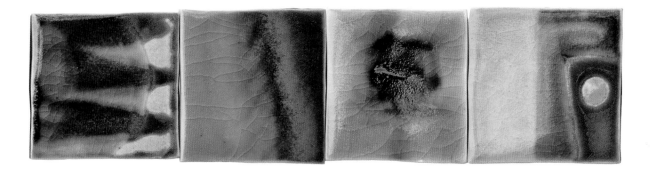

Figure 1.17. Two glazes applied in four different ways. From left: dipped, painted, poured and sprayed.

Glazes

Matt black			*Lime green*	
Nepheline syenite	55		Nepheline syenite	36
Whiting	16		Whiting	9
Talc	13		Barium carbonate	9
Kaolin	16		Soft borosilicate frit	9
+ Copper carbonate	4		Silica	32
			Kaolin	5
			+ Chrome oxide	0.02

In the photo at the beginning of this chapter (p. 4), from the top down, five glazes were respectively sprayed, painted and poured, creating different surface finishes. All five were applied in the same order: a tenmoku, then a high-feldspar glaze (white), then a rutile oatmeal glaze, followed by a rutile blue glaze, and finally a copper red. Just by changing the order in which the glazes are applied, you would have a possible 125 combinations, and with the three different application methods shown, that makes 375 in all. If you take into account varying thickness of application, and all the other varaibles discussed in this chapter, the possibilities for effects are just about endless.

Your interaction

You are the last of the variables! Your interaction with all these factors – clay body, materials, kiln, firing, and application of the glaze – is the outcome of your gut feeling in putting these together to create glaze surfaces and finishes that are truly yours.

I once heard a story about an apprentice who, on leaving the pottery where he had worked, asked for the recipe of a glaze he liked using. The master gave it to him and he went away to establish a studio. Later he came back to complain that the glaze was not the same. The master said, 'When I gave you that glaze it became yours. Why do you complain that it looks like your glaze instead of mine?'

2 Getting started

Before we begin testing, you need to consider how you will record your glaze testing and mixing. We need to record these tests in order to be able to make sense of them later, and to be able to identify the glaze test and recipe that goes with a particular test tile. It is important to keep records of recipes, firings and outcomes, and to have a procedure for mixing and applying the tests. It is easy to develop a mental block with glaze testing, due to the time you assume it will take. Record-keeping, weighing the glaze ingredients, mixing and applying the glaze to test tiles or rings, as well as firing the tests, seems like a lot of work, but if you are prepared and organised, the process doesn't take long at all, and the effort is small compared to the rewards.

Recording

You should record all your glaze tests in one large book or using a centralised electronic system like a spreadsheet, rather than multiple scraps of paper, which are easily lost. Use a simple numbering system for ease of identification and reference – there is nothing wrong with starting at 1, 2, 3, 4, 5... Alternatively, you may choose a prefix for a particular series of glaze tests, e.g. for copper reds, as in CR1, CR2, CR3, etc. It doesn't matter if you use shorthand markings on the glaze tests, as long as you know and can identify the mark the following week or in five years' time.

Another, quite different approach to numbering is to code the various elements of the test, a particularly useful tactic when you are using a number of glaze bases. Give glazes a letter from the alphabet. For example, the E base glaze referred to in this book is nepheline syenite 55, whiting 16, talc 13, kaolin 16. The right-hand colour blend in Figure 5.5 (p. 83) shows the glaze test tile E-1/27 OX-S. In this case, the base glaze is E and the colour blend number is 1. The tile number from the colour blend is 27, i.e. the 27th tile when counting left to right across the rows. OX stands for oxidised firing, S for stoneware. No other test would have the same marking. The code identifies the base glaze, the colour blend the test is from, the tile number, whether the test is reduced or oxidised, and the firing range. This is the system I use to identify a number of glaze tests. It is handy to do when you use the same base a lot to explore colour, especially using colour blends.

Have a system and stick to it. It is important to make comments in your testing book next to the glaze recipe (or, these days, on a spreadsheet, with a photo). Note the clay body, the materials used (feldspar, kaolin, etc.), and the firing – whether it was overfired, reduced earlier or later than normal (e.g. a delay in starting the reduction of the kiln can influence the result). Firing an electric kiln may take longer than usual,

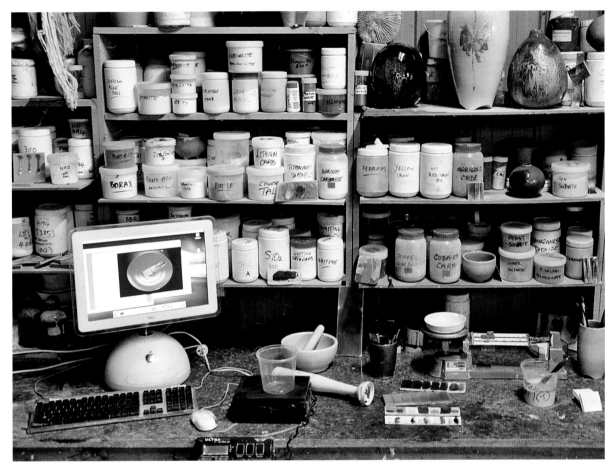

Figure 2.1. My glaze testing area.

and this could also influence the result. Minor changes may seem nothing at the time but could be the missing piece of information when a glaze comes out one way in a test and another on a pot.

Weighing and mixing

Measuring spoons, cups, hats, boots, pinches and handfuls are all volumetric measures. Glazes can be made using the volumetric method, but more commonly a measurement of weight is used to find the correct proportions of glaze ingredients. Accurate scales are required. A set of triple-beam balance scales or digital scales using grams or ounces as a unit of measurement is ideal. Don't make your weight measurements too small. For example, when trying to weigh out a test that you have reduced to a total amount of 20g, inaccuracies may occur when weighing very small amounts – say, less than 1g. On the whole, materials are relatively inexpensive, so it is worth doing the test properly and weighing out no less than 50g, or better still, 100g, a quantity that will enable you to weigh the glaze correctly and apply it with confidence. Keep the mix

until after the firing; if a glaze looks promising, you will be able to try it in the next firing on a larger surface – and it is already made up!

Scale is another factor to consider. How often does a colour on a wall-paint chart look right, but application to a larger area changes its character? After a successful test, one is apt to mix up a large amount and glaze most of the work for the next firing. Mix 1kg of glaze and apply it to a few pots. Place them in different parts of the kiln and see what comes out. You may find that the glaze responds differently in some areas; it may take time to get to know a glaze completely.

Safety

It is good practice to keep your studio clean and wear a good dust mask. Keep this in a sealed container between uses and wash it out with warm soapy water after use, taking off the filters first. Replace dust masks regularly and never bring food and drinks into the studio. Some of the materials are toxic and carcinogenic, while dust can lead to silicosis. Your supplier can provide you with Material Safety Data Sheets (MSDS).

Don't underestimate the dangers of any of the materials. Keep the glaze-testing area clean. Because materials can accumulate in the body, some potters I know have a blood test for heavy metals every few years. Be sensible.

I would suggest that you keep a small amount of each of your materials in an easily accessible container (100–500g) rather than scooping small amounts from large bins. This allows for easy access and quick, less messy weighing up. Carrying material from bulk storage can result in more being dropped than is needed for the test.

Mixing

There are many approaches to mixing and preparing glaze tests. One of the most common is to use a pestle and mortar. A small amount of water is poured into the mortar, then ingredients are added and mixed with the pestle, with more water added if required, before the glaze is sieved. This slow process is what can put potters off testing. I originally used this method, but now my procedure is quite different, with no noticeable change to the finished results – I've described the process below.

I use materials of a fine mesh size, silica at 350 mesh, for example; your supplier can tell you what size the materials are ground to. If I use an un-ground material such as wood, ash or rock dust, I sieve it first. Materials such as natural bone ash and some barium carbonates are lumpy and hard to break down, and both sieving and the use of pestle and mortar may be required. (This problem is caused by the materials having been water-ground and heat-dried by the manufacturer). Synthetic bone ash (tri-calcium phosphate) will give the same or a very similar result without the lumps.

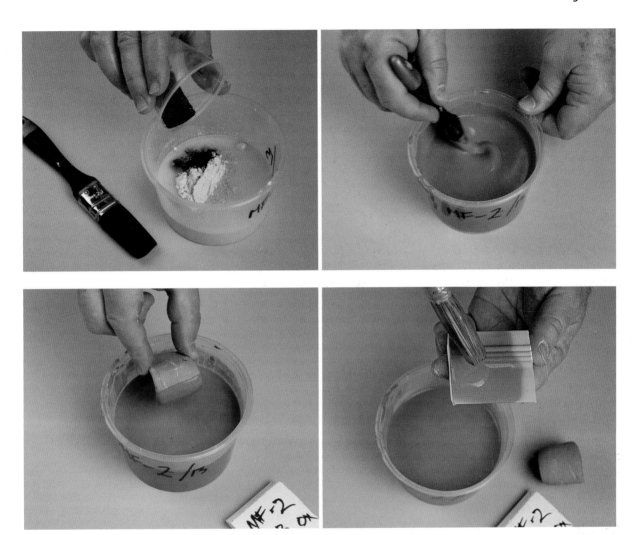

Figure 2.2. Adding material to water (left) and mixing the glaze (right).

ABOVE LEFT AND RIGHT

Figure 2.3. Dipping a test ring (left), and brushing three glaze thicknesses onto a tile (right). Note that the tile has a texture for the glaze to break on.

As the glaze is weighed, the materials are put into a container with some water. Adding the dry material to water means there is less dust and results in a glaze that will mix easily with no lumps. If it is left for a few minutes while other tests are weighed, you will find that the glaze will mix without trouble. For mixing the glaze, I use a nylon paintbrush, 2–3 cm (¾–1¼ in.) thick, which breaks down and mixes the ingredients quickly. An electric hand mixer is also very effective. Water is added to achieve the desired consistency. There is no set ratio of water to material. A glaze with a high clay content may requires nearly twice as much water as a glaze without clay, while a glaze with magnesium carbonate light (a very fine material) will require more water than the same glaze with magnesium carbonate heavy.

For a glaze test, you should add more water. To obtain the most from your glaze test, varying thicknesses of glaze need to be applied and thus a thinner mix is required. The first application is the thin application (if it was being applied over an iron body you would just be able to see the colour of the body). The second coating

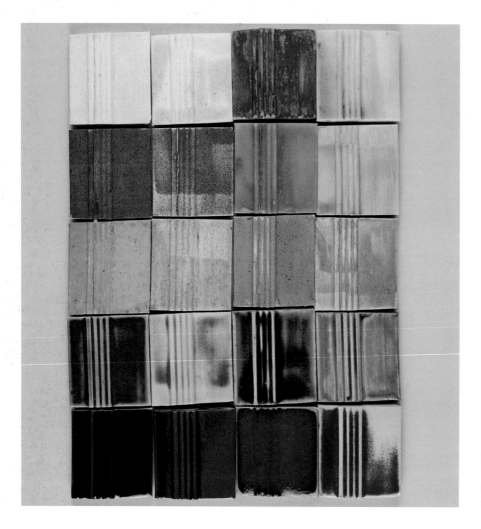

Figure 2.4. Application of 10 glazes, with thick and thin application next to each other.

gives a normal thickness of application, 1–2 mm, while the third application is thick, 2–3 mm. You won't know at that stage what the best thickness will be, but you do know that thickness will play an important role in the surface effect and colour response. By applying only one thickness of glaze you are limiting the amount of information to be gained, and as time has been invested in the recipe decision, as well as weighing and mixing the glaze, so the time invested in application (not to mention the nature of the test tile) is all-important. How to apply the glaze test is again a choice – it may be by dipping, pouring or brushing. All the test tiles in this book were brushed. Brushing has advantages, being quick and clean, but the brush can also give an uneven application, which affects the possible outcomes. If a ring test is used, then dipping is best.

Using white-firing clay test tiles or rings gives a brighter colour response than using a coloured clay. If you normally use an iron-bearing clay, do use it as the base for your tests, but try the tests on other clays as a comparison. As we have seen in Chapter 1, even different white-firing clays can change the glaze response (p. 17).

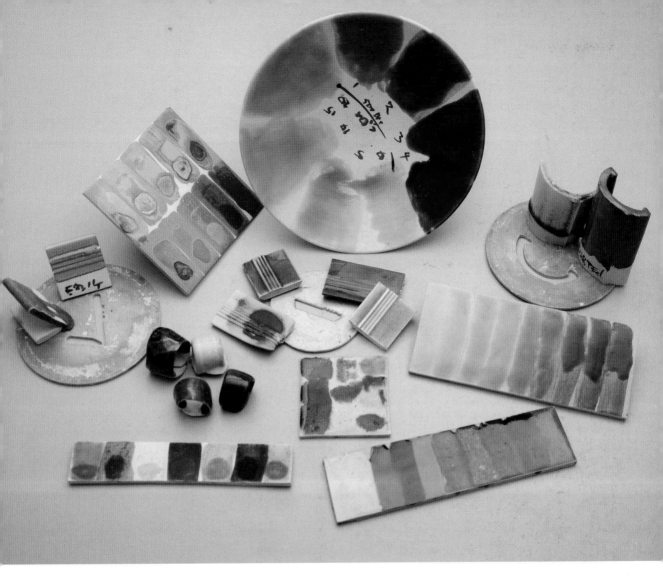

Figure 2.5. A variety of glaze test forms – rings, tiles, extruded tiles and bowl.

Potters like using different objects to test their glazes on. Keep this in mind when deciding what kind of test shape to use: it should be large enough to see colour development, the effects of different thicknesses of glaze (with space for an oxide stroke to gauge future colour development), and various brush decoration qualities; and to observe texture from a stamp, raised trailed slip, fabric pattern, finger lines left from making rings, and so on. It is important to see how and if a glaze breaks or pools, and how it reacts on a thin edge such as the rim of a bowl or cup. This information is acquired from the object you decide to test the glaze on. A shallow bowl or large tile is ideal when testing variations of one glaze, as all the tests – e.g. the additions of silica in a glaze to overcome crazing – can be contained on one object.

Figure 2.5, above, displays several testing units. Tiles are made very easily with an extruder; in one morning, a few hundred can be made. Note the free-standing tiles on the left: these are extruded and cut, the design of the die allowing the base to be broken off easily for storage, while also allowing the glaze test to be fired on a 75-degree angle for observing possible glaze movement. The test tiles used in this

33

book were extruded and made in a variety of clays (the dye shown in the centre of the image was used to extrude the tests in this book). A day or two of making and bisque-firing test tiles will give you a supply when required. A simple stamp to help identify the clay used is also helpful.

The glaze tests in this book are standardised to the following parameters:

1. Application of all glazes was by a 3 cm (1¼ in.) brush onto a flat tile with a raised pattern. Any variations are noted in the particular test. Extruded tiles measuring 6 x 6 cm (2½ x 2½ in.), cut when plastic, are used to test the glazes in this book.

2. All earthenware tests were fired to cone 03 (1080°C/1976°F) unless stated otherwise.

3. All mid-fire glaze tests were fired to cone 5 (1200°C/2192°F) unless stated otherwise, both in oxidation and reduction. Reduction commenced at 850°C (1562°F). Reduction continued until cone 5 began to bend, then the tests were fired in oxidation until firing was finished.

4. All stoneware glaze tests were fired to cone 9–10 (cone 10 half over) unless stated otherwise. Reduction began at 900°C (1652°F), except for glazes containing a frit, where reduction began at 850°C (1562°F); this continued throughout the firing until cone 9 was down, then oxidised to the finish of the firing. These firing cycles were standard for all tests. With some glazes, different reduction cycles will give changed results. Experiment and keep a record.

5. The glazes have been tested on white-firing clays. In some tests, an iron-bearing clay was used for comparison with the white clay.

6. Kiln wash is calcined alumina 80, kaolin 20. For extra kiln-shelf protection alumina can be applied to the kiln shelf using a large salt-shaker.

7. All tests in the photographs were fired flat. For testing on a vertical surface, see the extruded test tiles in Figure 2.5 (standing up at left and right). The use of a bowl will show glaze flow too.

These are guides for one approach – every potter has variations and tips. When we are on a journey, we listen to different people along the way for advice on the best restaurants, hotels or galleries, or the best roads to take to reach them; in the same way, we can listen to other potters and learn about their approaches.

For me, the testing process needs to be easy, quick and reliable. Create a system for yourself that allows this. In the next chapter, we will look at ways to approach testing systems.

Systems for glaze testing

3

In this chapter we will look at different approaches and systems that will enable you to create your own glazes, with no previous experience. Having an easy and straightforward way of testing is very important. Some kind of systematic approach will bring you results that inform what direction to go in order to develop your glaze surfaces and colour.

The following systems will give you feedback and results. The first system is designed to test the raw materials, leading to quick and simple tests with base glazes and oxides that will give a colour response. The next explains how to employ line blends in increasing amounts of a material, colourant and glaze. The last system explains how to use triaxial and square blends to develop base glazes that will result in a number of results from one blend. All these systems will show a wide variation in surface and colour response with oxides, an example being that where one glaze base will give a grass green from copper, another base glaze will give turquoise.

Raw materials

First, test the raw materials on their own. This will enable you to examine the fired raw materials that go into making up a glaze recipe, be it glossy, satin, matt or coloured. What is interesting is that the materials in their own way will naturally produce a fired surface if taken to high enough temperatures, in this case 1280°C (2336°F). Following this simple test, you will discover that, even on their own, individual materials can lead to workable, creative, interesting surfaces. As you can see in Figure 3.1, over the page, these are certainly not dull and uninteresting results; varying thicknesses of the materials have been applied, to display as much information as possible. Take titanium dioxide (row 1, tile 3, or tile number 1C): thinly applied, it is an orange colour; thickly, a yellow. Just water and titanium dioxide applied to a ceramic piece will give you a coloured matt surface. All these raw material tests have been applied to an iron-bearing clay to give a response (ground colour) for a better visual effect.

Many other materials are worth close examination in Figure 3.1. Nepheline syenite (1A), which was used as an example in Chapter 1, makes a workable surface and can be applied very thickly (1 cm/½ in.), to give an interesting, crazed ice-white. Try both potash (3C) and soda feldspar (7A). These three materials usually form the larger percentage of a glaze recipe at stoneware temperatures. They contain silica, alumina and a flux, the three elements that go to make up a glaze (see Chapter 1, p. 6).

	A	B	C	D	E	F
Row 1	nepheline syenite	potassium carbonate (on porcelain)	titanium dioxide	spodumene	copper carbonate	amblygonite (on porcelain)
Row 2	cullet	borax (on stoneware)	cobalt carbonate	lepidolite	Cornish stone	amblygonite (on high iron)
Row 3	zinc oxide	lithium carbonate (on porcelain)	potash feldspar	slate	rutile	whiting
Row 4	lithium carbonate (on stoneware)	dolomite	basalt	whiting	borax (on porcelain)	tin oxide
Row 5	soda ash	nickel oxide	magnesium carbonate	lead bisilicate	yellow ochre	barium carbonate
Row 6	ilmenite	bone ash	vanadium pentoxide	petalite	lithium carbonate (on stoneware)	silica
Row 7	soda feldspar (on stoneware)	talc	kaolin	chrome	potassium carbonate (on stoneware)	iron oxide

Fired to earthenware

	A	B	C	D	E	F
Row 8	manganese dioxide	lithium carbonate	soda ash	borocalcite	copper carbonate	cryolite
Row 9	basalt	nickel oxide	amblygonite	cobalt carbonate	borax	calcium borosilicate

Figure 3.1. Raw material identification tests. These tests were done on white stoneware clay unless otherwise specified: stoneware tests were fired to 1280°C (2336°F) in oxidation, earthenware to 1080°C (1976°F).

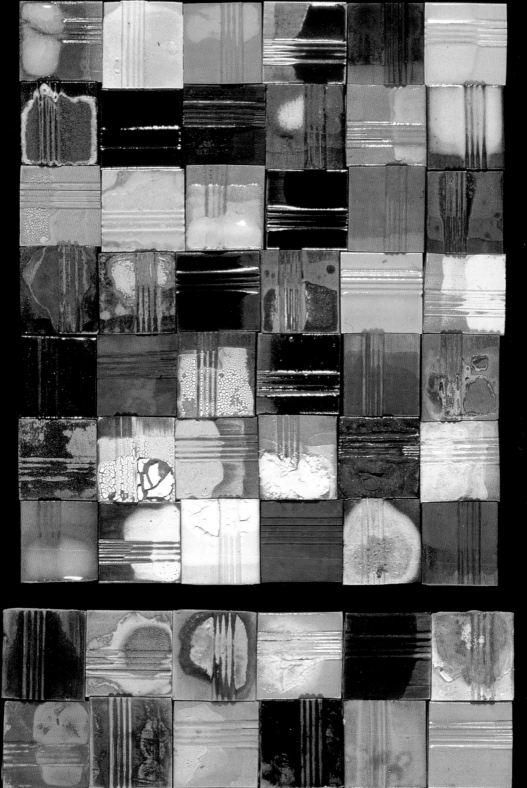

Spodumene is also a feldspar but has lithium as its flux. Amblygonite on a porcelain body (1F) produced a smooth, white, satin, craze-free surface. On the iron-bearing clay (2F) the surface is pitted and not as smooth. The tests were fired next to each other, illustrating why one should test a glaze on more than one clay when seeking a particular surface finish.

Cullet (crushed window glass, 2A) can be used as a frit in glazes (it is a flux source). Borax, which can be used in earthenware glazes, usually in the form of a frit, crystallises when mixed with water. It is not normally used at higher temperatures, but at 1280°C (2336°F) creates a very interesting response on the iron bearing-clay (2B), giving a glossy, black, mottled colour. On a porcelain body (4E), the colour is glossy-clear, but borax will run off the pot at this temperature. It is clear and glossy at earthenware temperature and doesn't run if applied thinly. Borax is normally used as a major flux for low-temperature glazes (9E).

Zinc oxide (3A) is a flux used in mid-fire and stoneware glazes. The yellow is from the iron of the clay; applied thickly, it gives an interesting cracked surface.

Lithium, a very active flux, is used in small percentages at all temperatures. In Figure 3.1 you can see four tests with lithium: on porcelain (3B), iron clay (6E), white stoneware clay (4A) and earthenware (8B). All show quite different responses. It is an important flux for colour response with metal oxides. Lithium has a low coefficient of expansion and, used in small amounts, will help to prevent crazing.

Slate is a metamorphic rock which started life as clay or mudstone before high pressure formed it into slate. It contains iron and other impurities. Slate produces a dense, black, glossy surface, and possesses all the requirements for making a glaze (3D).

Dolomite, composed of calcium and magnesium carbonates, is normally used in amounts up to 25g in a glaze and is known for producing smooth, buttery surfaces. Trace elements, especially iron, give a particular quality to this material. On the test tile (4B) it can be seen to be glossy where thinly applied like a glaze; here the silica from the body has combined with the fluxes to produce the glaze. Where it is thickly applied, the surface is matt, due to insufficient silica. (See p. 8 for more on flux–silica balance.)

Basalt is an igneous rock composed of iron, calcium and magnesium, and contains 45–55% silica. As can be seen in 4C, it produces an excellent glaze surface. Blending it with feldspar and clay can create some very interesting glazes.

Soda ash, even though it is a low-temperature flux (8C), like borax gives a glossy glaze at high temperatures (5A). Metal oxides develop metallic surfaces from thin copper (1E), cobalt (2C) and iron (7F) washes, with varying tones depending on the clay body.

It is important to mix up the materials and test-fire them in your kiln, as a test in the hand can reveal far more information than a photograph. Try other materials as well, like stock cubes or house paint, for example; you may be more than surprised at the result. House paint, for instance, has a very high percentage of titanium dioxide as a main constituent, and some of the stains have metallic oxides in them. You may try other found materials, such as laundary detergent, sea shells, table salt, cat litter or rocks from your garden. In this way, you will learn about each of the materials that go into a glaze and what they do on their own.

Random glazes

Preconceived notions about what a glaze should be and what should go into a glaze recipe limit the possibilities of glaze development. Glaze recipes can be very simple. To demonstrate just how absurdly simple the process of developing a recipe can be, think of any four materials. Try not to pick the ones you think must be in a glaze, like feldspar or silica. Now think of any four numbers between 5 and 55. You now have a recipe for a glaze which, depending on thickness, may be matt, satin, glossy or all three. This is not as mad as it may at first seem! Glaze recipes aren't fixed and immutable, but develop, are passed on and evolve. Say you have a glossy glaze and would like to make it matt. As we saw in Chapter 1, adding either more silica or alumina, or more flux, will change the glaze recipe. To take a further example, another way to create an opaque glaze is by adding materials such as tin, zirconium or titaniun. In fact, you can begin with one base glaze and evolve very nearly all your glazes from that one beginning.

The process of picking an arbitrary quantity of any four, five, six or even seven materials can produce some very interesting results. I call them random glazes. All the glazes in Figure 3.2, over the page, were developed this way. The materials were written down on pieces of paper and drawn out of a bowl. The weights were chosen in the same way. True, they are not all perfect, clear glazes, but not all of the glazes you use will be. There hasn't been one during all the years I have been demonstrating this way that couldn't be developed to become a surface finish. There is a varied collection, as can be seen in Figure 3.3 (p. 42).

Remember, to compare the glazes, the ingredients in a recipe need to add up to 100. To accomplish this, multiply the quantity of each material by 100 and divide by the total of the original amounts.

For example

Amblygonite	27g x 100 = 2700 / 88 =	31
Zinc oxide	28g x 100 = 2800 / 88 =	32
Dolomite	16g x 100 = 1600 / 88 =	18
Magnesium carbonate	17g x 100 = 1700 / 88 =	19
Total:		100

Recalculated to 100, this glaze contains amblygonite 31, zinc oxide 32, dolomite 18, magnesium carbonate 19, which equals 100 (with additions being added on top). This can now be compared with other glaze recipes. All the tests in Figure 3.2 were fired to 1280°C (2336°F) in oxidation; on the left side of each tile, a stroke of iron and copper was applied over the glaze to observe colour response. Random glaze numbers 2, 9 and 12 have been mixed with the metal oxide additions for colour development response. In Figure 3.3 the same metal oxides (and amounts) have been added to random base glazes, so you can see how each of the oxides gives different colour responses.

1		2		3		4	
Amblygonite	27	Talc	42	Soda feldspar	46	Barium carbonate	44
Zinc oxide	28	Lithium carbonate	17	Sodium bicarbonate	18	Dolomite	5
Dolomite	16	Nepheline syenite	28	Zinc oxide	22	Magnesium carbonate	28
Magnesium carbonate	17	Whiting	5	Soft borosilicate frit	15	Soft borosilicate frit	12

5		6		7		8	
Cullet (glass)	12	Kaolin	46	Whiting	14	Whiting	14
Lithium carbonate	5	Lithium carbonate	8	Barium carbonate	32	Barium carbonate	32
Nepheline syenite	48	Barium carbonate	23	Strontium carbonate	8	Strontium carbonate	8
Barium carbonate	14	Zinc oxide	14	Talc	20	Talc	20
						Soft borosilicate frit	15

9		10		11		12	
Silica	27	Barium carbonate	25	Barium carbonate	18	Barium carbonate	25
Whiting	48	Soda ash	10	Soda ash	16	Soda ash	10
Kaolin	8	Zinc oxide	16	Zinc oxide	10	Zinc oxide	16
Soda feldspar	7	Magnesium carbonate	18	Magnesium carbonate	25	Magnesium carbonate	18
						Soft borosilicate frit	10

13		14		15		16	
Lithium carbonate	7	Barium carbonate	20	Barium carbonate	20	Soda feldspar	46
Kaolin	45	Lithium carbonate	18	Lithium carbonate	18	Soda ash	18
Whiting	30	Zinc oxide	14	Zinc oxide	14	Zinc oxide	7
Potash feldspar	9	Talc	20	Talc	20	Dolomite	15
		Soft borosilicate frit	15			Soft borosilicate frit	10

Note that, to demonstrate the random glaze exercise, these recipes have not been recalculated to 100.

Simple additions to base glaze

We have a base glaze but we need to know what colours it will produce with the metal oxides. In Chapter 4 we will cover the importance of the fluxes in the glaze and the influence fluxes have on the colour given by an oxide.

There are two ways to gain information for use in developing your glazes. The first is to take a base glaze, apply it to a tile (or bowl, cylinder, etc.), then brush an oxide solution over the glaze. This will show you the colour response from the oxide

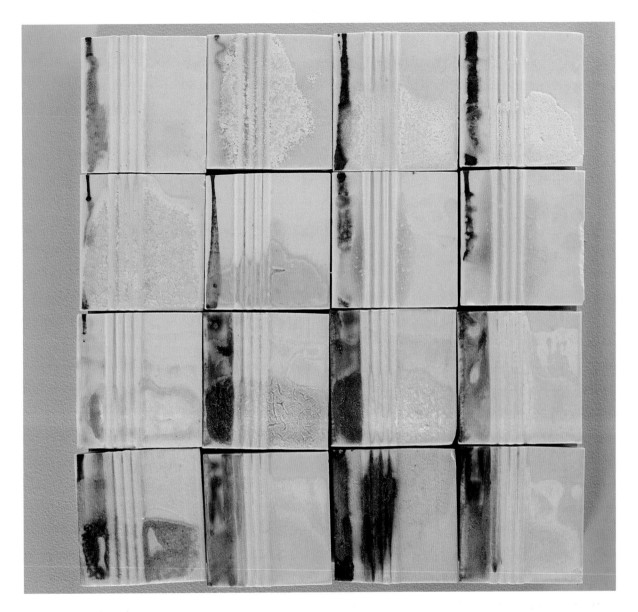

Figure 3.2. Random glazes.

and show you also if the glaze will be good for brushwork. Some glazes will give a blurred result, others a clean crisp line. To gauge the strength of the solution I use newsprint paper – if I can't see the print through the brushstroke, the solution is strong; if I can see the print through the stroke, it is medium; and when I can clearly see the print and just the tone of the oxide, it is weak. Note that all oxides have different strengths. Do a test of the different oxides and their strengths on a glaze, recording the print stroke on the paper for future reference.

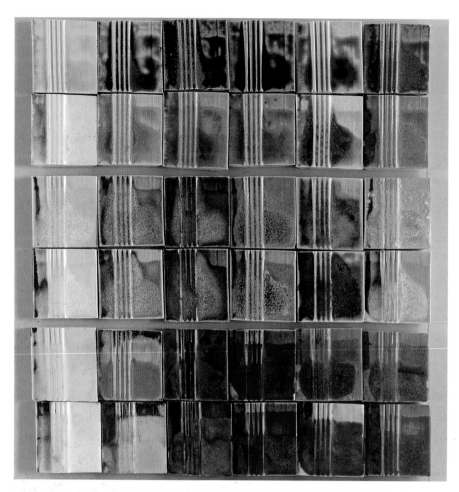

Figure 3.3. Oxide response in random glaze bases.

Base glaze 100g of		Base + iron 2	Base + iron 10	Base + cobalt 2	Base + copper 4	Base + rutile 10
Silica	27					
Whiting	48					
Kaolin	8					
Soda feldspar	7					
Talc	42					
Lithium carbonate	17					
Nepheline syenite	28					
Whiting	5					
Barium carbonate	25					
Soda ash	10					
Zinc oxide	6					
Magnesium carbonate	18					
Soft borosilicate frit	10					

Note that, to demonstrate the random glaze exercise, these recipes have not been recalculated to 100.

1		**2**	
Lead bisilicate frit	83	Soft borosilicate frit	90
Silica	7	Silica	4
Kaolin	10	Kaolin	6

3		**4**	
Soft borosilicate frit	45	Soft borosilicate frit	45
Gerstley borate	45	Lead bisilicate	45
Silica	5	Silica	4
Kaolin	5	Kaolin	6

5		**6**	
Lead bisilicate frit	83	Nepheline syenite	60
Silica	7	Barium carbonate	30
Kaolin	10	Lithium carbonate	5
+ Rutile	10	Kaolin	5

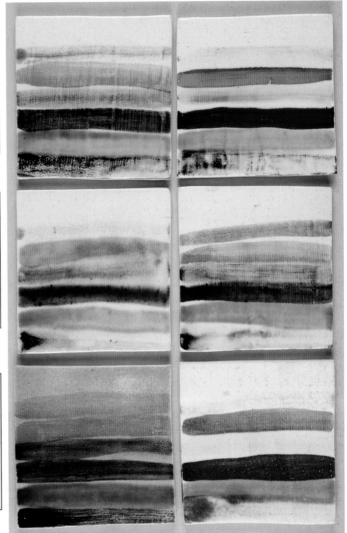

Figure 3.4. Oxide responses with six earthenware glaze bases.

In Figures 3.4 (earthenware, above), 3.5 (mid-fire, over page) and 3.6 (stoneware, over page), six different base glazes for each temperature are shown with the same oxides. Note the differences in colour and strength responses. This test will give you information to be used as a basis for other tests. Oxides starting from the top: base glaze on its own, a stroke of rutile, nickel oxide, chrome oxide, cobalt carbonate, copper carbonate and iron wash at the bottom, across the tile, applied on top of the base glaze.

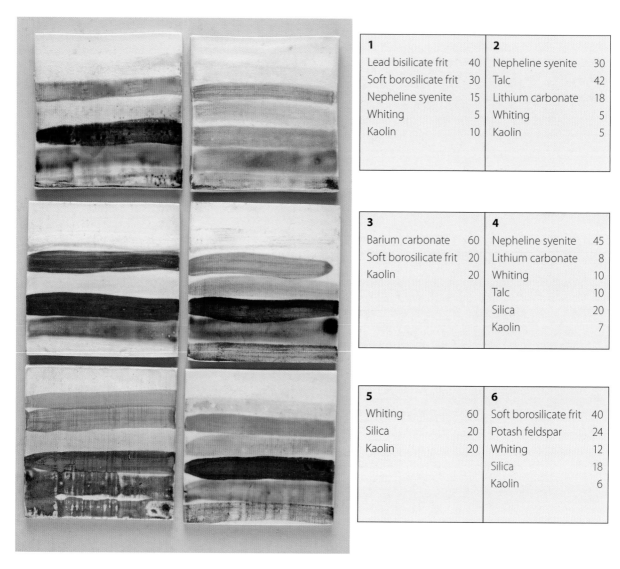

1		2	
Lead bisilicate frit	40	Nepheline syenite	30
Soft borosilicate frit	30	Talc	42
Nepheline syenite	15	Lithium carbonate	18
Whiting	5	Whiting	5
Kaolin	10	Kaolin	5

3		4	
Barium carbonate	60	Nepheline syenite	45
Soft borosilicate frit	20	Lithium carbonate	8
Kaolin	20	Whiting	10
		Talc	10
		Silica	20
		Kaolin	7

5		6	
Whiting	60	Soft borosilicate frit	40
Silica	20	Potash feldspar	24
Kaolin	20	Whiting	12
		Silica	18
		Kaolin	6

Figure 3.5. Oxide responses with six mid-fire glaze bases.

1		**2**	
Potash feldspar	25	Nepheline syenite	55
Whiting	25	Whiting	16
Silica	25	Talc	13
Kaolin	25	Kaolin	16

3		**4**	
Nepheline syenite	60	Potash feldspar	63
Barium carbonate	30	Whiting	6
Lithium carbonate	5	Talc	10
Kaolin	5	Bone ash	6
		Silica	10
		Kaolin	5

5		**6**	
Potash feldspar	20	Potash feldspar	10
Whiting	10	Whiting	40
Silica	15	Silica	20
Kaolin	5	Kaolin	30
Alumina hydrate (or calcine)	50		

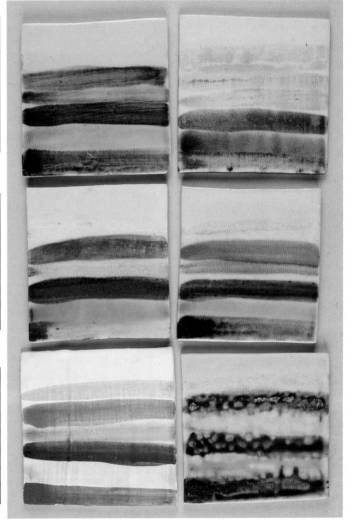

Figure 3.6. Oxide responses with six stoneware glaze bases.

Earthenware		Earthenware		Mid-fire		Mid-fire		Stoneware		Stoneware	
Lead bisilicate frit	83	Soft borosilicate frit	90	Nepheline syenite	25	Nepheline syenite	60	Potash feldspar	25	Nepheline syenite	55
Silica	7	Silica	4	Whiting	12	Barium carbonate	30	Whiting	25	Whiting	16
Kaolin	10	Kaolin	6	Calcium borosilicate frit	38	Lithium carbonate	5	Silica	25	Talc	13
				Silica	19	Kaolin	5	Kaolin	25	Kaolin	16
				Kaolin	6						
+ Iron oxide	3	+ Iron oxide	3	+ Iron oxide	3	+ Iron oxide	3	+ Iron oxide	3	+ Iron oxide	3
+ Iron oxide	10	+ Iron oxide	10	+ Iron oxide	10	+ Iron oxide	10	+ Iron oxide	10	+ Iron oxide	10
+ Cobalt carbonate	1	+ Cobalt carbonate	1	+ Cobalt carbonate	1	+ Cobalt carbonate	1	+ Cobalt carbonate	1	+ Cobalt carbonate	1
+ Copper carbonate	4	+ Copper carbonate	4	+ Copper carbonate	4	+ Copper carbonate	4	+ Copper carbonate	4	+ Copper carbonate	4
+ Nickel oxide	3	+ Nickel oxide	3	+ Nickel oxide	3	+ Nickel oxide	3	+ Nickel oxide	3	+ Nickel oxide	3
+ Rutile	10	+ Rutile	10	+ Rutile	10	+ Rutile	10	+ Rutile	10	+ Rutile	10

The second way to test your base glaze with oxides is as follows.

Start with a dry mix of the base glaze, then add the different oxides to the base. In the example in Figure 3.7, there are six tests needing 6–100g of glaze each, so multiply each ingredient by six. I find it easier to multiply by 10 (just add a 0 to the amount of each ingredient). This gives 1kg, which should be more than enough. Having more than you need for these tests will give you the base already made up for further testing. When the results come out, you can mix up a larger amount or use the next system, line blends, to further explore an oxide test response that looks promising. You will save time this way, and testing goes quicker.

In Figure 3.7, opposite, 4g and 10g iron, 4g copper carbonate, 1g cobalt carbonate, 4g nickel oxide and 10g rutile are used as additions to a 100g base. Other oxides or glaze stains can be added to or substituted in the test to see the colour response. Further tests can be done using greater or lesser amounts, but those given are the average amounts used.

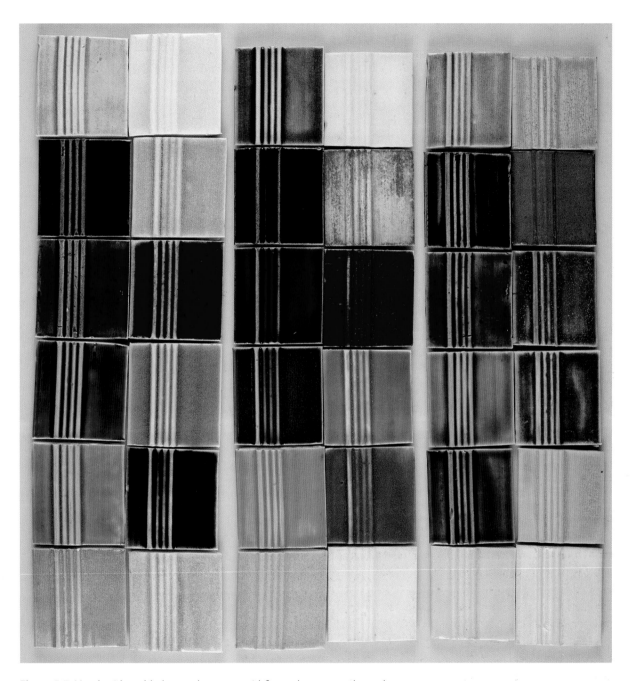

Figure 3.7. Metal oxides added to earthenware, mid-fire and stoneware base glazes.

Dry-mixing a base glaze in sufficient quantity allows you to have an amount of base glaze in dry form that can be used to do a number of tests, rather than having to weigh up the recipe every time. Decide on how much of the glaze you will need for your tests and multiply each of the ingredient quantities by that amount. I always work to a larger amount, so if you need 800g, weigh up 1kg. Use a container that can be sealed, bearing in mind that when the materials are in the container there needs to be at least 30–40% free space. Now shake and turn the container for a few minutes. **Don't remove the lid until the dust inside settles and always wear a mask when handling and mixing materials.** Keep any unused glaze in a container and label it for future use.

When testing base glazes for colour response, I find it easier to weigh up my oxides in cups, making up 4–10 cups at a time of each oxide amount; again it is easier and quicker to do it this way than opening each oxide in turn for a single test. I then add a small amount of water, weigh out the needed amount of dry, mixed base glaze, and add it to the oxide. It is far easier and quicker to do it this way than weighing each test individually; the average test uses very small amounts of oxide, which can be difficult to measure accurately. If 100g is too much for your test, you can halve the base glaze amount to 50g and halve the oxide, too, e.g. from 4g to 2g. See Figure 3.8 for the testing set-up; note there is more than one amount of iron and copper to be tested, these being the most used oxides, which show the most variation in colour responses as the amount used increases.

Figure 3.8. Testing cups containing oxides ready for base glaze addition.

Line blends

Line blends are one of the most useful methods by which to blend two materials together, such as an oxide or stain into a glaze base, or even two glazes together. Within these variations there is more flexiblity in how they can be used to give quick and easy responses. A number of variations will show how you can use this method for blending. This is probably the most valuable system for finding out simply and quickly what the response is between two materials.

In Figure 3.9, over the page, the first line blend is of potash feldspar and barium. The 11 tiles in this group show a variety of surface finishes. Note from the copper brushstroke on the edge the change in colour as the barium increases. Test tiles 1B and 1C (row 1, tiles 2 and 3) would be worth examining in an expanded line blend, as there is a radical change between the two surfaces.

Row 4 is a blend of basalt and dolomite, with basalt varying from 40 to 100g, dolomite 0 to 40g. The line test shows a full line blend is not needed. The 50/50 mix (4F) appears the most promising. The colour is there but the glaze needs more body to it, with potash feldspar being the most appropriate material to blend in, judging from the results on the two clay bodies (an iron-bearing body and a porcelain) in rows 5 and 6. These tests were run to see how the clay body would affect this glaze. Feldspar was blended in, up to 60g, with basalt 20g and dolomite 20g; this gives a number of usable glazes. The basalt is supplying materials such as iron, calcium (whiting), magnesium and small amounts of silica; dolomite supplies both magnesium and calcium; while feldspar provides potassium, silica and alumina. The three materials supply all the elements needed for a glaze. It is the magnesium that gives the mottled effect, while the combination of calcium, magnesium and iron gives the yellow-green. This glaze would belong in the family of tea-dust iron glazes. Note that a black iron glaze (tenmoku) will produce a tea dust if you add 10–15g talc (magnesium silicate), while the whiting might also need to be increased by 5g. Decreasing the iron content will change the shade of green.

In row 3 of Figure 3.9 let us examine the effect of basalt line-blended into a stoneware base glaze, taking a widely-used glaze (potash feldspar 40, whiting 20, silica 30, kaolin 10) to start with. Note on tile 3B that the change to 5g basalt and 9g base glaze gives a delicate iron green (celadon).

Line-blend additions

Here are two examples of using a line blend to add iron to a base glaze. The first is adding 11 additions of iron to the glaze – from 0.5 to 25g iron oxide. Here we can see the breadth of iron response in a base glaze. This is a straight addition of an oxide to a glaze.

The process is as follows: take a 100g of base glaze, add colourant, mix, and apply to the test piece. Then add the next addition to the mix, apply and keep repeating these steps. Note that as we are removing some of the mixture to apply to a test tile each time, and as there are 11 additions, the final mixture is thrown

Developing glazes

Row 1

	1	2	3	4	5	6	7
Potash feldspar	100	90	80	70	60	50	40
Barium carbonate	0	10	20	30	40	50	60

	8	9	10	11
Potash feldspar	30	20	10	0
Barium carbonate	70	80	90	100

Row 2

	1	2	3	4	5	6	7
Whiting	100	90	80	70	80	90	100
Kaolin	0	10	20	30	40	50	60

Row 3

	1	2	3	4	5	6	7
Base glaze	100	95	90	85	80	75	70
Basalt	0	5	10	15	20	25	30

	8	9	10	11	12	13	14
Base glaze	55	45	35	25	15	5	0
Basalt	45	55	65	75	85	95	100

Row 4

	1	2	3	4	5	6	7
Basalt	100	90	80	70	60	50	40
Dolomite	0	10	20	30	40	50	60

Row 5

Line blend of basalt 50, dolomite 50 with additions of potash feldspar tested on porcelain clay							
	1	2	3	4	5	6	7

	1	2	3	4	5	6	7
(Basalt 50, dolomite 50)	100	90	80	70	60	50	40
Potash feldspar	0	10	20	30	40	50	60

Row 6

Line blend of 50 basalt, 50 dolomite with additions of potash feldspar tested on an iron-bearing clay						

	1	2	3	4	5	6	7
(Basalt 50, dolomite 50)	100	90	80	70	60	50	40
Potash feldspar	0	10	20	30	40	50	60

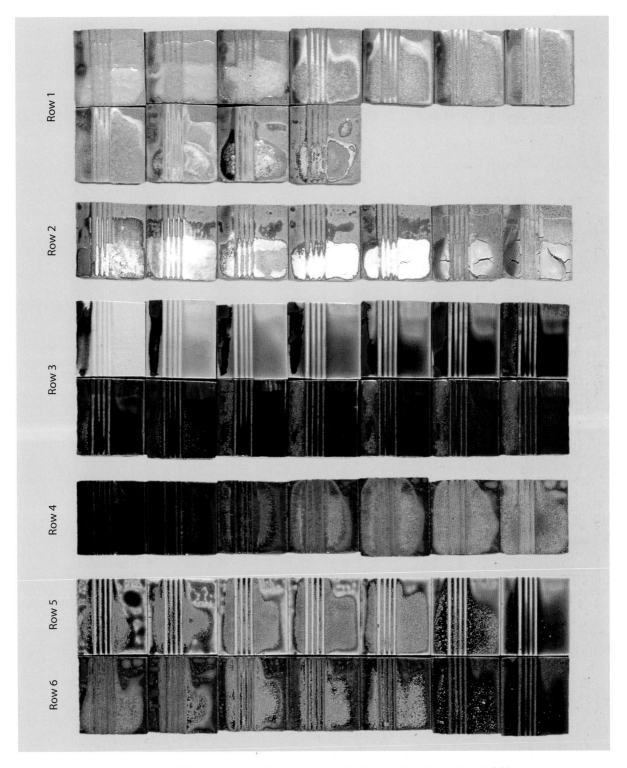

Figure 3.9. Line-blending potash feldspar/barium carbonate, basalt/dolomite, basalt-dolomite/potash feldspar.

out of proportion, with a higher amount of added oxide/material in the mix than we have recorded. There is a simple solution to this problem: use a larger amount of base glaze to start with – say, 200g or even 500g. Increase your additions by the same ratio. This iron test shown in Figure 3.10, using 500g of base glaze with iron additions, took 20–25 minutes to complete.

With 12 test applications you are removing glaze from the mix at around 2–3g per application, which will skew your final results: they will have a greater amount of iron in each application than you originally intended. You can either mix 12 tests individually or use a quicker method: start with a larger amount of 200g or 500g of base and this will give you accurate results. Remember to multiply your oxide by the same amount, e.g. for 200g of base glaze, multiple quantities of every addition by two also.

In the second and third line blends with iron and cobalt, a larger amount of base glaze was used also, but for a different reason. Iron at stoneware temperatures in reduction will produce a light green colour called celadon.

Very small amounts of iron oxide, as in a celadon glaze where less than 0.25g is

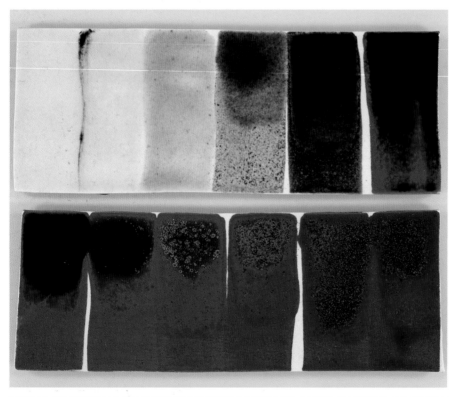

Figure 3.10. Additions of iron to a stoneware base glaze, from 0.5–30g to 100g of base glaze. Fired in reduction to 1280°C (2336°F).

Base glaze: nepheline syenite 40, whiting 20, silica 30, kaolin 10 (a variation of Leach's cone 8 glaze). Note the iron additions: each time you only have to add 1g, 2g, 3g or 5g of iron to increase the overall amount. This makes it quicker and easier than weighing 12 individual tests.

Iron 0.5g	Iron 1g + 1	Iron 2g + 1	Iron 4g + 2	Iron 7g + 3	Iron 10g + 3
Iron 13g + 3	Iron 15g + 3	Iron 18g + 3	Iron 21g + 3	Iron 25g + 5	Iron 30g + 5

added, will give shades of green and very light blue colours from cobalt. The amout of base glaze for testing can begin at a quantity of 1kg or larger. With ten times the normal base amount to begin with, 0.5g/1g (which most scales can weigh) added to 1kg becomes a 0.005/0.01 addition. This will open up a new range of colours to explore, as can be seen in Figures 3.11 and 3.12, which show additions of iron and cobalt.

Figure 3.11. Additions of iron into 1kg of base glaze. Fired to 1280°C (2336°F) reduction firing.

Base glaze: nepheline syenite 33, whiting 16, barium carbonate 8, lithium carbonate 2, silica 33, kaolin 8. Note the iron additions each time you add more iron.

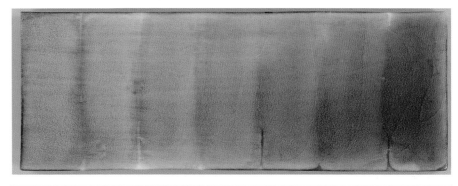

Iron 1g	Iron 2g	Iron 4g	Iron 6g	Iron 8g	Iron 10g	Iron 12g
+ 1	+ 2	+ 2	+ 2	+ 2	+ 2	+ 2

Figure 3.12. Small additions of cobalt to 1kg and 500g of base glaze on porcelain clay. Fired to 1280°C (2336°F) in oxidation.

Top row: 1kg base: nepheline syenite 36, whiting 9, barium carbonate 9, soft borosilicate frit 9, silica 30, kaolin 7.

Bottom row: 500g of base: nepheline syenite 36, whiting 9, barium carbonate 9, soft borosilicate frit 9, silica 30, kaolin 7.

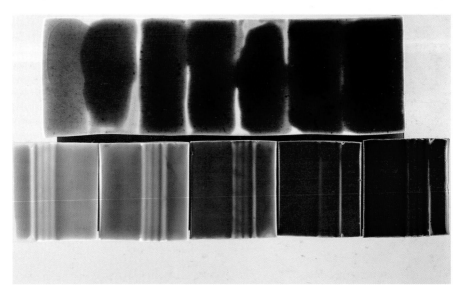

Cobalt 0.5g	Cobalt 1g	Cobalt 1.5g	Cobalt 2g	Cobalt 2.5g	Cobalt 3g	Cobalt 4g
+ 0.5	+ 0.5	+ 0.5	+ 0.5	+ 0.5	+ 0.5	+ 1

Cobalt nitrate 0.25g	Cobalt nitrate 0.5g	Cobalt nitrate 1g	Cobalt nitrate 1.5g	Cobalt nitrate 2g
+ 0.25	+ 0.25	+ 0.5	+ 0.5	+ 0.5

A line blend allows you to blend in materials, too. In the example in Figure 3.13, the aim was to lower the melting temperature of a copper-red stoneware glaze by adding a soft borosilicate frit in the line blend to a stoneware copper-red glaze in 10g increments. As a low-temperature flux, this frit lowers the melting temperature of the glaze, transforming a stoneware copper red into a red that works at earthenware and mid-fire temperatures. Reduction began at 850°C (1562°F). The glaze tests in the line blend begin with matt, then change to satin and then gloss as the frit percentage increases, finally giving a glossy copper red. The same line-blend mix was used for both temperatures.

Copper red base glaze 100g	Soft borosilicate frit 10g + 10g	Soft borosilicate frit 20g + 10g	Soft borosilicate frit 30g + 10g
Soft borosilicate frit 40g + 10g	Soft borosilicate frit 50g + 10g	Soft borosilicate frit 60g + 10g	Soft borosilicate frit 70g + 10g
Soft borosilicate frit 80g + 10g	Soft borosilicate frit 90g + 10g	Soft borosilicate frit 100g + 10g	

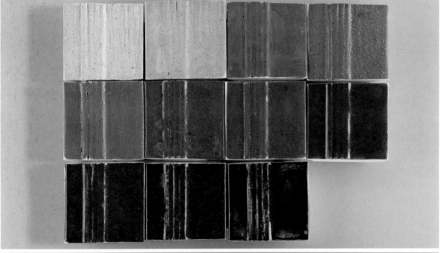

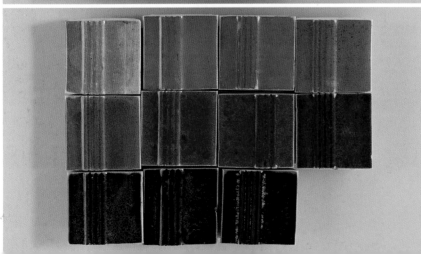

Figure 3.13. Line-blending soft borosilicate frit into a copper-red stoneware glaze.

Upper series: Fired to 1080°C (1976°F), reduction began at 850°C (1562°F).

Lower series: Fired to 1200°C (2192°F), reduction began at 850°C (1562°F).

Copper-red base glaze: nepheline syenite 35, whiting 18, soft borosilicate frit 13, silica 26, kaolin 8, + tin oxide 2, + copper carbonate 0.5.

If a line blend is used to add silicon carbide to a copper earthenware glaze, the silicon carbide creates a localised reduction as the carbon burns out below 1000°C (1832°F), reducing the copper as the glaze melts. Here, two different recipes are used to see which responds more to silicon carbide. Note that in the top series, the red is developing with a small addition of 0.25g silicon carbide in the copper glaze, whereas the lower series takes an addition of 1g before colour change. As only a small amount of silicon carbide is needed, 200g of the base glaze was used with a 0.5g addition.

Base copper glaze 100g	Silicon carbide 0.25g + 0.25	Silicon carbide 0.5g + 0.25	Silicon carbide 0.75g + 0.25
Silicon carbide 1g + 0.25	Silicon carbide 1.5g + 0.5	Silicon carbide 2g + 0.5	Silicon carbide 3g + 1

Figure 3.14. Addition of silicon carbide into two different copper earthenware glazes. Fired at 1080°C (1976°F) in oxidation.

Upper row: Base glaze: soft borosilicate frit 90, silica 4, kaolin 6, + tin oxide 2, + copper carbonate 1.

Lower row: Base glaze: soft borosilicate frit 45, gerstley borate 45, silica 4, kaolin 6, + tin oxide 2, + copper carbonate 1.

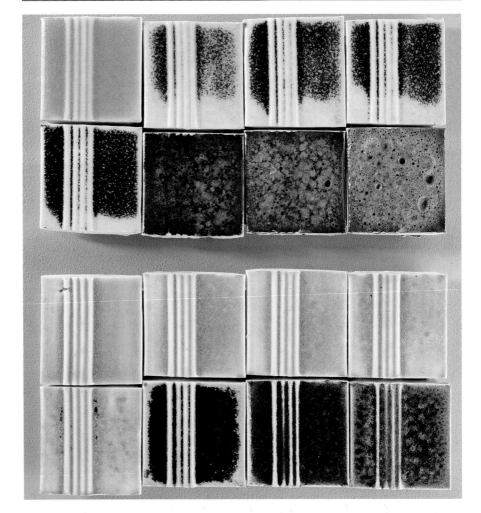

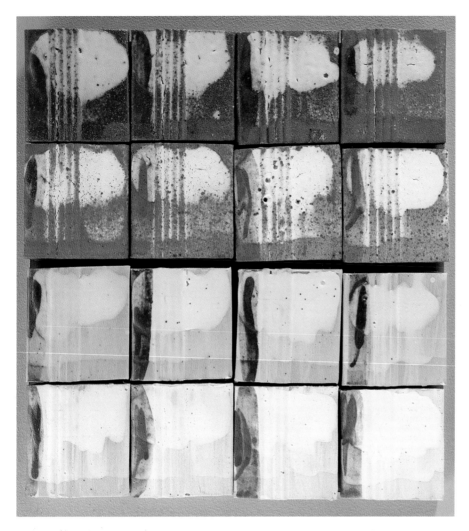

Figure 3.15. Line blend of alumina hydrate into a feldspar glaze on both iron (upper) and white (lower) bodies. Fired to 1280°C (2336°F) in reduction, with iron stroke over the glaze. Note the iron colour change as the alumina increases to an orange.

Base glaze: nepheline syenite 40, spodumene 30, soda ash 10, kaolin 20.

Base feldspar glaze 100g	Alumina 5g + 5	Alumina 10g +5	Alumina 20g +10
Alumina 30g + 10	Alumina 40g + 10	Alumina 50g + 10	Alumina 60g + 10

In Figure 3.15, a line blend with a refractory material – here, alumina (hydrate or calcined) – is used in a feldspar glaze over an iron-bearing body and a white body. As the alumina increases it has an effect on the iron, changing from a dark brown to an orange rust. Even though the final test is dry, it is silky to the touch. Try adding alumina to any glaze, and you'll find interesting surfaces and colour tones result, especially with iron, cobalt and vanadium.

In the examples of line blends I have shown here, I have just shown one material being blended into a base glaze. In Figure 3.13 (p. 54), after 10 additions, the mix is 50/50. This is sometimes called a single line blend; you can keep adding, but you will never have a test with 100% of the material you are adding. There is a second type of line blend, called a double line blend, which is very useful when you are blending two materials, a material with a glaze, or glaze with a glaze evenly together. In Figure 3.16, over the page, you can see the double blend in these two examples. The divisions can be as small as you like, with 5g increments , or even 1g in a line blend.

A 100	90	80	70	60	50	40	30	20	10	0
0	10	20	30	40	50	60	70	80	90	B 100

A 100	75	50	25	0
0	25	50	75	B 100

Two examples of a double line blend.

The double line blend in Figure 3.16 uses two glazes, a copper-red and a rutile-blue glaze. In this example, 5g increments were used, as smaller increments show subtle changes when the two glazes are blended. In Figure 3.25, p. 67 (a triaxial blend using the same two glazes), you can observe 25g increments, but these do not show the full story of the variation.

For Figure 3.16, both glazes were dry-mixed then weighed into 21 cups. The approach for mixing was as follows: line up the cups, mark on them the numbers 1 to 21 and also the amount of each glaze in the cup, e.g. A-60, B-40. Labelling means that, when the cups are stored after testing, you can easily find the ones you would like to test further. You can also use half the amounts given in each, e.g. A 80 = 40, B 20 = 10. Do one glaze/mix at a time. Once again, I need to stress that this double line test doesn't take long to do.

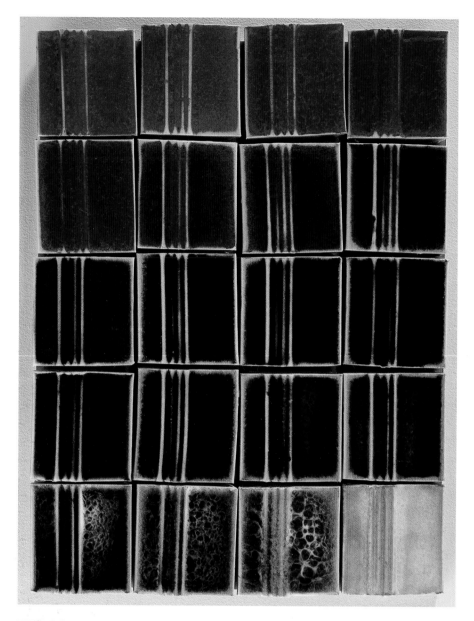

A Glaze	
Soda feldspar	36
Whiting	17
Soft borosilicate frit	13
Silica	26
Kaolin	8
+ Copper carbonate	0.5
+ Tin oxide	2

B Glaze	
Nepheline syenite	38
Whiting	9
Barium carbonate	9
Soft borosilicate frit	9
Silica	30
Kaolin	5
+ Rutile	8

Glazes used in the Figure 13.6 line blend.

A 100	90	80	70	60	50	40	30	20	10	0
0	10	20	30	40	50	60	70	80	90	B 100

Figure 3.16. Line blend of two glazes: copper-red and rutile-blue glaze, 1280°C (2336°F), reduced from 850°C (1562°F).

In the next example, only part of the double line blend is used, but the chrome is kept constant through the tests by mixing the same amount into A and B. In this series of blends, the reaction of the chrome with lead and other fluxes is being explored. Lead bisilicate with chrome at 760°C (1400°F) gives a bright orange (which can be used as an enamel), while at just over 1000°C (1832°F) the orange colour is lost. Other fluxes – lithium, strontium, whiting and magnesium carbonate light – are blended with the lead bisilicate to produce a range of orange/green colours and surface finishes. These are only to be used on nonfunctional (i.e. decorative) pieces, due to the lead and chrome toxicity.

These are just some of the results that can be achieved from a single or double line blend. They do not take long to do, but will give you good results that are broad and varied.

Figure 3.17. Lead bisilicate frit and chrome, line-blended with lithium, whiting magnesium carbonate light and strontium carbonate, fired to 900°C (1652°F) in oxidation.

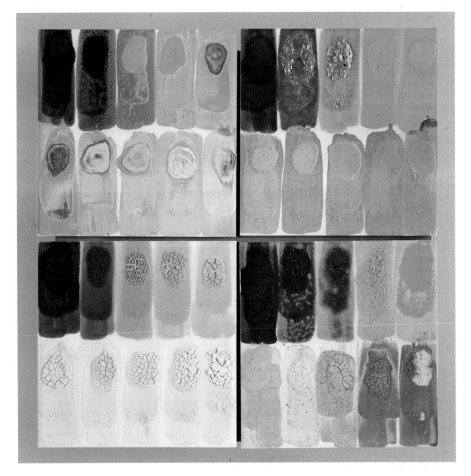

Lithium carbonate	Whiting
Magnesium carbonate light	Strontium carbonate

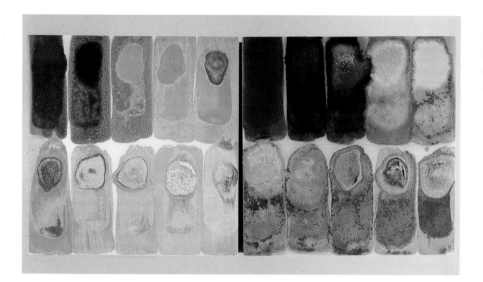

Figure 3.18. Lead bisilicate/lithium and chrome line blend. Left tile fired to 900°C (1652°F), right tile to 1000°C (1832°F), in oxidation.

Line blend for Figure 3.17 and 3.18: Row B gives amounts for lithium carbonate, whiting, magnesium carbonate, strontium carbonate.

A				
Lead bisilicate 100	Lead bisilicate 95	Lead bisilicate 90	Lead bisilicate 85	Lead bisilicate 80
+ Chrome 3	+ Chrome 3	+ Chrome 3	+ Chrome 3	+ Chrome 3
B – 0	B – 5	B – 10	B – 15	B – 20

A				
Lead bisilicate 75	Lead bisilicate 70	Lead bisilicate 65	Lead bisilicate 60	Lead bisilicate 55
+ Chrome 3	+ Chrome 3	+ Chrome 3	+ Chrome 3	+ Chrome 3
B – 25	B – 30	B – 35	B – 40	B – 45
+ Chrome 3	+ Chrome 3	+ Chrome 3	+ Chrome 3	+ Chrome 3

Line blends for developing glazes at any temperature

How do you formulate a glaze that will mature at 1220°C (2228°F), or at any temperature, with a satin finish or a clear glossy finish? There are many approaches to this problem, one of which is to apply the Seger formula.

Another is a very straightforward solution – take any stoneware glaze and a low-temperature frit and line-blend them together. Fire this line blend at the temperature at which you want the glaze to mature. The resulting line blend will provide you with glossy, satin and matt base glazes, with the best results seen if increments in the line blend are not greater than 5g. This will give a broad view of progressive changes in the line blend, allowing for easy selection of a glaze. Additions of a frit (flux) will lower the melting point of the stoneware glaze. In the first two or three tiles of the blend, the maturation temperature may drop by one to two cones, as the frit is incorporated and becomes a more active component of the glaze melt. The line-blend test illustrates glaze changes from matt dry to milky satin to a clear glossy surface. In the case of the earthenware series in this chapter (Figure 3.20, over the page), the tests have been applied to terracotta clay so that body colour can be seen to emerge through the glaze as it melts. The upper series was fired to 1080°C (1976°F), the lower series is the same blend but fired to 1200°C (2192°F). A number of workable glazes can be found at both temperatures, including gloss, satin and matt.

In the glaze-frit line blend demonstrated in Figure 3.20, the stoneware glaze is a satin talc glaze and a dry barium–kaolin glaze. Two commonly used frits were employed: a soft sodium borosilicate and a lead bisilicate frit. There are many other frits available that will give varying results in melt and colour responses – for example, the tile in Figure 3.19 was set at an angle of 20 degrees off vertical with a selection of frits 1 cm (½ in.) thick applied to the top and fired in oxidation to 1000°C (1832°F). Any combination of frits may be used in a glaze to combine different fluxing powers, body fit and colour responses; in the majority of cases glaze stains are not affected.

Figure 3.19. Flow test of different frits fired to 1080°C (1976°F), 20 degrees off vertical, 1 cm (½ in.) thick at the top. Note how all the frits melt at a different temperature and flow down the tile. Test all the frits you use in this way to see how they melt.

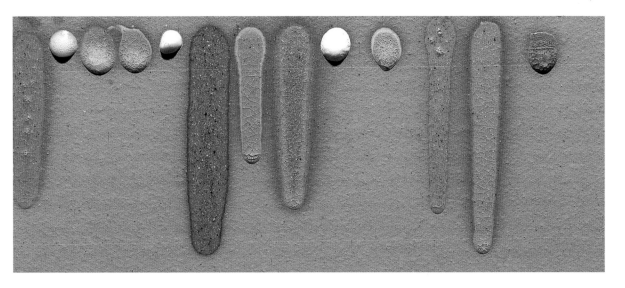

Figure 3.20. Glaze-frit line blend. A – nepheline syenite 55, whiting 16, talc 13, kaolin 16. Blend with B – lead bisilicate 60, soft borosilicate frit 40.

Earthenware cone 03 1080°C (1976°F)

	1	2	3	4	5	6	7
Row 1	glaze 100 frit 0	95 5	90 10	85 15	80 20	75 25	70 30
	8	**9**	**10**	**11**	**12**	**13**	**14**
Row 2	65 35	60 40	55 45	50 50	45 55	40 60	35 65
	15	**16**	**17**	**18**	**19**	**20**	**21**
Row 3	30 70	25 75	20 80	15 85	10 90	5 95	0 glaze 100 frit

OXIDISED

Colour response from line blend tests 15 and 5

	15 frit 4364 42 frit 4110 28 n. syenite 15 whiting 5.5 talc 4 kaolin 5.5	+ iron oxide 4	+ iron oxide 10	+ cobalt 1 carbonate	+ copper 4 carbonate	+ nickel oxide 4	+ rutile 10
Row 4							
Row 5	5 frit 4364 12 frit 4110 8 n. syenite 40 whiting 14.5 talc 11 kaolin 14.5	as above	as above	as above	as above	as above	as above

OXIDISED

Mid-fire cone 4 1180°C (2156°F)

	1	2	3	4	5	6	7
Row 6	glaze 100 frit 0	95 5	90 10	85 15	80 20	75 25	70 30
	8	**9**	**10**	**11**	**12**	**13**	**14**
Row 7	65 35	60 40	55 45	50 50	45 55	40 60	35 65
	15	**16**	**17**	**18**	**19**	**20**	**21**
Row 8	30 70	25 75	20 80	15 85	10 90	5 95	0 glaze 100 frit

OXIDISED (left margin for Rows 6–8)

Colour response from line blend test 9, oxidised and reduced

	9 frit 4364 24 frit 4110 16 n. syenite 30 whiting 11 talc 8 kaolin 11	+ iron oxide 4	+ iron oxide 10	+ cobalt carbonate 1	+ copper carbonate 4	+ nickel oxide 4	+ rutile 10
Row 9							
Row 10	9 as above	as above	as above	as above	as above	as above	as above

OXIDISED, *REDUCED*

The use of a line blend allows development of a glaze recipe intended for any temperature. Multiple sets of the same line blend can be made up and fired to different maturation temperatures – e.g. 1000°C (1832°F), 1080°C (1976°F), 1120°C (2048°F), 1180°C (2156°F), 1240°C (2264°F). From this base line blend, a large number of usable glazes will be obtained. Once you have selected a glaze, it will then be a simple matter of fine tuning if necessary.

Triaxial blends

Triaxial blends allow for three things – either materials, glazes or a combination of both – to be blended together. These are placed in each corner of the blend (tiles 1, 11 and 15). In this series I have used 25g increments; this gives a quick and broad response that enables you to determine whether or not a test series is worth pursuing. Later, a more detailed blend can be explored by taking promising results from the blend, or by working on an enlargement of a section that looks promising.

In Figures 3.21 to 3.23, base glazes for earthenware, mid-fire and stoneware are developed simply by choosing three ingredients. These become the corners of the triaxial blend and the test is designed so that the three ingredients will blend together. For the earthenware, two low-firing frits (corners A and B) and terracotta clay (corner C) are in the corners. The terracotta clay may be changed for a ball clay or kaolin and the two frits, in this case lead bisilicate and calcium borosilicate, can be subsitutes for any frit you have in these two corners. With the mid-fire and stoneware, two of the three ingredients were used: a calcium borosilicate frit (A), though any other fluxes can be used, e.g. whiting; nepheline syenite (B), replacing lead bisilicate, though another feldspar may be used; and terracotta clay (C), though, again, other clays can be subsituted. You are able to create your own base glazes from this one blend, to give gloss, satin and matt base glazes.

In the blend in Figure 3.24, over the page, the three glazes are a copper red (tile 1), a talc satin base glaze (tile 11) and a rutile blue (tile 15). The blending of the copper red and the rutile blue gave an interesting response: an electric blue/red and a brighter blue (tiles 6 and 10). A Jun-style glaze, instead of the talc glaze, could be an interesting alternative given the nature of Juns: a blue-purple response would be highly likely. The Jun ware of China's 12th and 13th centuries was glazed in a Jun blue glaze then decorated with copper. On some of those ancient pieces, the copper is so concentrated that patches of brilliant malachite green appear among the areas of purple.

FACING PAGE, TOP LEFT
Standard 15-section triaxial blend calculations.

TOP RIGHT
Figure 3.21. Triaxial blend: lead bisilicate and calcium borosilicate frits with terracotta clay. Fired to 1080°C (1976°F) in reduction.

BOTTOM LEFT
Figure 3.22. Triaxial blend: calcium borosilicate frit, nepheline syenite, terracotta clay. Fired to 1200°C (2192°F), reduction from 900°C (1652°F).

BOTTOM RIGHT
Figure 3.23. Triaxial blend: calcium borosilicate frit, nepheline syenite, terracotta clay. Fired to 1280°C (2336°F), reduction from 900°C (1652°F).

1		
A 100		

2	3	
A 75	A 75	
B 25	C 25	

4	5	6
A 50	A 50	A 50
B 50	B 25	C 50
	C 25	

7	8	9	10
A 25	A 25	A 25	A 25
B 75	B 50	B 25	C 75
	C 25	C 50	

11	12	13	14	15
B 100	B 75	B 50	B 25	C 100
	C 25	C 50	C 75	

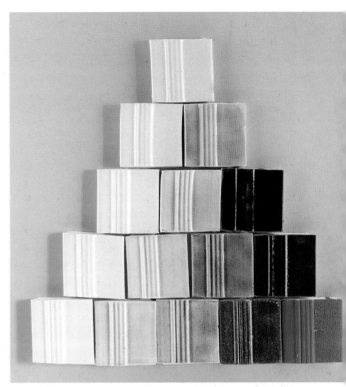

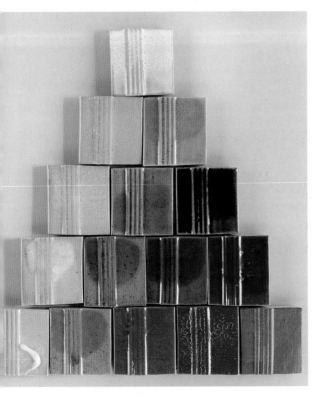

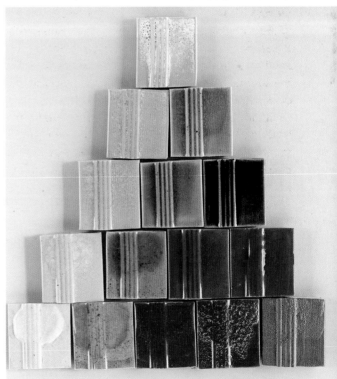

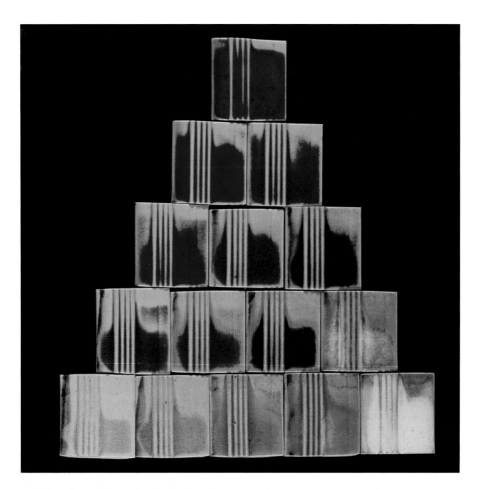

Figure 3.24. Triaxial blend: copper red, talc glaze, rutile glaze. Fired to 1280°C (2336°F), reduced from 850°C (1562°F).

Copper-red glaze		Rutile-blue glaze		Talc satin glaze	
Nepheline syenite	38	Nepheline syenite	38	Nepheline syenite	56
Whiting	9	Whiting	9	Whiting	16
Barium carbonate	9	Barium carbonate	9	Talc	12
Soft borosilicate frit	9	Soft borosilicate frit	9	Kaolin	16
Silica	30	Silica	30		
Kaolin	5	Kaolin	5		
+ Tin oxide	4	+ Rutile	8		
+ Copper carbonate	0.5				

Square or quadraxial blends

Square blends are a system for developing glazes that uses either four raw materials, four glazes or a combination. In each corner tile – A, B, C and D – there is 100g of the chosen material or glaze. The rest of the tiles show combinations of these ingredients, according to standard calculations shown in the chart on p. 71. An example of a square blend test with four raw materials is shown below in Figure 3.25. The materials chosen were nepheline syenite, dolomite, barium carbonate and kaolin. Standardised brush strokes of copper and iron applied to each tile give information for future colour development and the potential for surface brushwork. Note that as the proportion of barium carbonate increases, the copper turns to turquoise green. This series of tests has been applied to iron-bearing clay. Note also the responses to variation in thickness of glaze application.

This one square blend will give you numerous base glazes from which to develop colour. In blending four materials together, the different propotions in each test give a unique mix and glaze character. From just one blend like this, you'll find enough different glaze bases to explore for years.

Figure 3.25. Square blend: nepheline syenite, dolomite, barium carbonate, kaolin. Fired to 1280°C (2336°F) in oxidation.

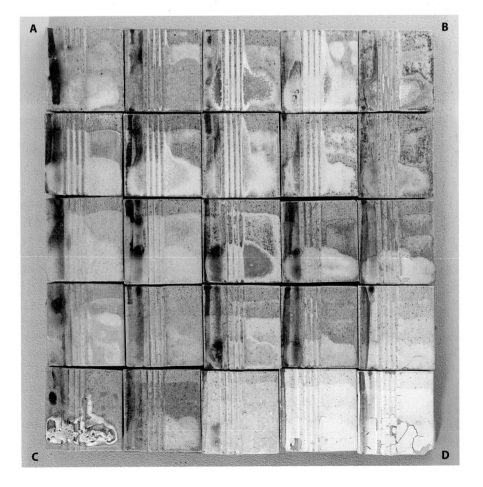

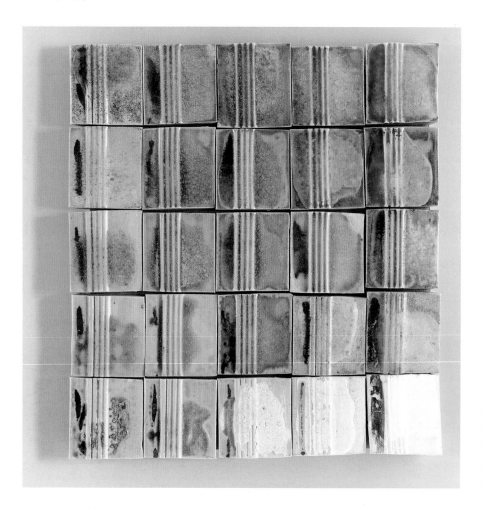

Figure 3.26. Square blend: nepheline syenite, lithium carbonate, barium carbonate, 50/50 silica/kaolin. Fired to 1280°C (2336°F), reduced.

Figure 3.26 is another square blend with raw materials, similar to Figure 3.25. This one has lithium as a component – a very strong alkaline flux. This square blend could be fired at earthenware (1080°C/1976°F) and mid-fire (1200°C/2192°F) temperatures to give results for a base glaze. Lithium is a material with a low coefficient of expansion (i.e. it doesn't contract or expand very much). Used in high quantities, its presence can lead to the glaze shivering off, particularly on the edges, as can be seen on tile 14. Also, it is partly soluble in water and will give a flashing, as shown in tiles 8, 9 and 10.

Suggested combinations for square blends:

A: any frit	B: any flux (e.g. whiting)
C: clay	D: any frit

Earthenware blend.

A: any frit	B: silica
C: clay	D: any frit/flux

Earthenware and mid-fire blend.

A: feldspar	B: any flux (e.g. whiting)
C: any frit	D: clay, or silica 60/clay 40

Earthenware and mid-fire blend.

A: feldspar	B: silica
C: clay	D: flux

Stoneware blend.

A: feldspar	B: flux
C: clay	D: silica

Stoneware blend: the arrangement/placement of the same materials in different corners will give a different result.

A: glaze	B: glaze
C: glaze	D: glaze

Earthenware, mid-fire, stoneware.

In square blends (shown in Figures 3.27 and 3.28, over the page) four different-coloured stoneware glazes were used (you can apply this blend to any temperature). Blending these four glazes together gives a change in colours and tones, especially if you do two sets of tests for oxidised and reduced. After all, the glazes are already made up; another set doesn't take long to do and will give you double the feedback.

A majority of tests from one square blend will give you base glazes that can be used without further development. From a simple square blend of only 25 tests, expanding a section that looks particularly promising is the next step, or perhaps an enlarged square blend of 121 tests using smaller increments of materials, which will give a more complete picture of the changes in the blend. See Figure 3.29 for calculations for the simple square blend, and Figure 3.30 for a more detailed square blend, on pp. 70–1. These two charts save an enormous amount of calculation. A, B, C and D can refer to any four glazes or materials.

It is possible, in one square blend, to obtain a complete range of base glazes with surfaces that are shiny, satin, satin to matt, matt and dry. These are starting points for exploring the creation of base glazes from scratch. In one corner, any base glaze may be used; another may have a base glaze from a different temperature.

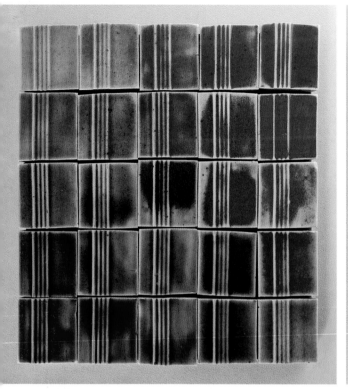

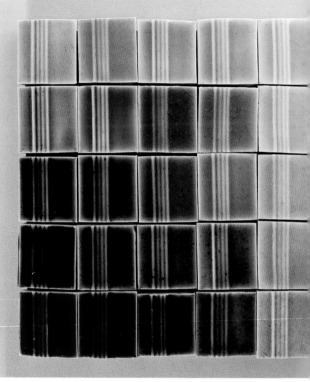

A Glaze	
Nepheline syenite	38
Whiting	9
Barium carbonate	9
Soft borosilicate frit	9
Silica	30
Kaolin	5
+ Chrome	0.25

B Glaze	
Soda feldspar	36
Whiting	17
Soft borosilicate frit	13
Silica	26
Kaolin	8
+ Copper carbonate	0.5
+ Tin oxide	2

C Glaze	
Soda feldspar	36
Whiting	17
Soft borosilicate frit	13
Silica	26
Kaolin	8
+ Cobalt carbonate	1

D Glaze	
Nepheline syenite	40
Whiting	20
Silica	30
Kaolin	10
+ Iron oxide	2

ABOVE LEFT **Figure 3.27.** Square blend of four glazes. Fired to 1280°C (2336°F), reduced from 850°C (1562°F).

ABOVE RIGHT **Figure 3.28.** Square blend of four glazes, fired to 1280°C (2336°F), oxidised.

LEFT Glazes used for square blends in Figures 3.27 and 3.28.

A _____ B

1		2		3		4		5	
A	100	A	75	A	50	A	25	B	100
		B	25	B	50	B	75		

6		7		8		9		10	
A	75	A	56	A	37.5	A	19	B	75
C	25	B	19	B	37.5	B	56	D	25
		C	19	C	12.5	C	6		
		D	6	D	12.5	D	19		

11		12		13		14		15	
A	50	A	37.5	A	25	A	12.5	B	50
C	50	B	12.5	B	25	B	37.5	D	50
		C	37.5	C	25	C	12.5		
		D	12.5	D	25	D	37.5		

16		17		18		19		20	
A	25	A	19	A	12.5	A	6	B	25
C	75	B	6	B	12.5	B	19	D	25
		C	56	C	37.5	C	19		
		D	19	D	37.5	D	56		

21		21		23		24		25	
C	100	C	75	C	50	C	25	D	100
		D	25	D	50	D	75		

C _____ D

B

1 A 100	**2** A 90 B 10	**3** A 80 B 20	**4** A 70 B 30	**5** A 60 B 40	**6** A 50 B 50	**7** A 40 B 60	**8** A 30 B 70	**9** A 20 B 80	**10** A 10 B 90	**11** B 100
12 A 90 C 10	**13** A 81 B 9 C 9 D 1	**14** A 72 B 18 C 8 D 2	**15** A 63 B 27 C 7 D 3	**16** A 54 B 36 C 6 D 4	**17** A 45 B 45 C 5 D 5	**18** A 36 B 54 C 4 D 6	**19** A 27 B 63 C 3 D 7	**20** A 18 B 72 C 2 D 8	**21** A 9 B 81 C 1 D 9	**22** B 90 D 10
23 A 80 C 20	**24** A 72 B 8 C 18 D 2	**25** A 64 B 16 C 16 D 4	**26** A 56 B 24 C 14 D 6	**27** A 48 B 32 C 12 D 8	**28** A 40 B 40 C 10 D 10	**29** A 32 B 48 C 8 D 12	**30** A 24 B 56 C 6 D 14	**31** A 16 B 64 C 4 D 16	**32** A 8 B 72 C 2 D 18	**33** B 80 D 20
34 A 70 C 30	**35** A 63 B 7 C 27 D 3	**36** A 56 B 14 C 24 D 6	**37** A 49 B 21 C 21 D 9	**38** A 42 B 28 C 18 D 12	**39** A 35 B 35 C 15 D 15	**40** A 28 B 42 C 12 D 18	**41** A 21 B 49 C 9 D 21	**42** A 14 B 56 C 6 D 24	**43** A 7 B 63 C 3 D 27	**44** B 70 D 30
45 A 60 C 40	**46** A 54 B 6 C 36 D 4	**47** A 48 B 12 C 32 D 8	**48** A 42 B 18 C 28 D 12	**49** A 36 B 24 C 24 D 16	**50** A 30 B 30 C 20 D 20	**51** A 24 B 36 C 16 D 24	**52** A 18 B 42 C 12 D 28	**53** A 12 B 48 C 8 D 32	**54** A 6 B 54 C 4 D 36	**55** B 60 D 40
56 A 50 C 50	**57** A 45 B 5 C 45 D 5	**58** A 40 B 10 C 40 D 10	**59** A 35 B 15 C 35 D 15	**60** A 30 B 20 C 30 D 20	**61** A 25 B 25 C 25 D 25	**62** A 20 B 30 C 20 D 30	**63** A 15 B 35 C 15 D 35	**64** A 10 B 40 C 10 D 40	**65** A 5 B 45 C 5 D 45	**66** B 50 D 50
67 A 40 C 60	**68** A 36 B 4 C 54 D 6	**69** A 32 B 8 C 48 D 12	**70** A 28 B 12 C 42 D 18	**71** A 24 B 16 C 36 D 24	**72** A 20 B 20 C 30 D 30	**73** A 16 B 24 C 24 D 36	**74** A 12 B 28 C 18 D 42	**75** A 8 B 32 C 12 D 48	**76** A 4 B 36 C 6 D 54	**77** B 40 D 60
78 A 30 C 70	**79** A 27 B 3 C 63 D 7	**80** A 24 B 6 C 56 D 14	**81** A 21 B 9 C 49 D 21	**82** A 18 B 12 C 42 D 28	**83** A 15 B 15 C 35 D 35	**84** A 12 B 18 C 28 D 42	**85** A 9 B 21 C 21 D 49	**86** A 6 B 24 C 14 D 56	**87** A 3 B 27 C 7 D 63	**88** B 30 D 70
89 A 20 C 80	**90** A 18 B 2 C 72 D 8	**91** A 16 B 4 C 64 D 16	**92** A 14 B 6 C 56 D 24	**93** A 12 B 8 C 48 D 32	**94** A 10 B 10 C 40 D 40	**95** A 8 B 12 C 32 D 48	**96** A 6 B 14 C 24 D 56	**97** A 4 B 16 C 16 D 64	**98** A 2 B 18 C 8 D 72	**99** B 20 D 80
100 A 10 C 90	**101** A 9 B 1 C 81 D 9	**102** A 8 B 2 C 72 D 18	**103** A 7 B 3 C 63 D 27	**104** A 6 B 4 C 54 D 36	**105** A 5 B 5 C 45 D 45	**106** A 4 B 6 C 36 D 54	**107** A 3 B 7 C 27 D 63	**108** A 2 B 8 C 18 D 72	**109** A 1 B 9 C 9 D 81	**110** B 10 D 90
111 C 100	**112** C 90 D 10	**113** C 80 D 20	**114** C 70 D 30	**115** C 60 D 40	**116** C 50 D 50	**117** C 40 D 60	**118** C 30 D 70	**119** C 20 D 80	**120** C 10 D 90	**121** D 100

D

LEFT **Figure 3.29.** Standard 25-tile square blend calculations.

ABOVE **Figure 3.30.** Standard 121-tile square blend calculations.

Further development: grid test

A grid test is a method of further testing your glazes for responses with other glazes. It is a simple and easy test that will demonstrate a glaze's response under and over another glaze – essential information when working with glaze-on-glaze decoration.

First you need to choose the glazes you would like to test. A combination of gloss, satin and matt can give surprising results; choose coloured glazes from the recipes given in Chapter 6. Line up the glazes as show in Figure 3.31, below, and mark the back of the tile, listing the glazes in order. Indicate which glazes are applied under and which over by use of an arrow and 'U' or 'O' marks, as well as whether it is reduced or oxidised. The glazes are applied across the tile in lines; divide up the tile first using a pencil or marking pen, as this will help keep the lines the same width. Apply the glaze 2–3 cm (¾–1¼ in.) wide. When you are done, turn the tile 90 degrees and repeat the application, using the same order of glazes. A thicker application can be applied in the very centre, again giving important information on glaze thickness. The tiles can be any size from 10 cm (4 in.) square to 30 cm (11¾ in.) square.

A useful technique to enable you to better see the colours and surface effects from the grid tests is to look at the test through a hole in a piece of paper. The paper acts as a frame and allows you to see only a small area of the tile. You will see colours and effects that may well have been overlooked when viewing the whole surface pattern and colour. This approach will allow you to see the results more clearly, while imagining what the small area would look like over a larger area on a pot.

BELOW LEFT **Figure 3.31.** The application of a grid test.

BELOW RIGHT **Figure 3.32.** Grid glaze tests, under and over.

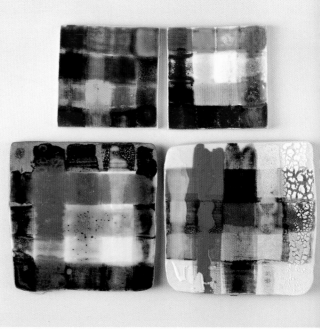

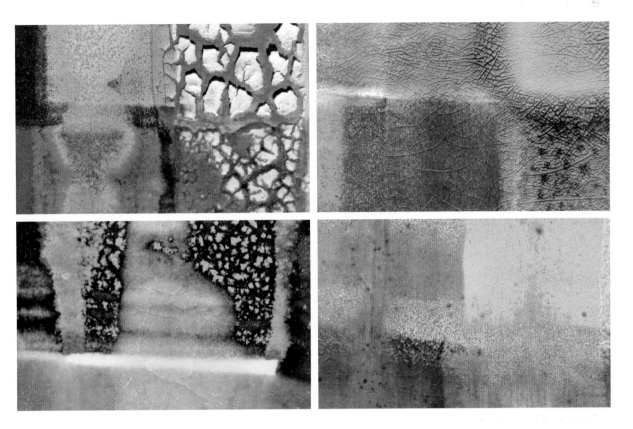

Figure 3.33. Close-up of grid tests from Figure 3.32.

FIRED AT 1000°C (1832°F)	100% FLUX	A + iron oxide 3	B + copper carbonate 3	C + nickel oxide 3	D + manganese dioxise 4	E + chrome oxide 2	F + cobalt carbonate 1	G + titanium dioxide 8
Row 1 lead oxide								
Row 2 lead bisilicate frit								
Row 3 borax								
Row 4 frit 4110 sodium borosilicate								
Row 5 boric acid								
Row 6 lithium carbonate								
Row 7 soda ash								
Row 8 potassium nitrate								
Row 9 frit 4050 lead boric acid								
	Tile 1 Flux 100g	**Tile 2** Flux + iron oxide 3g	**Tile 3** Flux + Copper carbonate 3g	**Tile 4** Flux + Nickel oxide 3g	**Tile 5** Flux + Manganese dioxide 4g	**Tile 6** Flux + Chrome oxide 2g	**Tile 7** Flux + Cobalt carbonate 1g	**Tile 8** Flux + Titanium dioxide 8g

4 Fluxes and colour

Fluxes have so far only been mentioned in relation to silica and alumina, in terms of the balancing act required to create glossy, satin or matt glazes. If the glaze is a flux matt or clay matt (see the square blend examples in Chapter 3, pp. 67–71), different fluxes may be chosen for different temperatures, but the selection of a flux has other important implications. The choice of a flux influences colour development; for example, copper in a lead glaze will give green, whereas in a sodium/borax (alkaline) glaze, the colour will be turquoise/blue. When designing square or triaxial line blends, you need to consider this.

The flux is a major controller of colour, but how varied is the colour response from colouring oxides when they are used with different fluxes? To be able to pinpoint a particular material, in this case a flux, I tested 100g of each flux with the oxide colourants, as shown in Figure 4.1. Both fritted forms of the flux (lead bisilicate frit and soft borosilicate frit) were tested to determine if there was much variation in the colour response between the two.

Beginning at the top of Figure 4.1, from row 1 down to row 9, the fluxes are lead oxide, lead bisilicate frit, borax, a soft borosilicate frit, boric acid, lithium carbonate, soda ash, potassium nitrate and a lead boric frit, all fired to 1000°C (1832°F). From rows 10–15, beginning at the top of Figure 4.2 on p. 77, a series of higher-temperature fluxes were fired to 1280°C (2336°F) (Cone 9) in an oxidising atmosphere – whiting (calcium carbonate), zinc oxide, barium carbonate, magnesium carbonate, strontium carbonate and nepheline syenite (a naturally occurring frit).

The intent of the exercise was not to create a perfect glazed surface but to seek a colour response, and indeed some very workable colours and surface finishes emerged. The majority of them would be difficult to transfer to the vertical surfaces of functional forms on account of their fluidity and metal release, especially in the case of lead, but such surfaces could certainly be explored with tiles or sculptural work.

Viewing such tests for the first time brings a startling awareness of the range of colours and tones available. The lead and lead bisilicate rows (rows 1 and 2) respond as you would expect of colourants, the exception being 2g chrome (1E) with 100g lead (litharge), where an orange-yellow occurs; this is lost when fired higher, but at lower temperatures the orange is stronger. If lead bisilicate is used with chrome and fired to 700–800°C (1292–1472°F), a bright orange with an opaque satin surface results; this could be used as an on-glaze enamel for decoration.

Borax (row 3) gives an alkaline response with copper (3B) and manganese (3D) in particular, the latter resulting in a purple; cobalt (3F) can be seen to give a more intense blue compared with its response with lead (1F). With chrome, the yellow-green is an interesting response (3E), as fritted borax usually gives dense green (4E). Boric acid (row 5) gives the test a smooth satin, waxy quality.

Figure 4.1. Low-temperature fluxes and oxide response. Fired to 1000°C (1832°F) in oxidation.

The colour response with copper (5B) and manganese (5D) is similar to borax, while a brown/fawn colour develops with cobalt (5F), rather than a blue. Iron (5A) gives dark purple-brown, leading me to the conclusion that a larger percentage of iron was used than was required. Where borax frit was used, the iron (4A) has been taken in, giving a pale honey-coloured result that would require a higher percentage of iron for darker tones. What is interesting about borax and boric acid is that both are glass-forming oxides like silica; when melted alone, they will form glass. Other non-glass-forming materials will melt but will not form a glass except in combination with a glass-former like silica. Note from the tests that many of these fluxes, if applied thickly, give dry matts when melted; where thin to medium thickness is applied, the surface becomes glassy, because the flux combines with the silica from the clay to form a glaze.

Lithium carbonate (row 6), an alkaline material, gives responses similar to borax, i.e. copper blues (6B). What stands out is the red/brown response from manganese (6D) and the strong yellow from chrome (6E); both are worth trying in a lithium glaze to see if the colour persists.

Soda ash (row 7) and potassium nitrate (row 8) are both alkaline materials; they give blues from copper blue (7B and 8B) and a purple response to manganese (7D and 8D). Soda ash with chrome (7E) gives an intense yellow. These alkaline materials promote brilliant, clear colours in glazes. While giving some difference in colour response, glazes that have a predominance of these materials have poor resistance to water and acids (lithium has a slightly better capacity in this respect). Thickly applied soda-ash tests, even fired to 1000°C (1832°F), will become sticky when left in a humid atmosphere, as water is absorbed by the fired soda-ash surface. Only where the soda ash is thinly applied has a glass surface developed, due to the flux combining with the silica from the body to form a glaze.

The final row of the low-temperature fluxes is a low-maturing frit, its composition being lead boric silicate. What is interesting here is that its response can be like that of either lead or alkali. The copper blue-green alkali response (9B) can be used as the basis of an on-glaze enamel fired to 700–800°C (1292–1472°F). With chrome an orange-yellow, lead colour develops. Additions of glaze stains create a palette of on-glaze enamels firing as low as 680°C (1256°F).

The second group of fluxes, in Figure 4.2, are predominantly mid- to high-temperature fluxes. Whiting (calcium carbonate) is the most widely used flux in this range, and can be seen to require a glass-former (silica) to form a glaze; note that where the thinly-applied whiting has combined with silica from the body, a glossy glaze surface has developed (row 10, the first row in Figure 4.2). Zinc oxide's best colour response is with cobalt (11F), giving a sky-blue tone. Used mainly as a secondary flux, it is important for colour and crystal development in glazes.

Barium carbonate (row 12) needs to be treated with care because of its poisonous nature. Its colour response is similar to that of the alkalis, especially with copper (12B) and manganese (12D), giving blues and purples, and with nickel (12C) a deep purple grape colour. Cobalt (12F) develops an intense blue with barium and a blue to mauve with a magnesium glaze (13F), but with magnesium only, no colour results. The chrome (12E) response to barium is a yellow-green (at lower temperatures a bright yellow will

occur). The magnesium carbonate responses (row 13) appear to be washed out, except for the iron (13A) and manganese (13D). On its own magnesium is a very refractory material, having a melting temperature of 2800°C (5072°F). A secondary flux, it can have a marked effect upon colour response, developing nickel greens, cobalt mauves and iron tea dusts.

Strontium carbonate (row 14) is comparable to whiting and zinc as a flux and has colour reactions similar to whiting, except in the case of nickel (14C) where a purple-brown develops. Little used, strontium is not a new flux, but was tried as a replacement for lead in the late 19th century. Nowadays it is used as a barium subsitute.

Nepheline syenite (row 15) is a natural frit, with both soda and potash as fluxes, along with silica and alumina. Colour responses from the tested oxides are very similar to those of lead at low temperatures and are often regarded as a benchmark. Copper (15B) gives green, nickel (15C) a muddy green, and manganese (15D) a brown. Chrome (15E) gives green, cobalt gives blue (15F), while titanium (15G) yields a smooth, satin-cream surface.

As we can see, the flux determines the colour response from the oxides added. When you want a turquoise glaze from copper, the base glaze will need alkaline fluxes. In Chapter 6, each page is devoted to one oxide, but the base glazes contain different fluxes, or combinations of fluxes, which give variations in colour and tone from an oxide at different temperatures.

Figure 4.2. High-temperature fluxes and oxide response. Fired to 1280°C (2336°F) in oxidation.

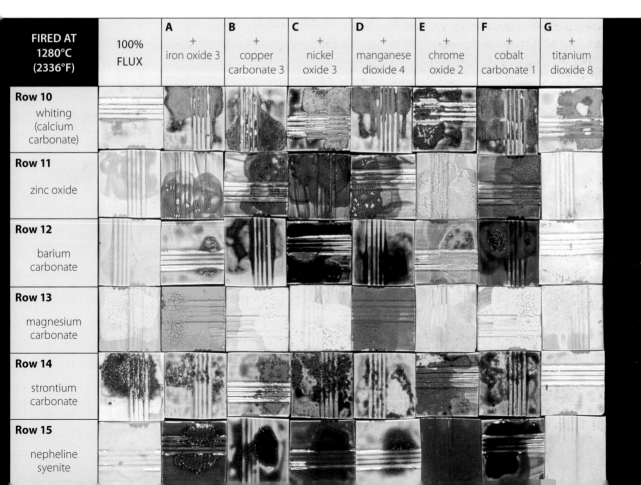

5 Developing colour

In preceding chapters we have seen how to develop glazes, and we have also examined fluxes and how they influence colour obtained from oxides. Standard amounts of oxides have been used to enable comparison of colourant properties in different base glazes.

Further colour development can now proceed, but how? Randomly picking the amount of colourant out of a hat is one way. Looking at other recipes and seeing what has been used can be another guide. But using planned colour blends, which give a larger number of results with relatively little weighing and mixing, is a method of incorporating more than one oxide into a base glaze to give broader and more diverse results (in previous chapters only one oxide has been mixed with a given base glaze). You can use one oxide to modify the colour of another – for example, a small amount of iron with cobalt will give a softer blue; where titanium is used with another oxide, it can break up the colour, giving a mottled effect and making the glaze satin at the same time.

Figure 5.1 demonstrates how varied a colour blend can be; any material/glaze/oxide can be blended for an observed result. There are two ways such a colour blend may be approached. The first is that each of the blended boxes can be weighed and mixed individually for 28 tests. This could require over 200 times the materials to be weighed, which would take a considerable amount of time. The second is that the top row can be be weighed and dry mixed in one amount, then 100g of base glaze weighed into each cup, added with the colourant, mixed with water, and an equal amount from each mix blended by volume. This saves substantial time in the mixing of glaze tests for the colour blend. A colour blend based on 28 test tiles, from start to finish, including application of glaze to the test tiles, takes about an hour – when you become proficient, a little less time.

If you choose to glaze two sets of tests, one for reduction, the other for oxidation, or another temperature, there will be 56 tests in total. In the examples in this chapter, each test has three thicknesses of application, plus an iron stroke; in total you will gain 336 pieces of information for an hour's work.

Testing procedure

The top row of a colour blend might look like this:

1	2	3	4	5	6	7
100g base	100g base	100g base	100g base	100g base	100g base	100g base
	+ iron oxide 2g	+ copper carbonate 6g	+ zinc oxide 20g	+ cobalt carbonate 4g	+ chrome oxide 0.5g	+ rutile 20g

The procedure for setting up a colour blend is quite straightforward. First, decide on how many test tiles you will use on the top row of the blend and draw up a colour-blend chart to match; you can choose as little as three or more than 30. List in the corresponding boxes on the chart what you would like to put in the tests. You can choose to put on another glaze, or a raw material only, like feldspar or alumina. Normally, oxides or ceramic stains are used. An oxide such as iron that can be used in both small and large amounts in a glaze might take up two or three of the boxes on your chart – likewise copper, rutile, titanium, manganese, and ceramic stains. Cobalt is a strong colourant, so one test is normal.

Figure 5.2. Colour blend chart.

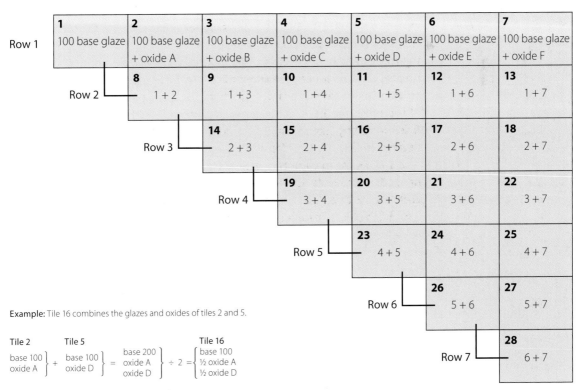

79

Row 1

Following the examples in Figures 5.1 and 5.2, mark the combinations in each box on your chart. This will determine the amount of base glaze required, assuming that all the tests have the same base glaze. In the example, seven tiles are required, so 700g of the base glaze will be needed. However, I recommend you weigh up 1000g for ease of measuring, leaving 300g extra glaze. This means you'll have spare base glaze already mixed if a problem occurs when you are weighing up oxides.

The base glaze is weighed up dry and put into a lidded container, such as a plastic bucket with a lid. The container can be shaken for a few minutes to blend the materials together (the same as with the line blends in Chapter 3, p. 49–64). Don't remove the lid immediately but allow the materials to settle. **A face mask should always be used when mixing and preparing glazes.** Weighing and mixing the base glaze in one go saves time.

At this stage, lay out and number some containers, like the plastic cups shown below, from 1 to 28 (assuming there will be seven tiles in the top row). Arrange the containers following the colour-blend layout, as shown in Figure 5.3. Put 100g (3½ oz) of base glaze into each cup on the first line, then add the quantity of oxide that is recorded in the matching box on the test chart.

It is important that the same amount of water is added to each of the containers on the top line. To determine the amount of water required, take 100g of the extra glaze and add water to it from a measuring container. That way, you can measure how much water is used, and make sure to add the same amount to each other cup with glaze and oxide. It is important that the same amount is added to each cup, because the measuring of the mixes into the cups is done by volume. Each cup should have the same water volume and 100g of base glaze, but a few extra or fewer grams of oxide will not alter the result. If using a material like magnesium light, the mix will be thick – DON'T add more water. The glaze consistency needs to be thinner than normal to allow for three distinct thicknesses of glaze to be applied to the test tile. Different base glazes will require varying amounts of water. Having established the amount,

Figure 5.3. Measuring equal parts by volume of each glaze, following the sequence in Figure 5.2.

add the water to each of the containers on the top line and mix thoroughly. Choose a measuring device that will accurately measure equal amounts of the glaze and oxide mix: either a plastic syringe marked in millilitres or a dessert or soup spoon. I find a dessert spoon quick, easy and accurate to use.

Take two spoons of material from cup 1. Add them to cups 8, 9, 10, 11, 12 and 13 (across row 2).

Take two spoons of material from cup 2. Add them to cup 8 (directly below cup 2). Add two spoons of material from cup 2 to each of the cups (14–18) (from left to right in row 3).

Take two spoons of material from cup 3. Add to cups 9 and 14 (directly below cup 3). Then add two spoons of material from cup 3 to each of the cups (19–22) (from left to right in row 4).

Continue this procedure, beginning with each of the remaining top-row cups (4–7), until each cup contains the appropriate material.

NOTE: When you move across the row, the cups you are approaching should be empty. If there is already glaze in the cups, stop, go to the next row, and move along that one.

When you are done, you should have the top row of cups mixed, with the cups arranged in the same layout outlined in Figure 5.2. Remember to number the cups first for identification. Then you are ready to start. Note in Figure 5.3 how cup 3 is being added to the blend, moving down and across into empty cups. The use of a desert spoon makes the measuring easy.

Another way of explaining the procedure is as follows:

Working *downwards*, add two spoons of the mix from each top row cup *only* to the cup or cups immediately below it (nothing comes out of cup 1 in this step). For example, material from cup 5 goes into 11, 16, 20 and 23.

Working *across*, add two spoons of the mix in cup 1 to every cup in row 2 (8–13); the mix in cup 2 is added to every cup in row 3, and so on.

This will give you four spoons in each container, which is enough glaze to pour, paint and even dip onto a test tile or ring.

Also note the addition of a red food dye to the glaze to help mixing and testing. If you have three or four mixes with little or no colour in the raw mix – e.g. cobalt carbonate 1, or copper 0.5 + tin oxide 2 – adding different food dyes helps keep track of each glaze test. The food dye will burn out in firing. Food dye can be added to any glaze to help in application and identification. Colour-coding your clear and white glazes helps greatly in knowing which glaze was used on the pot when doing brushwork.

Take your time to work through the sequence of containers. The whole test procedure should take an average of one hour. As the tests are mixed, it is worthwhile doing both an oxidised and a reduced series. Each tile can be both oxidised and reduced, with an iron oxide brush across each tile, and with three distinct thicknesses of application of glaze test. Each test could then reveal 12 pieces of information; the colour blend base applied to 28 tiles could yield 336 possible variations.

LEFT **Figure 5.4.** Layout of glaze-test containers for colour-blend testing with mixes completed. Test tiles laid out alongside the glaze containers.

RIGHT **Figure 5.5.** Colour blend, based on chart in Figure 5.2. Left set are reduced, right set are oxidised. Three thicknesses of iron oxide stroke have been applied. Fired to cone 9 (1280°C/2336°F).

BELOW **Figure 5.6.** Colour blends for testing.

	1	2	3	4	5	6	7
Blend 1	base	base 100 + iron oxide 8	base 100 + copper carbonate 6	base 100 + manganese dioxide 6	base 100 + cobalt carbonate 1	base 100 + nickel oxide 6	base 100 + rutile 15
Blend 2	base	base 100 + iron oxide 6	base 100 + copper carbonate 10	base 100 + nickel oxide 6	base 100 + titanium dioxide 15	base 100 + cobalt carbonate 1	base 100 + talc 15
Blend 3	base	base 100 + iron oxide 2	base 100 + copper carbonate 6	base 100 + zinc oxide 20	base 100 + cobalt carbonate 4	base 100 + potassium dichromate 4	base 100 + rutile 20
Blend 4	base	base 100 + rutile 10	base 100 + iron oxide 2	base 100 + iron oxide 10	base 100 + iron oxide 25	base 100 + bone ash 15	base 100 + talc 25
Blend 5	base	base 100 + iron oxide 4	base 100 + copper carbonate 2	base 100 + nickel oxide 4	base 100 + manganese dioxide 6	base 100 + copper carbonate 8	base 100 + frit 4712 12
Blend 6	base	100 base + copper carbonate 1	100 base + copper carbonate 3	100 base + tin oxide 8	100 base + iron oxide 3	100 base + barium carbonate 10	100 base + frit 3110 10 + iron oxide 2 + tin oxide 6

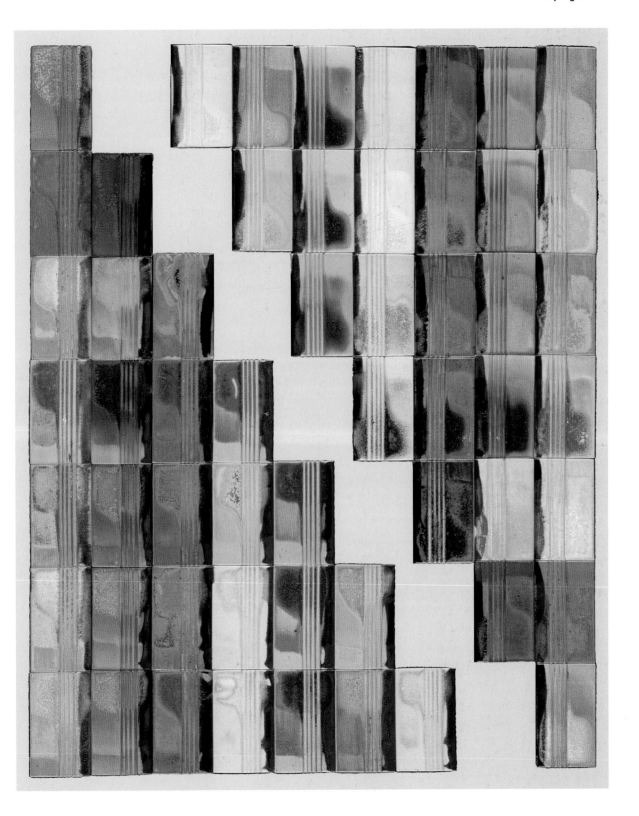

When you have finished preparing the glazes, set out your test tiles in the same formation as the containers, numbering each test – see Figure 5.4. This way, when you apply the test mixtures to the test tile, you will be able to keep track.

When you mix up a test result, mix together the ingredients in the two top-row boxes on your chart. For example, test 16 is made up of box 2 and 5. Box number 2 asks for 100g base glaze and the oxide amount. Box 5 has 100g of base glaze and oxide. Added together this equals 200g of base and the oxide. You need to divide by two to give you the oxide amounts for test 16. Simply, when two cups are mixed together, the oxide/ colourant in each should be halved. See Figure 5.2 for calculations.

Six examples of colour blends are given on p. 82, designed to develop different colours and finishes. Transpose line 1 from Figure 5.6 to the top line of the grid illustrated in Figure 5.2 (providing the colour blend series is designed to give you 28 mixtures). Each succeeding line in Figure 5.6 is intended to be the top line of a different colour-blend series, which would be based on the grid in Figure 5.2.

• **Colour blend 1** is a general-response blend with conventional, average amounts of the different oxides, designed to illustrate colour development in different base glazes. It is suitable for base glazes of any temperature.

• **Colour blend 2** includes two colour modifiers, titanium and magnesium (talc). The oxides in this blend will have a changed response with colour development. This depends upon the base glaze selected. Suitable for mid-fire and stoneware glazes.

• **Colour blend 3** is similar in intent to 2, but contains different percentages of oxides; the colour modifiers are rutile and zinc. Suitable for base glazes of any temperature.

• **Colour blend 4** is designed to develop iron as a colourant in a glaze. Three different amounts of iron in the top row produce nine different percentages in the colour-blend grid. Rutile, talc and bone ash are important colour modifiers of iron in the base glaze you are testing; the variety of iron responses is nearly limitless. Suits any temperature.

• **Colour blend 5** is a general blend similar to blend 1. For base glazes of any temperature.

• **Colour blend 6** has copper as the main oxide colourant; other oxide colourants will change copper's colour response. Designed for the development of copper reds in a glaze. Box 7 is included as an example to show that a number of materials may be included in a colour-blend test. Suits mid-fire and stoneware glazes.

Colour blends will help you develop colour and surface finishes easily with little weighing up of materials. This method can be used for stains, coloured slips, lustres – indeed, any instance where you need to see combinations of materials, glazes and slips.

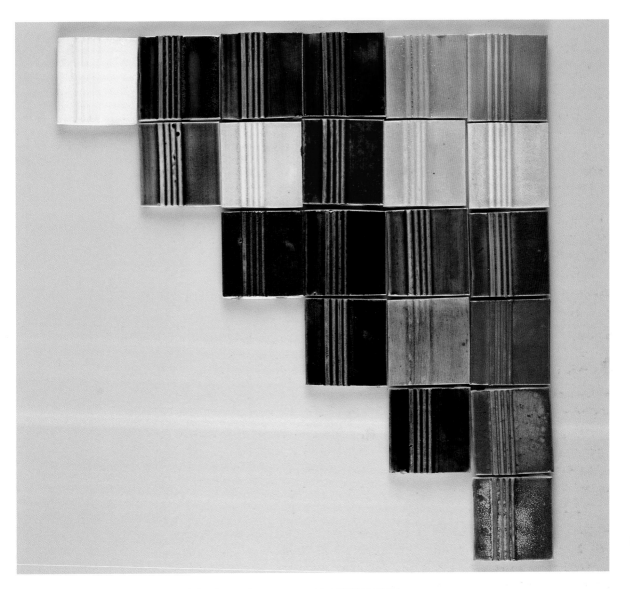

Figure 5.7. Earthenware colour blend, fired in oxidation to cone 03, 1080°C (1976°F).

1		2		3		4		5		6	
Base glaze:		Base glaze:		Base glaze:		Base glaze:		Base glaze:		Base glaze:	
Soft borosilicate frit	90	Lead bisilicate frit	82	Lead bisilicate frit	82	Lead bisilicate frit	82	Soft borosilicate frit	90	Lead bisilicate frit	82
Silica	4	Silica	8	Silica	8	Silica	8	Silica	4	Silica	8
Kaolin	6	Kaolin	10	Kaolin	10	Kaolin	10	Kaolin	6	Kaolin	10
		+ Copper carbonate	12	+ Iron oxide	10	+ Cobalt carbonate	1	+ Chrome oxide	1	+ Rutile	20

Note that there are two different base glazes used, giving a broader response to the oxides.

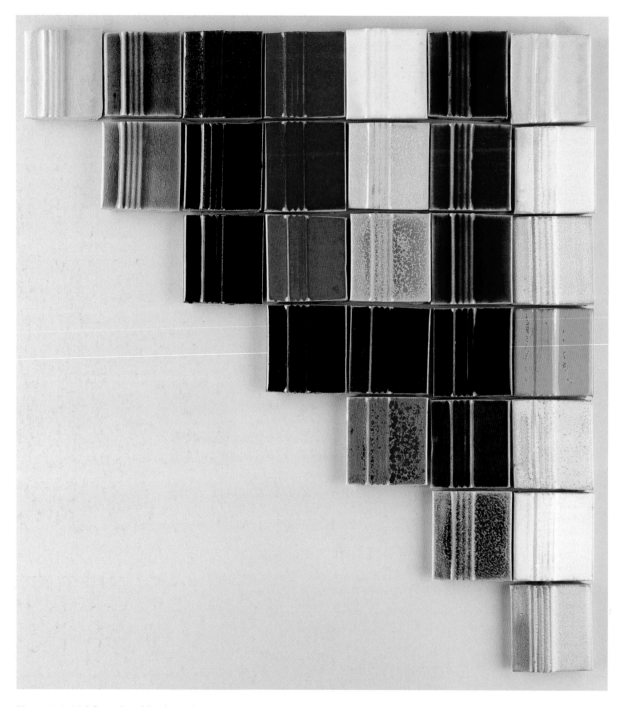

Figure 5.8. Mid-fire colour blend. Fired to 1200°C (2192°F), reduction began at 850°C (1562°F).

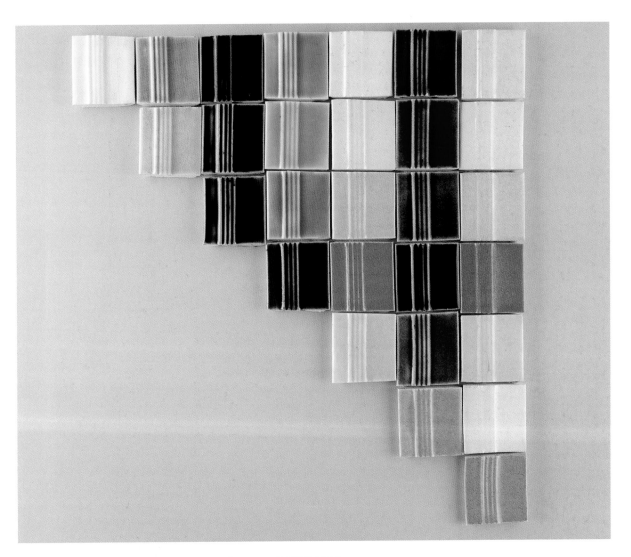

Figure 5.9. Mid-fire colour blend. Fired in oxidation to 1200°C (2192°F).

1	2	3	4	5	6	7
Base glaze: Nepheline syenite 25 Whiting 12 Calcium borosilicate frit 37 Silica 20 Kaolin 6	Base glaze 100 + Iron oxide 4	Base glaze 100 + Iron oxide 20	Base glaze 100 + Copper carbonate 1 Tin oxide 4	Base glaze 100 + Talc 20	Base glaze 100 + Cobalt carbonate 1	Base glaze 100 + Titanium dioxide 20

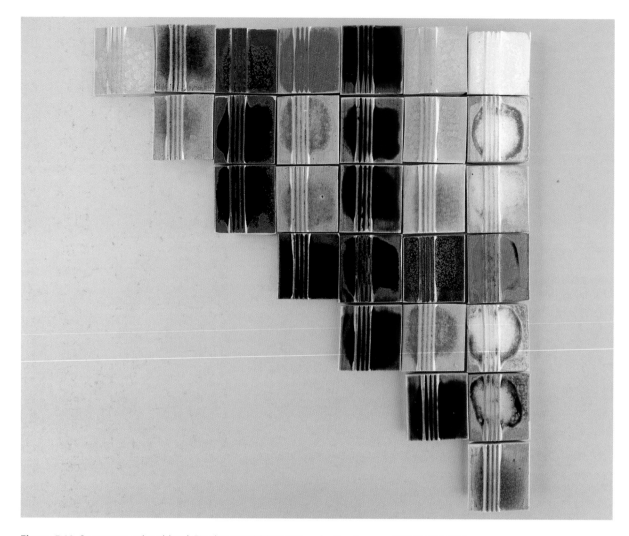

Figure 5.10. Stoneware colour blend. Fired to 1280°C (2336°F), reduction began at 850°C (1562°F).

1	2	3	4	5	6	7
Base glaze: Nepheline syenite 85 Whiting 10 Silica 5 + Bentonite 3 (optional, but prevents it settling)	Base glaze 100 + Iron oxide 4	Base glaze 100 + Iron oxide 20	Base glaze 100 + Copper carbonate 1 Tin oxide 4	Base glaze 100 + Cobalt carbonate 1	Base glaze 100 + Talc 20	Base glaze 100 + Titanium dioxide 20

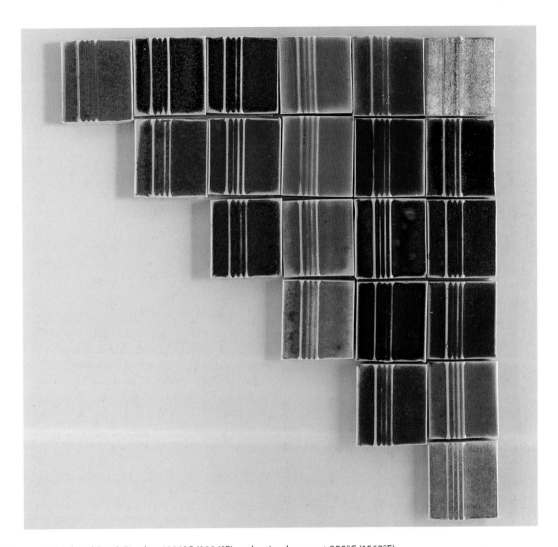

Figure 5.11. Copper-red colour blend. Fired to 1280°C (2336°F), reduction began at 850°C (1562°F).

1		2		3		4		5		6	
Base glaze:		Base glaze	100	Base glaze	100	Base glaze	100	Base glaze	100	Base glaze	100
Soda feldspar	36	+ Gerstley		+ Barium		+ Zinc oxide	15	+ Bone ash	15	+ Titanium	
Whiting	17	borate	15	carbonate	15					dioxide	20
Soft borosilicate	13										
Silica	26										
Kaolin	8										
+ Copper											
carbonate	1										
+ Tin oxide	4										

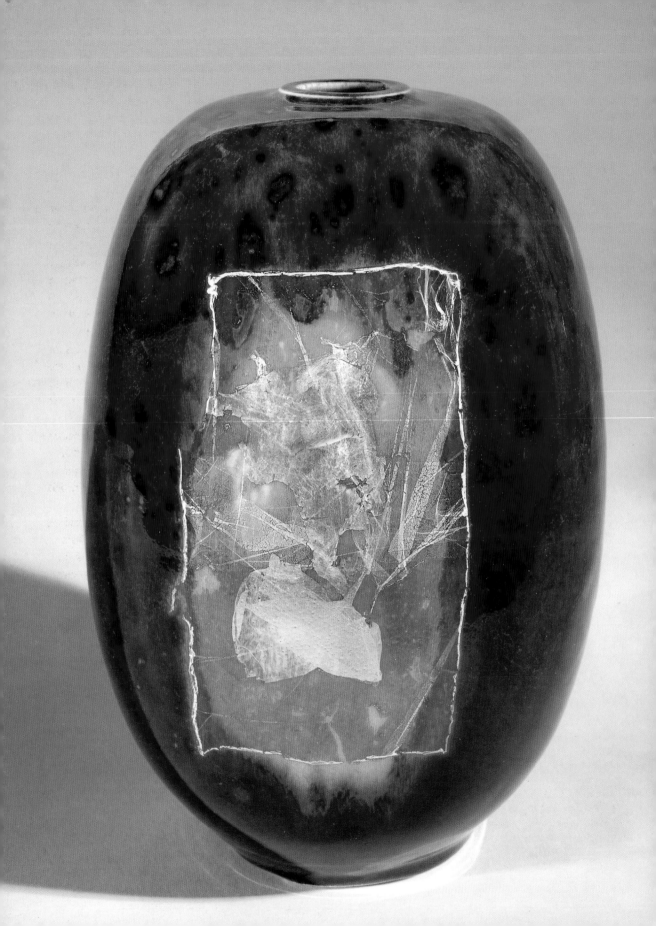

6

Glaze recipes

This chapter takes cobalt, copper, chrome, iron, manganese, nickel and rutile/titanium, and individually mixes them with base glazes fired at earthenware, mid-fire and stoneware temperatures, each test batch containing a different flux or fluxes, and giving a broad pallete of colours and surfaces. Only single oxides are used in the base glazes; rutile/titanium is the only one to use a combination of metal oxides. These tests show that different bases can produce a broad pallet of colour and tones with the addition of a single metal oxide. The recipes for the base glazes, and the colour developed with them, came out of the testing process covered in earlier chapters.

For further colour development, you can choose from these glazes as the bases for colour blends, giving endless possibilities. Iron and copper are two of the most-used metal oxides for colour and a greater range of these are shown in this chapter, both in oxidation and reduction. Note that a number of tests show both oxidation and reduction results.

Except where noted, these tests were fired on a white clay. The firing temperature for the earthenware tests was to cone 03, 1080°C (1976°F), the mid-fire tests to cone 5, 1200°C (2192°F), and stoneware tests to cone 9, 1280°C (2336°F). Reduction began at 850°C (1562°F) unless otherwise noted, through to the end of the firing for mid-fire and stoneware tests.

If in doubt about the procedure for mixing and testing materials, refer to previous chapters. The most important thing is to enjoy, observe and record. Don't be afraid to try something out of the ordinary. If you can repeat a fault, it becomes your effect.

I would like to remind you of good studio practice for keeping your studio clean, especially your glaze testing area. Wipe up any spillage with a damp sponge or cloth. Wear a suitable dust mask and replace filters regularly; keep them in a sealed container between uses and wash out with warm soapy water after use (taking off the filters first). Some of the materials you may use are toxic and carcinogenic, while clay and silica dust can lead to silicosis. Your supplier can provide you with Material Safety Data Sheets (MSDS). Don't underestimate the dangers of any materials. Keep your glaze testing area clean and use latex gloves when weighing, for added safety.

With regards to concerns around using lead in glazes, I fully recommend to you that glazes containing lead bisilicate frit only be used as decorative glazes for sculptural work and the outside of vases. They should not be applied to any domestic ware, unless you first have the glaze tested for lead release. Lead bisilicate frit was designed for safe handling of lead when melted with silica into a glass.

By now you are empowered and confident to change and add materials to your glaze. If you don't have a material in any of these glazes recipes, try another and observe the outcome. For instance if you don't have the frit suggested in the recipe, try one you do have.

Vase with reduced copper-red glaze (see Cu-89, p. 104), coarsely mixed and applied, not sieved, creates the dappled effect. Fired in reduction to 1280°C (2336°F). Gold and silver leaf applied and fired to 760°C (1400°F). *Photo: Stuart Hay*.

OXIDE: Chrome (Cr) Earthenware Cone 03, Mid-Fire Cone 5, Stoneware Cone 9

Cr-1 Nepheline syenite 60 Barium carbonate 30 Lithium carbonate 5 Kaolin 5 + Chrome oxide 1 OX, S/W	**Cr-2** Nepheline syenite 40 Whiting 20 Silica 30 Kaolin 10 + Chrome oxide 0.5 OX, S/W	**Cr-3** Nepheline syenite 38 Whiting 9 Barium carbonate 9 Soft borosilicate frit 9 Silica 30 Kaolin 5 + Chrome oxide 4 R, S/W	**Cr-4** Nepheline syenite 55 Whiting 16 Talc 13 Kaolin 16 Zinc oxide 10 + Chrome oxide 0.5 OX, S/W	**Cr-5** Nepheline syenite 40 Barium carbonate 30 Zinc oxide 20 Kaolin 10 + Chrome oxide 1 OX, S/W
Cr-6 Nepheline syenite 38 Whiting 9 Barium carbonate 9 Soft borosilicate frit 9 Silica 30 Kaolin 5 + Chrome oxide 0.2 R, S/W	**Cr-7** Nepheline syenite 38 Whiting 9 Barium carbonate 9 Soft borosilicate frit 9 Silica 30 Kaolin 5 + Chrome oxide 0.2 OX, S/W	**Cr-8** Potash feldspar 10 Whiting 40 Silica 20 Kaolin 30 + Chrome oxide 0.5 R, S/W	**Cr-9** Nepheline syenite 38 Whiting 9 Barium carbonate 9 Soft borosilicate frit 9 Silica 30 Kaolin 5 + Chrome oxide 4 OX, S/W	**Cr-10** Potash feldspar 20 Whiting 10 Silica 15 Kaolin 5 Alumina hydrate (or calcined) 50 + Chrome oxide 3 OX, S/W
Cr-11 Nepheline syenite 38 Whiting 9 Barium carbonate 9 Soft borosilicate frit 9 Silica 30 Kaolin 5 + Chrome oxide 0.05 OX, S/W	**Cr-12** Barium carbonate 60 Kaolin 40 + Chrome oxide 1 OX, S/W	**Cr-13** Nepheline syenite 60 Barium carbonate 30 Lithium carbonate 5 Kaolin 5 + Chrome oxide 1 OX, M/F	**Cr-14** Hard borosilicate frit 50 Zinc oxide 25 Kaolin 25 + Chrome oxide 2 OX, M/F	**Cr-15** Nepheline syenite 30 Talc 42 Lithium 18 Whiting 5 Kaolin 5 + Chrome oxide 0.5 OX, M/F
Cr-16 Soft borosilicate frit 60 Barium carbonate 24 Kaolin 16 + Chrome oxide 2 OX, E/W	**Cr-17** Nepheline syenite 25 Whiting 12 Calcium borosilicate 38 Silica 19 Kaolin 6 + Chrome oxide 0.5 OX, MF	**Cr-18** Nepheline syenite 20 Lead bisilicate frit 35 Soft borosilicate frit 30 Whiting 5 Talc 5 Kaolin 5 + Chrome oxide 0.5 OX, M/F	**Cr-19** Nepheline syenite 30 Talc 42 Lithium 18 Whiting 5 Kaolin 5 + Chrome oxide 2 OX, M/F	**Cr-20** Barium carbonate 60 Soft borosilicate frit 20 Kaolin 20 + Chrome oxide 0.5 OX, M/F
Cr-21 Soft borosilicate frit 87 Silica 4 Kaolin 9 + Chrome oxide 0.5 OX, E/W	**Cr-22** Nepheline syenite 60 Barium carbonate 30 Lithium carbonate 5 Kaolin 5 + Chrome oxide 1 OX, E/W	**Cr-23** Soft borosilicate frit 45 Lead bisilicate frit 45 Silica 4 Kaolin 6 + Chrome oxide 2 OX, E/W	**Cr-24** Lead bisilicate frit 60 Magnesium carbonate (light) 40 + Chrome oxide 3 OX, 1000°C (1832°F)	**Cr-25** Lead bisilicate frit 50 Magnesium carbonate (light) 50 + Chrome oxide 3 OX, 1000°C (1832°F)
Cr-26 Lead bisilicate frit 60 Strontium carbonate 40 + Chrome oxide 3 OX, 1000°C (1832°F)	**Cr-27** Lead bisilicate frit 60 Whiting 40 + Chrome oxide 3 OX, 1000°C (1832°F)	**Cr-28** Lithium carbonate 100 + Chrome oxide 2 OX, 900°C (1652°F)	**Cr-29** Lead bisilicate frit 70 Magnesium carbonate (light) 30 + Chrome oxide 3 OX, 900°C (1652°F)	**Cr-30** Lead bisilicate frit 40 Strontium carbonate 60 + Chrome oxide 3 OX, 900°C (1652°F)

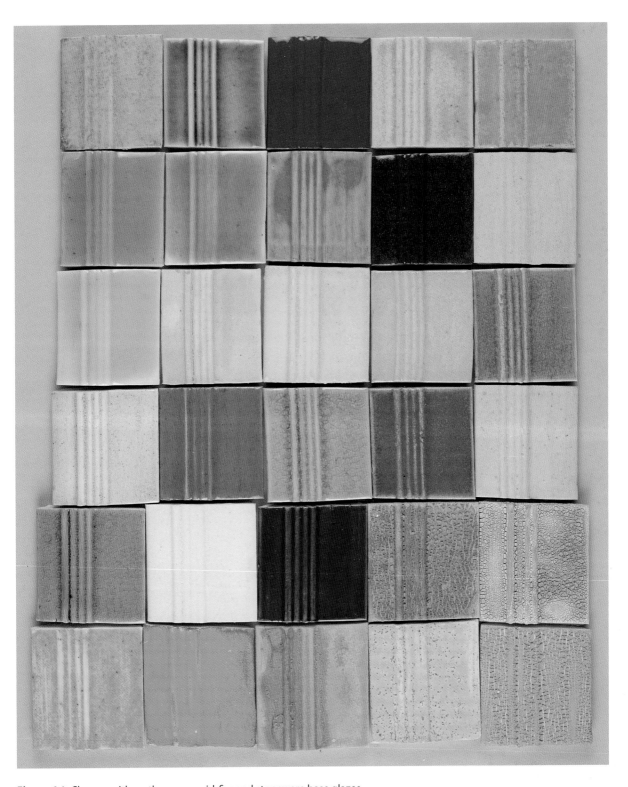

Figure 6.1. Chrome with earthenware, mid-fire and stoneware base glazes.

OXIDE: Cobalt (Co) Earthenware Cone 03, Mid-Fire Cone 5

Co-1		Co-2		Co-3		Co-4		Co-5	
Nepheline syenite	20	Nepheline syenite	20	Potash feldspar	20	Potash feldspar	20	Nepheline syenite	53
Lead bisilicate frit	35	Lead bisilicate frit	35	Whiting	10	Whiting	10	Lead bisilicate	15
Soft borosilicate frit	30	Soft borosilicate frit	30	Silica	15	Silica	15	Whiting	10
Whiting	5	Whiting	5	Kaolin	5	Kaolin	5	Talc	8
Talc	5	Talc	5	Alumina hydrate		Alumina hydrate		Silica	9
Kaolin	5	Kaolin	5	(or calcined)	50	(or calcined)	50	Kaolin	5
+ Cobalt carbonate	4	+ Cobalt carbonate	4	+ Cobalt carbonate	2	+ Cobalt carbonate	4	+ Cobalt carbonate	1
R, M/F		OX, M/F		OX, M/F and S/W		OX, M/F and S/W		OX, M/F	

Co-6		Co-7		Co-8		Co-9		Co-10	
Nepheline syenite	15	Magnesium		Nepheline syenite	60	Nepheline syenite	25	Nepheline syenite	30
Lead bisilicate frit	40	carbonate (light)	70	Barium carbonate	30	Whiting	12	Talc	42
Soft borosilicate frit	30	Nepheline syenite	20	Lithium carbonate	5	Calcium borosilicate	38	Lithium	18
Whiting	5	Soft borosilicate frit	10	Kaolin	5	Silica	19	Whiting	5
Talc	5	+ Cobalt carbonate	1	+ Cobalt carbonate	1	Kaolin	6	Kaolin	5
Kaolin	5	OX, M/F		OX, M/F		+ Cobalt carbonate	1	+ Cobalt carbonate	1
+ Rutile	10					OX, M/F		OX, M/F	
+ Cobalt carbonate	1								
OX, M/F									

Co-11		Co-12		Co-13		Co-14		Co-15	
Barium carbonate	60	Nepheline syenite	20	Nepheline syenite	10	Nepheline syenite	35	Hard borosilicate	
Soft borosilicate frit	20	Lead bisilicate frit	35	Whiting	40	Whiting	18	frit	50
Kaolin	20	Soft borosilicate frit	30	Soft borosilicate frit	20	Talc	13	Zinc oxide	25
+ Cobalt carbonate	1	Whiting	5	Barium carbonate	20	Silica	26	Kaolin	25
OX, M/F		Talc	5	Kaolin	10	Kaolin	8	+ Cobalt carbonate	1
		Kaolin	5	+ Cobalt carbonate	1	+ Soft borosilicate		OX, M/F	
		+ Cobalt carbonate	1	OX, M/F		frit	10		
		OX, M/F				+ Cobalt carbonate	1		
						OX, M/F			

Co-16		Co-17		Co-18		Co-19		Co-20	
Nepheline syenite	60	Soft borosilicate frit	87	Nepheline syenite	10	Lead bisilicate frit	83	Nepheline syenite	34
Barium carbonate	30	Silica	4	Whiting	40	Silica	7	Lead bisilicate	28
Lithium carbonate	5	Kaolin	9	Soft borosilicate frit	20	Kaolin	10	Calcium borosilicate	18
Kaolin	5	+ Cobalt carbonate	1	Barium carbonate	20	+ Rutile	10	Talc	9
+ Cobalt carbonate	1	OX, E/W		Kaolin	10	+ Cobalt carbonate	1	Kaolin	11
OX, E/W				+ Cobalt carbonate	1	OX, E/W		+ Cobalt carbonate	2
				OX, E/W				OX, E/W	

Co-21		Co-22		Co-23		Co-24		Co-25	
Soft borosilicate frit	45	Lead bisilicate frit	83	Barium carbonate	60	Lead bisilicate frit	83	Soft borosilicate frit	17
Lead bisilicate frit	45	Silica	7	Soft borosilicate frit	20	Silica	7	Barium carbonate	36
Silica	4	Kaolin	10	Kaolin	20	Kaolin	10	Whiting	16
Kaolin	6	+ Cobalt carbonate	2	+ Cobalt carbonate	2	+ Cobalt carbonate	1	Zinc	9
+ Cobalt carbonate	1	OX, E/W		OX, E/W		OX, E/W		Talc	22
OX, E/W								+ Cobalt carbonate	1
								OX, E/W	

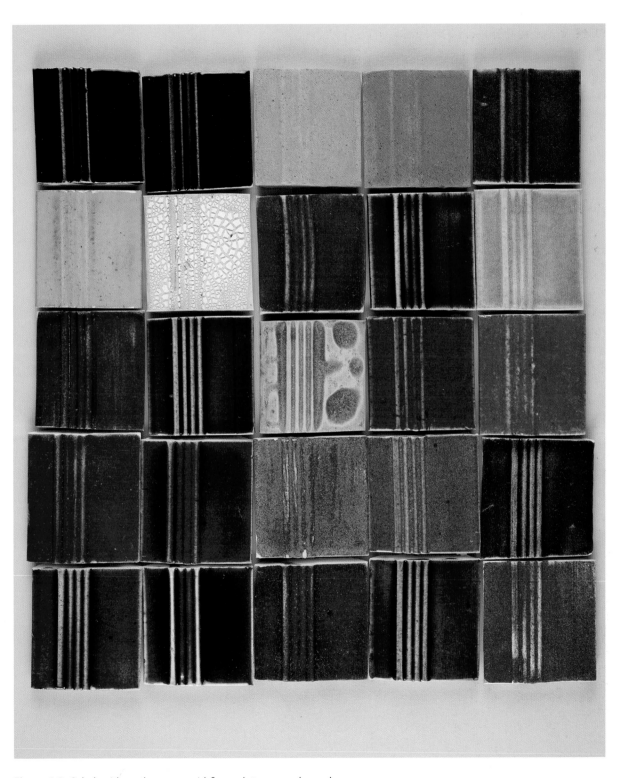

Figure 6.2. Cobalt with earthenware, mid-fire and stoneware base glazes.

OXIDE: Cobalt (Co) Stoneware Cone 9

Co-26
Nepheline syenite 55
Whiting 16
Talc 13
Kaolin 16
+ Cobalt carbonate 1
R, S/W

Co-27
Nepheline syenite 55
Whiting 16
Talc 13
Kaolin 16
+ Cobalt carbonate 1
OX, S/W

Co-28
Magnesium carbonate (light) 80
Nepheline syenite 20
+ Cobalt carbonate 1
OX, S/W

Co-29
Magnesium carbonate (light) 80
Nepheline syenite 20
+ Cobalt carbonate 1
R, S/W

Co-30
Magnesium carbonate (light) 80
Nepheline syenite 20
+ Cobalt carbonate 1
R, S/W, over iron glaze Fe-

Co-31
Potash feldspar 63
Whiting 6
Talc 10
Bone ash 6
Silica 10
Kaolin 5
+ Rutile 10
+ Cobalt carbonate 2
OX, S/W

Co-32
Nepheline syenite 38
Whiting 9
Barium carbonate 9
Soft borosilicate frit 9
Silica 30
Kaolin 5
+ Cobalt nitrate 0.4
OX, S/W

Co-33
Nepheline syenite 38
Whiting 9
Barium carbonate 9
Soft borosilicate frit 9
Silica 30
Kaolin 5
+ Cobalt nitrate 2
OX, S/W

Co-34
Nepheline syenite 38
Whiting 9
Barium carbonate 9
Soft borosilicate frit 9
Silica 30
Kaolin 5
+ Cobalt carbonate 0.5
OX, S/W

Co-35
Nepheline syenite 38
Whiting 9
Barium carbonate 9
Soft borosilicate frit 9
Silica 30
Kaolin 5
+ Cobalt carbonate 1
OX, S/W

Co-36
Nepheline syenite 38
Whiting 9
Barium carbonate 9
Soft borosilicate frit 9
Silica 30
Kaolin 5
+ Cobalt carbonate 5
R, S/W 1

Co-37
Nepheline syenite 55
Whiting 16
Talc 13
Kaolin 16
+ Zinc oxide 10
+ Cobalt carbonate 2
R, S/W

Co-38
Barium carbonate 60
Kaolin 40
+ Cobalt carbonate 2
OX, S/W

Co-39
Nepheline syenite 40
Whiting 20
Silica 30
Kaolin 10
+ Cobalt carbonate 1
OX, S/W

Co-40
Nepheline syenite 38
Whiting 9
Barium carbonate 9
Soft borosilicate frit 9
Silica 30
Kaolin 5
+ Cobalt carbonate 3
OX, S/W

Co-41
Potash feldspar 63
Whiting 6
Talc 10
Bone ash 6
Silica 10
Kaolin 5
+ Cobalt carbonate 1
R, S/W

Co-42
Barium carbonate 60
Kaolin 40
+ Cobalt carbonate 0.5
OX, S/W

Co-43
Nepheline syenite 38
Whiting 9
Barium carbonate 9
Soft borosilicate frit 9
Silica 30
Kaolin 5
+ Cobalt carbonate 0.5
+ Manganese dioxide 3
OX, S/W

Co-44
Nepheline syenite 38
Whiting 9
Barium carbonate 9
Soft borosilicate frit 9
Silica 30
Kaolin 5
+ Cobalt carbonate 0.5
+ Copper carbonate 2
R, S/W

Co-45
Nepheline syenite 38
Whiting 9
Barium carbonate 9
Soft borosilicate frit 9
Silica 30
Kaolin 5
+ Cobalt carbonate 0.5
+ Copper carbonate 2
OX, S/W

Co-46
Potash feldspar 63
Whiting 6
Talc 10
Bone ash 6
Silica 10
Kaolin 5
+ Chrome oxide 0.5
R and OX, S/W

Co-47
Potash feldspar 10
Whiting 40
Silica 20
Kaolin 30
+ Cobalt carbonate 1
OX, S/W

Co-48
Nepheline syenite 60
Barium carbonate 30
Lithium carbonate 5
Kaolin 5
+ Cobalt carbonate 1
OX, S/W

Co-49
Potash feldspar 63
Whiting 6
Talc 10
Bone ash 6
Silica 10
Kaolin 5
+ Chrome oxide 3
+ Cobalt carbonate 2
R and OX, S/W

Co-50
Potash feldspar 25
Whiting 25
Silica 25
Kaolin 25
+ Talc 10
+ Cobalt carbonate 0.45
R, S/W

Co-51
Potash feldspar 63
Whiting 6
Talc 10
Bone ash 6
Silica 10
Kaolin 5
+ Cobalt carbonate 4
OX, S/W

Co-52
Nepheline syenite 55
Whiting 16
Talc 13
Kaolin 16
+ Alumina hydrate 20
+ Cobalt carbonate 2
R, S/W

Co-53
Potash feldspar 63
Whiting 6
Talc 10
Bone ash 6
Silica 10
Kaolin 5
+ Zinc oxide 10
+ Cobalt carbonate 2
OX, S/W

Co-54
Nepheline syenite 35
Whiting 18
Talc 13
Silica 26
Kaolin 8
+ Cobalt carbonate 1
R and OX, S/W

Co-55
Nepheline syenite 55
Whiting 16
Talc 13
Kaolin 16
+ Titanium 8
+ Cobalt carbonate 1
OX, S/W

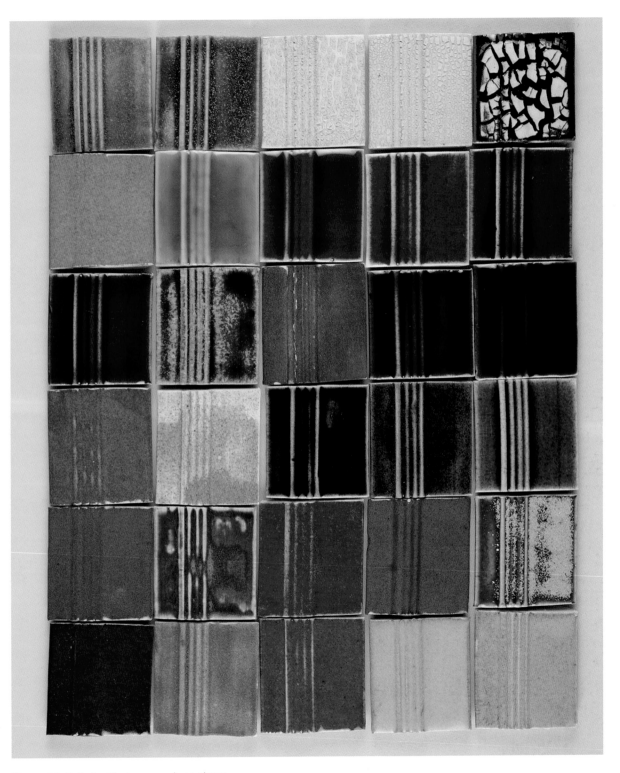

Figure 6.3. Cobalt with stoneware base glazes.

OXIDE: Copper (Cu) Earthenware Cone 03

Cu-1		Cu-2		Cu-3		Cu-4		Cu-5	
Lead bisilicate frit	83	Soft borosilicate frit	87	Lead bisilicate frit	83	Soft borosilicate frit	60	Nepheline syenite	34
Silica	7	Silica	4	Silica	7	Barium carbonate	24	Lead bisilicate frit	28
Kaolin	10	Kaolin	9	Kaolin	10	Kaolin	16	Calcium borosilicate	18
+ Copper carbonate	4	+ Copper carbonate	1	+ Copper carbonate	1	+ Copper carbonate	8	Talc	9
OX, E/W		OX, E/W		OX, E/W		OX, E/W		Kaolin	11
								+ Copper carbonate	2
								OX, E/W	

Cu-6		Cu-7		Cu-8		Cu-9		Cu-10	
Soft borosilicate frit	87	Soft borosilicate frit	45	Soft borosilicate frit	60	Lead bisilicate frit	83	Soft borosilicate frit	87
Silica	4	Lead bisilicate frit	45	Barium carbonate	24	Silica	7	Silica	4
Kaolin	9	Silica	4	Kaolin	16	Kaolin	10	Kaolin	9
+ Copper carbonate	4	Kaolin	6	+ Copper carbonate	12	+ Rutile	10	+ Copper carbonate	8
OX, E/W		+ Copper carbonate	8	OX, E/W		+ Copper carbonate	4	OX, E/W	
		OX, E/W				OX, E/W			

Cu-11		Cu-12		Cu-13		Cu-14		Cu-15	
Nepheline syenite	60	Nepheline syenite	60	Soft borosilicate frit	17	Soft borosilicate frit	45	Lead bisilicate frit	83
Barium carbonate	30	Barium carbonate	30	Barium carbonate	36	Lead bisilicate frit	45	Silica	7
Lithium carbonate	5	Lithium carbonate	5	Whiting	16	Silica	4	Kaolin	10
Kaolin	5	Kaolin	5	Zinc	9	Kaolin	6	+ Copper carbonate	12
+ Copper carbonate	2	+ Copper carbonate	3	Talc	22	+ Copper carbonate	4	OX, E/W	
OX, E/W		OX, E/W		+ Copper carbonate	12	OX, E/W			
				OX, E/W					

Cu-16		Cu-17		Cu-18		Cu-19		Cu-20	
Lead bisilicate frit	83	Lead bisilicate frit	75	Soft borosilicate frit	45	Hard borosilicate frit	50	Soft borosilicate frit	17
Silica	7	Potash feldspar	10	Lead bisilicate	40	Zinc oxide	25	Barium carbonate	36
Kaolin	10	Silica	10	Silica	7	Kaolin	25	Whiting	16
+ Copper carbonate	8	Kaolin	5	Kaolin	8	+ Copper carbonate	8	Zinc	9
OX, E/W		+ Copper carbonate	1	+ Copper carbonate	6	OX, E/W		Talc	22
		OX, E/W		OX, E/W				+ Copper carbonate	2
								OX, E/W	

Cu-21		Cu-22		Cu-23		Cu-24		Cu-25	
Nepheline syenite	60	Lead bisilicate frit	75	Soft borosilicate frit	87	Lead bisilicate frit	75	Soft borosilicate frit	87
Barium carbonate	30	Potash feldspar	10	Silica	4	Potash feldspar	10	Silica	4
Lithium carbonate	5	Silica	10	Kaolin	9	Silica	10	Kaolin	9
Kaolin	5	Kaolin	5	+ Copper carbonate	12	Kaolin	5	+ Copper carbonate	4
+ Copper carbonate	3	+ Copper carbonate	4	OX, E/W		+ Copper carbonate	12	OX, E/W	
OX, E/W		OX, E/W				OX, E/W			

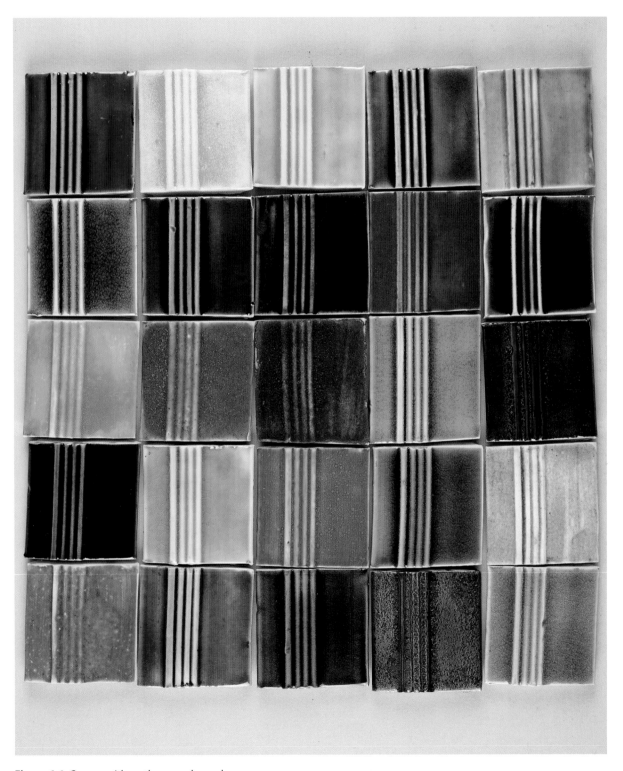

Figure 6.4. Copper with earthenware base glazes.

OXIDE: Copper (Cu) Mid–Fire Cone 5

Cu-26		Cu-27		Cu-28		Cu-29		Cu-30	
Nepheline syenite	35	Barium carbonate	60	Barium carbonate	60	Barium carbonate	60	Nepheline syenite	53
Whiting	18	Soft borosilicate frit	20	Soft borosilicate frit	20	Soft borosilicate frit	20	Lead bisilicate	15
Soft borosilicate frit	13	Kaolin	20	Kaolin	20	Kaolin	20	Whiting	10
Silica	26	+ Copper carbonate	2	+ Copper carbonate	8	+ Copper carbonate	12	Talc	8
Kaolin	8	OX, M/F		Thin application		OX, M/F		Silica	9
+ Tin oxide	2			OX, M/F				Kaolin	5
+ Copper carbonate	0.5							+ Copper carbonate	8
OX, M/F								OX, M/F	

Cu-31		Cu-32		Cu-33		Cu-34		Cu-35	
Nepheline syenite	30	Nepheline syenite	25	Hard borosilicate frit	50	Magnesium		Nepheline syenite	25
Talc	42	Whiting	12	Zinc oxide	25	carbonate (light)	70	Whiting	12
Lithium	18	Calcium borosilicate	38	Kaolin	25	Nepheline syenite	20	Calcium borosilicate	38
Whiting	5	Silica	19	+ Copper carbonate	12	Soft borosilicate frit	10	Silica	19
Kaolin	5	Kaolin	6	OX, M/F		+ Copper carbonate	4	Kaolin	6
+ Copper carbonate	4	+ Copper carbonate	2			OX, M/F		+ Copper carbonate	12
R, M/F		OX, M/F						OX, M/F	

Cu-36		Cu-37		Cu-38		Cu-39		Cu-40	
Nepheline syenite	25	Hard borosilicate frit	50	Nepheline syenite	20	Nepheline syenite	20	Nepheline syenite	30
Whiting	12	Zinc oxide	25	Lead bisilicate frit	35	Lead bisilicate frit	35	Talc	42
Calcium borosilicate	38	Kaolin	25	Soft borosilicate frit	30	Soft borosilicate frit	30	Lithium	18
Silica	19	+ Copper carbonate	4	Whiting	5	Whiting	5	Whiting	5
Kaolin	6	OX, M/F		Talc	5	Talc	5	Kaolin	5
+ Copper carbonate	4			Kaolin	5	Kaolin	5	+ Copper carbonate	4
OX, M/F				+ Rutile	10	+ Rutile	10	OX, M/F	
				+ Copper carbonate	4	+ Copper carbonate	12		
				OX, M/F		OX, M/F			

Cu-41		Cu-42		Cu-43		Cu-44		Cu-45	
Nepheline	60	Nepheline syenite	60	Nepheline syenite	60	Nepheline syenite	60	Nepheline syenite	60
Barium carbonate	30	Barium carbonate	30	Barium carbonate	30	Barium carbonate	30	Barium carbonate	30
Lithium carbonate	5	Lithium carbonate	5	Lithium carbonate	5	Lithium carbonate	5	Lithium carbonate	5
Kaolin	5	Kaolin	5	Kaolin	5	Kaolin	5	Kaolin	5
+ Copper carbonate	0.5	+ Copper carbonate	2	+ Copper carbonate	4	+ Copper carbonate	6	+ Copper carbonate	8
OX, M/F		OX, M/F		OX, M/F		OX, M/F		OX, M/F	

Cu-46		Cu-47		Cu-48		Cu-49		Cu-50	
Nepheline syenite	15	Hard borosilicate frit	50	Nepheline syenite	30	Nepheline syenite	53	Barium carbonate	60
Lead bisilicate frit	40	Zinc oxide	25	Talc	42	Lead bisilicate	15	Soft borosilicate frit	20
Soft borosilicate frit	30	Kaolin	25	Lithium	18	Whiting	10	Kaolin	20
Whiting	5	+ Copper carbonate	8	Whiting	5	Talc	8	+ Copper carbonate	8
Talc	5	OX, M/F		Kaolin	5	Silica	9	OX, M/F	
Kaolin	5			+ Copper carbonate	4	Kaolin	5	Thick application	
+ Iron oxide	3			OX, M/F		+ Copper carbonate	4		
+ Copper carbonate	3					OX, M/F			
OX, M/F									

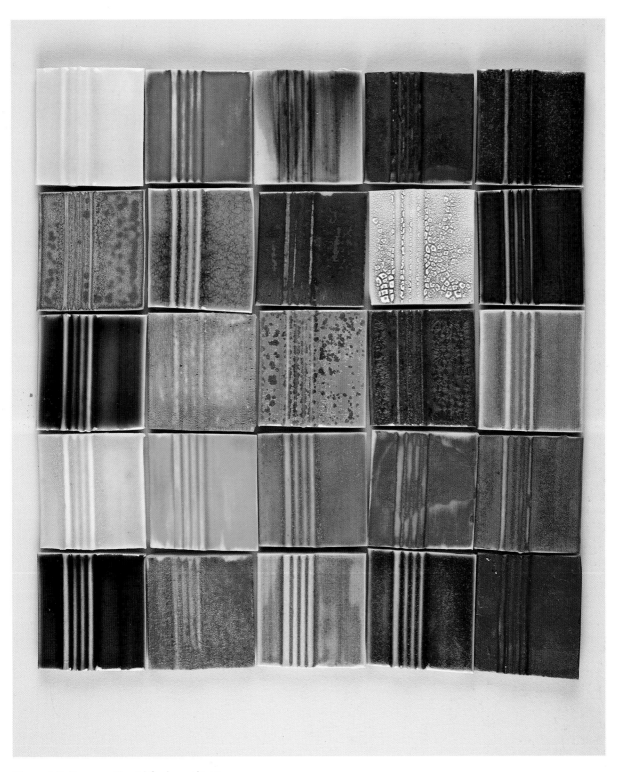

Figure 6.5. Copper with mid-fire base glazes.

Cu-51		Cu-52		Cu-53		Cu-54		Cu-55	
Potash feldspar	63	Nepheline syenite	55	Nepheline syenite	40	Potash feldspar	56	Nepheline syenite	35
Whiting	6	Whiting	16	Whiting	20	Whiting	6	Whiting	18
Talc	10	Talc	13	Silica	30	Talc	9	Talc	13
Bone ash	6	Kaolin	16	Kaolin	10	Bone ash	6	Silica	26
Silica	10	+ Copper carbonate	1	+ Copper carbonate	4	Silica	9	Kaolin	8
Kaolin	5	OX, S/W		OX, S/W		Kaolin	5	+ Copper carbonate	4
+ Copper carbonate	3					Soft borosilicate frit	9	OX, S/W	
OX, S/W						+ Tin oxide	4		
						+ Titanium dioxide	4		
						+ Copper carbonate	0.5		
						OX, S/W			

Cu-56		Cu-57		Cu-58		Cu-59		Cu-60	
Potash feldspar	10	Potash feldspar	10	Nepheline syenite	60	Nepheline syenite	38	Nepheline syenite	38
Whiting	40	Whiting	40	Barium carbonate	30	Whiting	9	Whiting	9
Silica	20	Silica	20	Lithium carbonate	5	Barium carbonate	9	Barium carbonate	9
Kaolin	30	Kaolin	30	Kaolin	5	Soft borosilicate frit	9	Soft borosilicate frit	9
+ Copper carbonate	4	+ Copper carbonate	4	+ Copper carbonate	4	Silica	30	Silica	30
R, S/W		OX, S/W		OX, S/W		Kaolin	5	Kaolin	5
						+ Copper carbonate	4	+ Copper carbonate	8
						OX, S/W		OX, S/W	

Cu-61		Cu-62		Cu-63		Cu-64		Cu-65	
Potash feldspar	63	Nepheline syenite	38	Potash feldspar	63	Nepheline syenite	40	Nepheline syenite	40
Whiting	6	Whiting	9	Whiting	6	Bicarbonate of soda	30	Bicarbonate of soda	30
Talc	10	Barium carbonate	9	Talc	10	Silica	20	Silica	20
Bone ash	6	Soft borosilicate frit	9	Bone ash	6	Kaolin	10	Kaolin	10
Silica	10	Silica	30	Silica	10	+ Copper carbonate	3	+ Tin oxide	2
Kaolin	5	Kaolin	5	Kaolin	5	OX, S/W		+ Copper carbonate	1
+ Soft borosilicate frit	10	+ Copper carbonate	12	+ Soft borosilicate frit	10			OX, S/W	
+ Tin oxide	4	OX, S/W		+ Tin oxide	4				
+ Barium carbonate	10			+ Zinc oxide	10				
+ Copper carbonate	0.5			Copper carbonate	0.5				
OX, S/W				OX, S/W					

Cu-66		Cu-67		Cu-68		Cu-69		Cu-70	
Nepheline syenite	60	Nepheline syenite	60	Nepheline syenite	60	Nepheline syenite	60	Nepheline syenite	55
Barium carbonate	30	Barium carbonate	30	Barium carbonate	30	Barium carbonate	30	Whiting	16
Lithium carbonate	5	Lithium carbonate	5	Lithium carbonate	5	Lithium carbonate	5	Talc	13
Kaolin	5	Kaolin	5	Kaolin	5	Kaolin	5	Kaolin	16
+ Copper carbonate	1	+ Copper carbonate	2	+ Copper carbonate	6	+ Copper carbonate	8	+ Copper carbonate	4
OX, S/W		OX, S/W		OX, S/W		OX, S/W		R, S/W	

Cu-71		Cu-72		Cu-73		Cu-74		Cu-75	
Soda feldspar	36	Nepheline syenite	55	Nepheline syenite	55	Barium carbonate	60	Barium carbonate	60
Whiting	17	Whiting	16	Whiting	16	Kaolin	40	Kaolin	40
Soft borosilicate frit	13	Talc	13	Talc	13	+ Copper carbonate	4	+ Copper carbonate	4
Silica	26	Kaolin	16	Kaolin	16	Thin application		Thick application	
Kaolin	8	+ Copper carbonate	0.5	+ Copper carbonate	0.5	OX, S/W		OX, S/W	
+ Barium carbonate	5	R, S/W		OX, S/W					
+ Tin oxide	2								
+ Copper carbonate	0.5								
R, S/W									

Cu-76		Cu-77		Cu-78		Cu-79		Cu-80	
Potash feldspar	63	Nepheline syenite	60	Potash feldspar	10	Nepheline syenite	55	Nepheline syenite	55
Whiting	6	Barium carbonate	30	Whiting	40	Whiting	16	Whiting	16
Talc	10	Lithium carbonate	5	Silica	30	Talc	13	Talc	13
Bone ash	6	Kaolin	5	Kaolin	20	Kaolin	16	Kaolin	16
Silica	10	+ Copper carbonate	2	+ Copper carbonate	12	+ Copper carbonate	6	+ Copper carbonate	2
Kaolin	5	R, S/W		OX, S/W		R, S/W		OX, S/W	
+ Zinc oxide	10								
+ Copper carbonate	3								
OX, S/W									

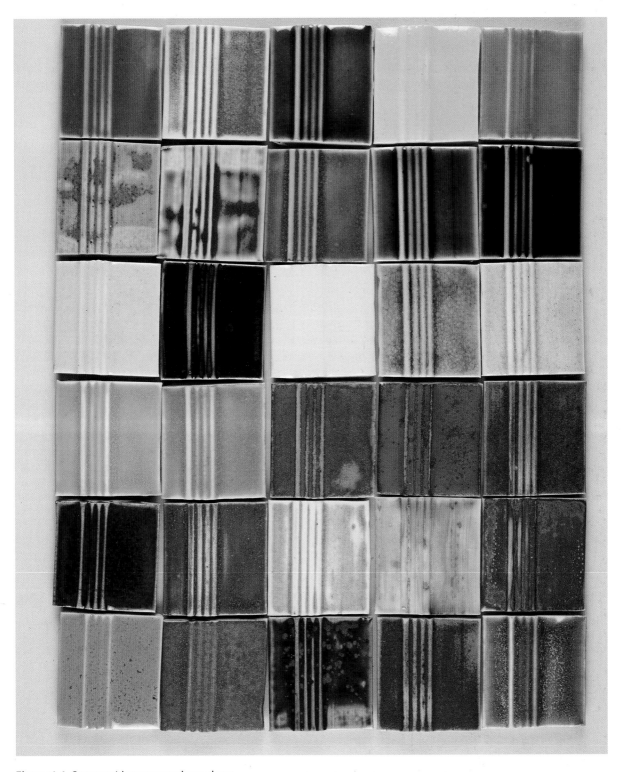

Figure 6.6. Copper with stoneware base glazes.

OXIDE: Copper – Cu Stoneware Cone 9

Cu-81
Nepheline Syenite 38
Whiting 9
Barium carbonate 9
Soft borosilicate frit 9
Silica 30
Kaolin 5
Copper Carbonate 1

OX

Cu-82
Nepheline Syenite 38
Whiting 9
Barium carbonate 9
Soft borosilicate frit 9
Silica 30
Kaolin 5
Copper carbonate 2

OX

Cu-83
Nepheline Syenite 38
Whiting 9
Barium carbonate 9
Soft borosilicate frit 9
Silica 30
Kaolin 5
Copper carbonate 4

OX

Cu-84
Nepheline Syenite 38
Whiting 9
Barium carbonate 9
Soft borosilicate frit 9
Silica 30
Kaolin 5
Tin oxide 2
Copper carbonate .5

OX

Cu-85
Nepheline Syenite 38
Whiting 9
Barium carbonate 15
Soft borosilicate frit 9
Silica 30
Kaolin 5
Tin oxide 2
Copper carbonate .5

OX

Cu-86
Nepheline Syenite 38
Whiting 9
Barium carbonate 9
Soft borosilicate frit 9
Silica 30
Kaolin 5
Copper carbonate 1

R

Cu-87
Nepheline Syenite 38
Whiting 9
Barium carbonate 9
Soft borosilicate frit 9
Silica 30
Kaolin 5
Copper carbonate 2

R

Cu-88
Nepheline Syenite 38
Whiting 9
Barium carbonate 9
Soft borosilicate frit 9
Silica 30
Kaolin 5
Copper carbonate 4

R

Cu-89
Nepheline Syenite 38
Whiting 9
Barium carbonate 9
Soft borosilicate frit 9
Silica 30
Kaolin 5
Tin oxide 2
Copper carbonate .5

R

Cu-90
Nepheline Syenite 38
Whiting 9
Barium carbonate 15
Soft borosilicate frit 9
Silica 30
Kaolin 5
Tin oxide 2
Copper carbonate .5

R

Cu-91
Nepheline Syenite 38
Whiting 9
Barium carbonate 9
Bicarbonate of Soda 9
Silica 30
Kaolin 5
Copper carbonate 2

OX

Cu-92
Nepheline Syenite 38
Whiting 9
Barium carbonate 9
Soft borosilicate frit 9
Silica 30
Kaolin 5
Tin oxide 2
Copper carbonate .5
Titanium Dioxide 2

OX

Cu-93
Nepheline Syenite 35
Whiting 14
Zinc oxide 4
Bone ash 3
Soft borosilicate frit 15
Silica 25
Kaolin 4
Tin oxide 2
Copper carbonate 1

R

Cu-94
Nepheline Syenite 44
Whiting 14
Soft borosilicate frit 14
Silica 25
Kaolin 3
Tin oxide 1
Copper carbonate .5

Light/medium rediction

R

Cu-95
Nepheline Syenite 44
Whiting 14
Soft borosilicate frit 14
Silica 25
Kaolin 3
Tin oxide 1
Copper carbonate .5

Reduction started at
950°c/1740°f

R

Cu-96
Nepheline Syenite 38
Whiting 9
Barium carbonate 9
Soft Borosilicate frit 9
Silica 30
Kaolin 5
Copper carbonate 2

R

Cu-97
Nepheline Syenite 38
Whiting 9
Barium carbonate 9
Soft borosilicate frit 9
Silica 30
Kaolin 5
Tin oxide 2
Copper carbonate .5
Titanium Dioxide 2

R

Cu-98
Nepheline Syenite 35
Whiting 14
Zinc oxide 4
Bone ash 3
Soft borosilicate frit 15
Silica 25
Kaolin 4
Tin oxide 2
Copper carbonate 1
(Same as Cu-93 but dry mix
add water when applying)

R

Cu-99
Nepheline Syenite 44
Whiting 14
Soft borosilicate frit 14
Silica 25
Kaolin 3
Tin oxide 1
Copper carbonate .5

Heavy reduction

R

Cu-100
Nepheline Syenite 44
Whiting 14
Soft borosilicate frit 14
Silica 25
Kaolin 3
Tin oxide 1
Copper carbonate .5
Bone Ash 8

R

Cu-101
Potash Feldspar 63
Whiting 6
Talc 10
Bone Ash 6
Silica 10
Kaolin 5
Soft borosilicate frit 10
Barium carbonate 10
Tin oxide 2
Copper carbonate .5

R

Cu-102
Nepheline Syenite 38
Whiting 9
Barium carbonate 9
Soft borosilicate frit 9
Silica 30
Kaolin 5
Tin oxide 2
Copper carbonate .5
Titanium Dioxide 5

R

Cu-103
Nepheline Syenite 44
Whiting 14
Soft borosilicate frit 14
Silica 25
Kaolin 3
Tin oxide 1
Copper carbonate .5
Gerstley Borate 10

R

Cu-104
Nepheline Syenite 44
Whiting 14
Soft borosilicate frit 14
Silica 25
Kaolin 3
Tin oxide 1
Copper carbonate .5
Gerstley Borate 10

R

Cu-105
Nepheline Syenite 44
Whiting 14
Soft borosilicate frit 14
Silica 25
Kaolin 3
Tin oxide 1
Copper carbonate .5
Iron oxide 4

R

Chart for Fig: 6–7 Copper with stoneware base glazes.

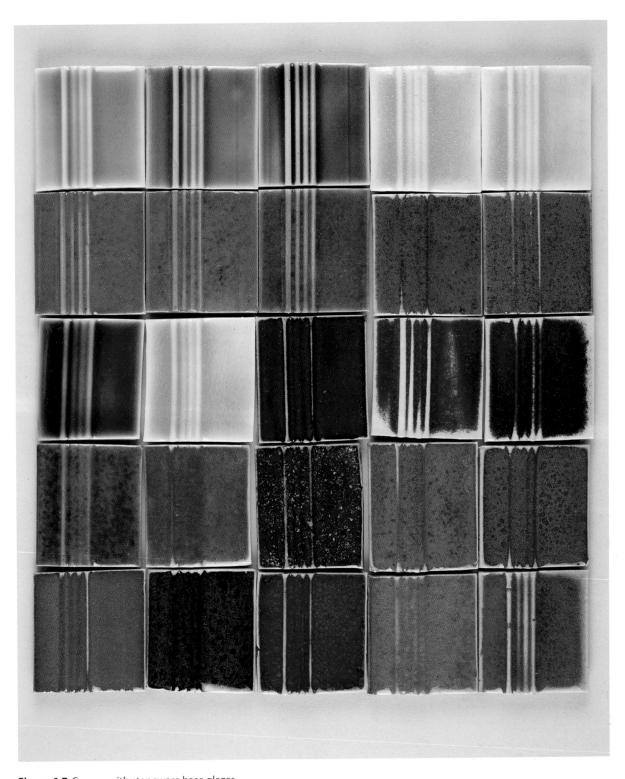

Figure 6.7. Copper with stoneware base glazes.

10 86 → 1131 (handwritten)

OXIDE: Iron (Fe) Earthenware Cone 03

Fe-1		Fe-2		Fe-3		Fe-4		Fe-5	
Soft borosilicate frit	87	Soft borosilicate frit	87	Soft borosilicate frit	60	Soft borosilicate frit	45	Soft borosilicate frit	60
Silica	4	Silica	4	Barium carbonate	24	Lead bisilicate frit	45	Barium carbonate	24
Kaolin	9	Kaolin	9	Kaolin	16	Silica	4	Kaolin	16
+ Iron oxide	15	+ Iron oxide	10	+ Iron oxide	4	Kaolin	6	+ Iron oxide	10
OX, E/W		OX, E/W		OX, E/W		+ Iron oxide	10	OX, E/W	
						OX, E/W			

Fe-6		Fe-7		Fe-8		Fe-9		Fe-10	
Nepheline syenite	60	Lead bisilicate frit	75	Lead bisilicate frit	83	Nepheline syenite	60	Soft borosilicate frit	45
Barium carbonate	30	Potash feldspar	10	Silica	7	Barium carbonate	30	Gerstley borate	45
Lithium carbonate	5	Silica	10	Kaolin	10	Lithium carbonate	5	Silica	5
Kaolin	5	Kaolin	5	+ Iron oxide	3	Kaolin	5	Kaolin	5
+ Iron oxide	2	+ Rutile	10	OX, E/W		+ Iron oxide	6	+ Iron oxide	30
OX, E/W		+ Iron oxide	4			OX, E/W		OX, E/W	
		OX, E/W							

Fe-11		Fe-12		Fe-13		Fe-14		Fe-15	
Soft borosilicate frit	45	Soft borosilicate frit	17	Soft borosilicate frit	60	Lead bisilicate frit	83	Soft borosilicate frit	17
Gerstley borate	45	Barium carbonate	36	Barium carbonate	24	Silica	7	Barium carbonate	36
Silica	5	Whiting	16	Kaolin	16	Kaolin	10	Whiting	16
Kaolin	5	Zinc	9	+ Iron oxide	15	+ Rutile	10	Zinc	9
+ Iron oxide	20	Talc	22	OX, E/W		+ Iron oxide	4	Talc	22
OX, E/W		+ Iron oxide	15			OX, E/W		+ Iron oxide	2
		OX, E/W						OX, E/W	

Fe-16		Fe-17		Fe-18		Fe-19		Fe-20	
Soft borosilicate frit	87	Lead bisilicate frit	83	Soft borosilicate frit	45	Soft borosilicate frit	87	Soft borosilicate frit	45
Silica	4	Silica	7	Gerstley borate	45	Silica	4	Lead bisilicate frit	45
Kaolin	9	Kaolin	10	Silica	5	Kaolin	9	Silica	4
+ Iron oxide	6	+ Iron oxide	10	Kaolin	5	+ Iron oxide	2	Kaolin	6
OX, E/W		OX, E/W		+ Iron oxide	5	OX, E/W		+ Iron oxide	15
				OX, E/W				OX, E/W	

Fe-21		Fe-22		Fe-23		Fe-24		Fe-25	
Soft borosilicate frit	45	Soft borosilicate frit	45	Soft borosilicate frit	45	Soft borosilicate frit	87	Lead bisilicate frit	83
Gerstley borate	45	Lead bisilicate frit	45	Gerstley borate	45	Silica	4	Silica	7
Silica	5	Silica	5	Silica	5	Kaolin	9	Kaolin	10
Kaolin	5	Kaolin	5	Kaolin	5	+ Iron oxide	4	+ Iron oxide	15
+ Iron oxide	10	+ Iron oxide	4	+ Iron oxide	25	OX, E/W		OX, E/W	
OX, E/W		OX, E/W		OX, E/W					
				Adventurine glaze					

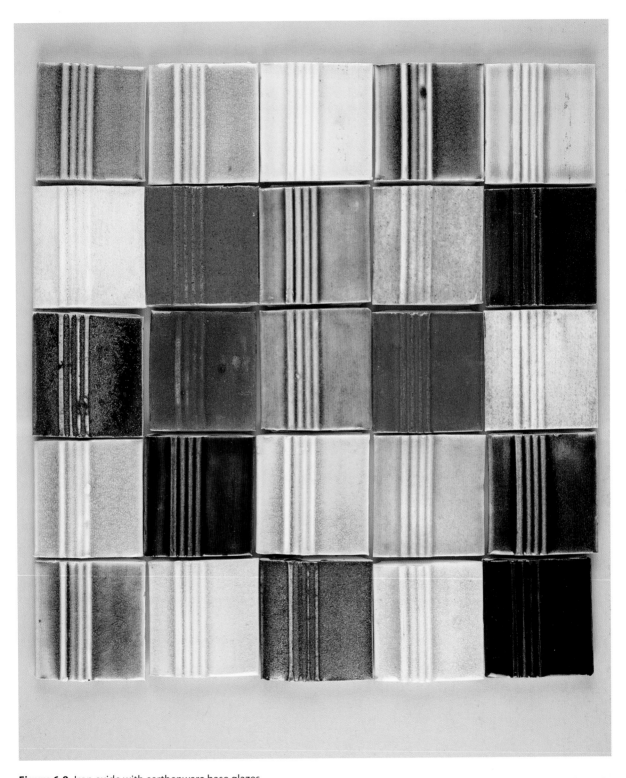

Figure 6.8. Iron oxide with earthenware base glazes.

OXIDE: Iron (Fe) Mid-Fire Cone 5

Fe-26		**Fe-27**		**Fe-28**		**Fe-29**		**Fe-30**	
Nepheline syenite	30	Nepheline syenite	30	Nepheline syenite	25	Nepheline syenite	60	Nepheline syenite	53
Talc	42	Talc	42	Whiting	12	Barium carbonate	30	Lead bisilicate	15
Lithium	18	Lithium	18	Calcium borosilicate	38	Lithium carbonate	5	Whiting	10
Whiting	5	Whiting	5	Silica	19	Kaolin	5	Talc	8
Kaolin	5	Kaolin	5	Kaolin	6	+ Iron oxide	4	Silica	9
+ Iron oxide	4	+ Iron oxide	27	+ Iron oxide	10	OX, M/F		Kaolin	5
OX, M/F		OX, M/F		OX, M/F				+ Iron oxide	10
								OX, M/F	

Fe-31		**Fe-32**		**Fe-33**		**Fe-34**		**Fe-35**	
Nepheline syenite	15	Nepheline syenite	25	Barium carbonate	60	Nepheline	60	Nepheline syenite	60
Lead bisilicate frit	40	Whiting	12	Soft borosilicate frit	20	Barium carbonate	30	Barium carbonate	30
Soft borosilicate frit	30	Calcium borosilicate	38	Kaolin	20	Lithium carbonate	5	Lithium carbonate	5
Whiting	5	Silica	19	+ Iron oxide	10	Kaolin	5	Kaolin	5
Talc	5	Kaolin	6	OX, M/F		+ Iron oxide	10	+ Iron oxide	15
Kaolin	5	+ Iron oxide	10			OX, M/F		OX, M/F	
+ Iron oxide	4	R, S/W							
OX, M/F									

Fe-36		**Fe-37**		**Fe-38**		**Fe-39**		**Fe-40**	
Nepheline syenite	30	Nepheline syenite	25	Nepheline syenite	53	Nepheline syenite	15	Barium carbonate	60
Talc	42	Whiting	12	Lead bisilicate	15	Lead bisilicate frit	40	Soft borosilicate frit	20
Lithium	18	Calcium borosilicate	38	Whiting	10	Soft borosilicate frit	30	Kaolin	20
Whiting	5	Silica	19	Talc	8	Whiting	5	+ Iron oxide	4
Kaolin	5	Kaolin	6	Silica	9	Talc	5	OX, M/F	
+ Iron oxide	10	+ Iron oxide	15	Kaolin	5	Kaolin	5		
OX, M/F		OX, M/F		+ Iron oxide	4	+ Rutile	10		
				R, S/W		+ Iron oxide	4		
						R, S/W			

Fe-41		**Fe-42**		**Fe-43**		**Fe-44**		**Fe-45**	
Nepheline	60	Nepheline syenite	25	Nepheline syenite	53	Nepheline syenite	15	Nepheline syenite	20
Barium carbonate	30	Whiting	12	Lead bisilicate	15	Lead bisilicate frit	40	Lead bisilicate frit	35
Lithium carbonate	5	Calcium borosilicate	38	Whiting	10	Soft borosilicate frit	30	Soft borosilicate frit	30
Kaolin	5	Silica	19	Talc	8	Whiting	5	Whiting	5
+ Iron oxide	2	Kaolin	6	Silica	9	Talc	5	Talc	5
OX, M/F		+ Iron oxide	15	Kaolin	5	Kaolin	5	Kaolin	5
		R, M/F		+ Iron oxide	4	+ Rutile	10	+ Iron oxide	6
				R, M/F		+ Iron oxide	4	OX, M/F	
						OX, M/F			

Fe-46		**Fe-47**		**Fe-48**		**Fe-49**		**Fe-50**	
Nepheline syenite	20	Barium carbonate	60	Nepheline syenite	20	Potash feldspar	52	Potash feldspar	52
Lead bisilicate frit	35	Soft borosilicate frit	20	Lead bisilicate frit	35	Lead bisilicate frit	15	Lead bisilicate frit	15
Soft borosilicate frit	30	Kaolin	20	Soft borosilicate frit	30	Whiting	10	Whiting	10
Whiting	5	+ Iron oxide	15	Whiting	5	Talc	8	Talc	8
Talc	5	OX, M/F		Talc	5	Silica	10	Silica	10
Kaolin	5			Kaolin	5	Kaolin	5	Kaolin	5
+ Iron oxide	2			+ Iron oxide	2	+ Iron oxide	2	+ Iron oxide	2
R, M/F				OX, M/F		R, M/F		OX, M/F	

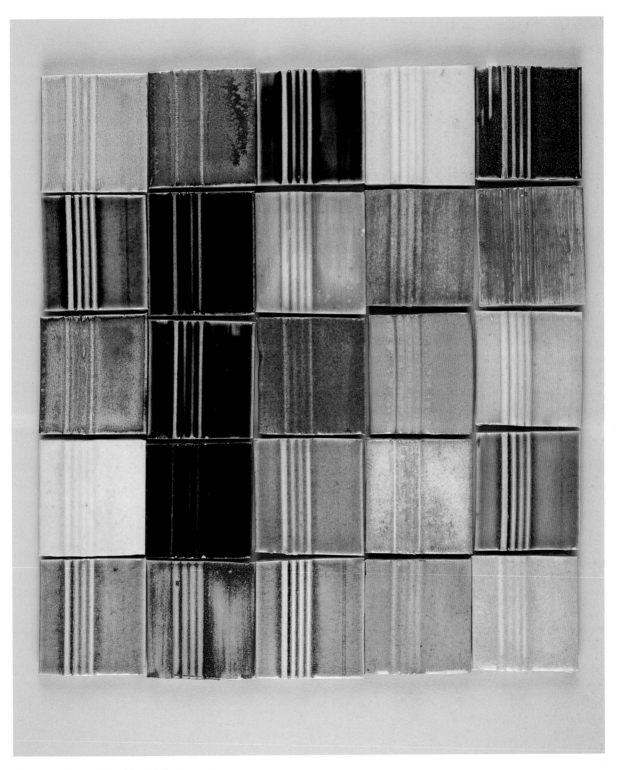

Figure 6.9. Iron oxide with mid-fire base glazes.

OXIDE: Iron (Fe) Stoneware Cone 9

Fe-51
Nepheline syenite	38
Whiting	9
Barium carbonate	9
Soft borosilicate frit	9
Silica	30
Kaolin	5
+ Iron oxide	0.5
OX, S/W	

Fe-52
Nepheline syenite	38
Whiting	9
Barium carbonate	9
Soft borosilicate frit	9
Silica	30
Kaolin	5
+ Iron oxide	1
+ Barium carbonate	10
OX, S/W	

Fe-53
Nepheline syenite	38
Whiting	9
Barium carbonate	9
Soft borosilicate frit	9
Silica	30
Kaolin	5
+ Iron oxide	1
+ Talc	10
OX, S/W	

Fe-54
Nepheline syenite	38
Whiting	9
Barium carbonate	9
Soft borosilicate frit	9
Silica	30
Kaolin	5
+ Iron oxide	1
+ Lithium carbonate	10
OX, S/W	

Fe-55
Nepheline syenite	38
Whiting	9
Barium carbonate	9
Soft borosilicate frit	9
Silica	30
Kaolin	5
+ Iron oxide	1
+ Bone ash	10
OX, S/W	

Fe-56
Nepheline syenite	38
Whiting	9
Barium carbonate	9
Soft borosilicate frit	9
Silica	30
+ Kaolin	5
+ Iron oxide	0.5
R, S/W	

Fe-57
Nepheline syenite	38
Whiting	9
Barium carbonate	9
Soft borosilicate frit	9
Silica	30
Kaolin	5
+ Iron oxide	1
+ Barium carbonate	10
R, S/W	

Fe-58
Nepheline syenite	38
Whiting	9
Barium carbonate	9
Soft borosilicate frit	9
Silica	30
Kaolin	5
+ Iron oxide	1
+ Talc	10
R, S/W	

Fe-59
Nepheline syenite	38
Whiting	9
Barium carbonate	9
Soft borosilicate frit	9
Silica	30
Kaolin	5
+ Iron oxide	1
+ Lithium carbonate	10
R, S/W	

Fe-60
Nepheline syenite	38
Whiting	9
Barium carbonate	9
Soft borosilicate frit	9
Silica	30
Kaolin	5
+ Iron oxide	1
+ Bone ash	10
R, S/W	

Fe-61
Nepheline syenite	38
Whiting	9
Barium carbonate	9
Soft borosilicate frit	9
Silica	30
Kaolin	5
+ Iron oxide	0.5
R, S/W	

Fe-62
Nepheline syenite	38
Whiting	9
Barium carbonate	9
Soft borosilicate frit	9
Silica	30
Kaolin	5
+ Iron oxide	1
+ Barium carbonate	10
R, S/W	

Fe-63
Nepheline syenite	38
Whiting	9
Barium carbonate	9
Soft borosilicate frit	9
Silica	30
Kaolin	5
+ Iron oxide	1
+ Talc	10
R, S/W	

Fe-64
Nepheline syenite	38
Whiting	9
Barium carbonate	9
Soft borosilicate frit	9
Silica	30
Kaolin	5
+ Iron oxide	1
+ Lithium carbonate	10
R, S/W	

Fe-65
Nepheline syenite	38
Whiting	9
Barium carbonate	9
Soft borosilicate frit	9
Silica	30
Kaolin	5
+ Iron oxide	1
+ Bone ash	10
R, S/W	

Fe-66
Nepheline syenite	55
Whiting	16
Talc	13
Kaolin	16
+ Soft borosilicate frit	10
+ Iron oxide	2
OX, S/W	

Fe-67
Barium carbonate	60
Kaolin	40
Iron oxide	6
OX, S/W	
Thin application	

Fe-68
Nepheline syenite	55
Whiting	16
Talc	13
Kaolin	16
+ Iron oxide	1
R, S/W	

Fe-69
Nepheline syenite	55
Whiting	16
Talc	13
Kaolin	16
+ Iron oxide	6
R, S/W	

Fe-70
Potash feldspar	10
Whiting	40
Silica	30
Kaolin	20
+ Iron oxide	15
OX, S/W	

Fe-71
Nepheline syenite	55
Whiting	16
Talc	13
Kaolin	16
+ Soft borosilicate frit	10
+ Iron oxide	2
OX, S/W	

Fe-72
Barium carbonate	60
Kaolin	40
+ Iron oxide	6
OX, S/W	
Thick application	

Fe-73
Nepheline syenite	60
Barium carbonate	30
Lithium carbonate	5
Kaolin	5
+ Iron oxide	2
OX, S/W	

Fe-74
Potash feldspar	20
Whiting	10
Silica	15
Kaolin	5
Alumina hydrate (or calcined)	50
+ Iron oxide	8
OX, S/W	

Fe-75
Nepheline syenite	40
Bicarbonate of soda	30
Silica	20
Kaolin	10
+ Iron oxide	4
OX, S/W	

Fe-76
Nepheline syenite	55
Whiting	16
Talc	13
Kaolin	16
+ Iron oxide	2
R, S/W	

Fe-77
Nepheline syenite	55
Whiting	16
Talc	13
Kaolin	16
+ Iron oxide	2
OX, S/W	

Fe-78
Nepheline syenite	60
Barium carbonate	30
Lithium carbonate	5
Kaolin	5
+ Iron oxide	2
R, S/W	

Fe-79
Nepheline syenite	35
Whiting	18
Talc	13
Silica	26
Kaolin	8
+ Iron oxide	4
R, S/W	

Fe-80
Nepheline syenite	40
Bicarbonate of soda	30
Silica	20
Kaolin	10
+ Iron oxide	4
R, S/W	

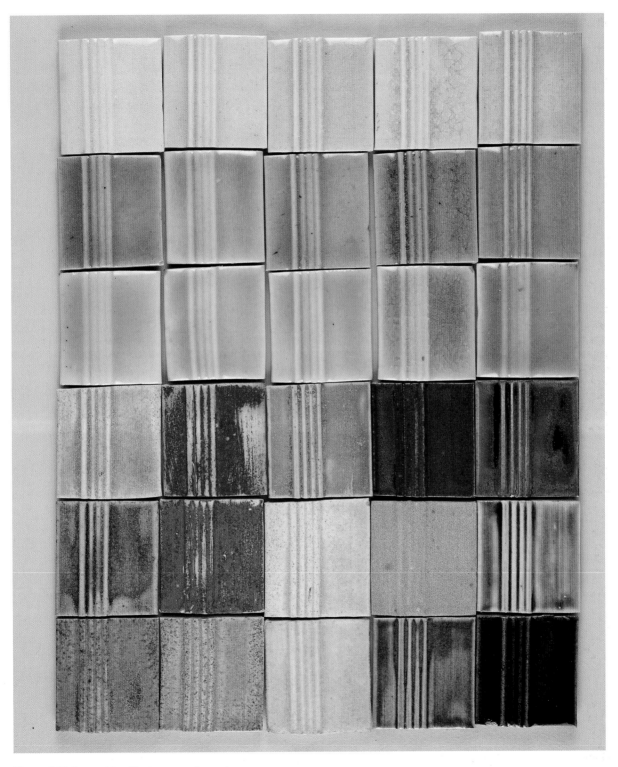

Figure 6.10. Iron oxide with stoneware base glazes.

OXIDE: Iron (Fe) Stoneware Cone 9

Fe-81		Fe-82		Fe-83		Fe-84		Fe-85	
Potash feldspar	10	Potash feldspar	10	Potash feldspar	10	Nepheline syenite	40	Nepheline syenite	40
Whiting	40	Whiting	40	Whiting	40	Whiting	20	Whiting	20
Silica	30	Silica	30	Silica	30	Silica	30	Silica	30
Kaolin	20	Kaolin	20	Kaolin	20	Kaolin	10	Kaolin	10
+ Iron oxide	4	+ Iron oxide	10	+ Iron oxide	15	+ Iron oxide	4	+ Talc	10
OX, S/W		OX, S/W		OX, S/W		OX, S/W		+ Iron oxide	4
								OX, S/W	

Fe-86		Fe-87		Fe-88		Fe-89		Fe-90	
Potash feldspar	10	Potash feldspar	10	Potash feldspar	10	Nepheline syenite	40	Nepheline syenite	40
Whiting	40	Whiting	40	Whiting	40	Whiting	20	Whiting	20
Silica	30	Silica	30	Silica	30	Silica	30	Silica	30
Kaolin	20	Kaolin	20	Kaolin	20	Kaolin	10	Kaolin	10
+ Iron oxide	4	+ Iron oxide	10	+ Iron oxide	15	+ Iron oxide	4	+ Talc	10
R, S/W		R, S/W		R, S/W		R, S/W		+ Iron oxide	4
								R, S/W	

Fe-91		Fe-92		Fe-93		Fe-94		Fe-95	
Nepheline syenite	38	Nepheline syenite	40	Nepheline syenite	40	Nepheline syenite	40	Nepheline syenite	40
Whiting	9	Whiting	20	Whiting	20	Whiting	20	Whiting	20
Barium carbonate	9	Silica	30	Silica	30	Silica	30	Silica	30
Soft borosilicate frit	9	Kaolin	10	Kaolin	10	Kaolin	10	Kaolin	10
Silica	30	+ Iron oxide	10	+ Talc	10	+ Iron oxide	15	+ Talc	10
Kaolin	5	OX, S/W		+ Iron oxide	10	OX, S/W		+ Iron oxide	15
+ Iron oxide	4			OX, S/W				OX, S/W	
OX, S/W									

Fe-96		Fe-97		Fe-98		Fe-99		Fe-100	
Nepheline syenite	38	Nepheline syenite	40	Nepheline syenite	40	Nepheline syenite	40	Nepheline syenite	40
Whiting	9	Whiting	20	Whiting	20	Whiting	20	Whiting	20
Barium carbonate	9	Silica	30	Silica	30	Silica	30	Silica	30
Soft borosilicate frit	9	Kaolin	10	Kaolin	10	Kaolin	10	Kaolin	10
Silica	30	+ Iron oxide	10	+ Talc	10	+ Iron oxide	15	+ Talc	10
Kaolin	5	R, S/W		+ Iron oxide	10	R, S/W		+ Iron oxide	15
+ Iron oxide	4			R, S/W				R, S/W	
R, S/W									

Fe-101		Fe-102		Fe-103		Fe-104		Fe-105	
Nepheline syenite	38	Nepheline syenite	40	Potash feldspar	40	Potash feldspar	40	Potash feldspar	63
Whiting	9	Bicarbonate of soda	30	Whiting	20	Whiting	20	Whiting	6
Barium carbonate	9	Silica	20	Silica	30	Silica	30	Talc	10
Soft borosilicate frit	9	Kaolin	10	Kaolin	10	Kaolin	10	Bone ash	6
Silica	30	+ Iron oxide	4	+ Talc	20	+ Talc	20	Silica	10
Kaolin	5	OX, S/W		+ Iron oxide	8	+ Iron oxide	2	Kaolin	5
+ Iron oxide	20			OX, S/W		OX, S/W		+ Barium carbonate	10
R, S/W								+ Iron oxide	2
Thick application								R, S/W: High-iron clay	

Fe-106		Fe-107		Fe-108		Fe-109		Fe-110	
Nepheline syenite	38	Nepheline syenite	55	Soda feldspar	20	Soda feldspar	20	Barium carbonate	60
Whiting	9	Whiting	16	Magnesium		Magnesium		Kaolin	40
Barium carbonate	9	Talc	13	carbonate (light)	80	carbonate (light)	80	+ Iron oxide	6
Soft borosilicate frit	9	Kaolin	16	+ Iron oxide	4	+ Iron oxide	10	OX, S/W	
Silica	30	+ Iron oxide	6	R, S/W		OX, S/W			
Kaolin	5	R, S/W							
+ Iron oxide	20								
R, S/W									
Thin application									

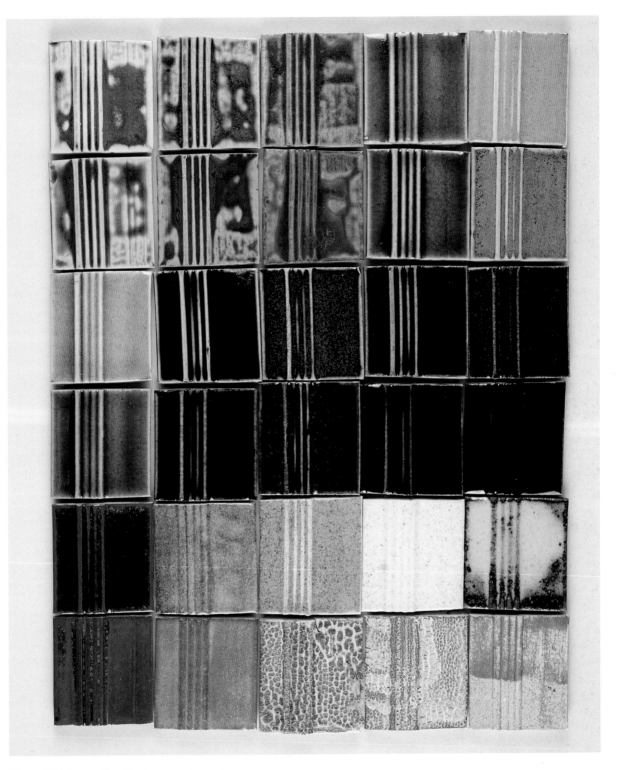

Figure 6.11. Iron oxide with stoneware base glazes.

OXIDE: Iron (Fe) Stoneware Cone 9

Fe-111
Nepheline syenite	38
Whiting	9
Barium carbonate	9
Soft borosilicate frit	9
Silica	30
Kaolin	5
+ Iron oxide	0.5

OX, S/W

Fe-112
Nepheline syenite	38
Whiting	9
Barium carbonate	9
Soft borosilicate frit	9
Silica	30
Kaolin	5
+ Iron oxide	1

OX, S/W

Fe-113
Nepheline syenite	38
Whiting	9
Barium carbonate	9
Soft borosilicate frit	9
Silica	30
Kaolin	5
+ Iron oxide	2

OX, S/W

Fe-114
Nepheline syenite	38
Whiting	9
Barium carbonate	9
Soft borosilicate frit	9
Silica	30
Kaolin	5
+ Iron oxide	4

OX, S/W

Fe-115
Nepheline syenite	38
Whiting	9
Barium carbonate	9
Soft borosilicate frit	9
Silica	30
Kaolin	5
+ Iron oxide	6

OX, S/W

Fe-116
Nepheline syenite	38
Whiting	9
Barium carbonate	9
Soft borosilicate frit	9
Silica	30
Kaolin	5
+ Iron oxide	0.5

R, S/W

Fe-117
Nepheline syenite	38
Whiting	9
Barium carbonate	9
Soft borosilicate frit	9
Silica	30
Kaolin	5
+ Iron oxide	1

R, S/W

Fe-118
Nepheline syenite	38
Whiting	9
Barium carbonate	9
Soft borosilicate frit	9
Silica	30
Kaolin	5
+ Iron oxide	2

R, S/W

Fe-119
Nepheline syenite	38
Whiting	9
Barium carbonate	9
Soft borosilicate frit	9
Silica	30
Kaolin	5
+ Iron oxide	4

R, S/W

Fe-120
Nepheline syenite	38
Whiting	9
Barium carbonate	9
Soft borosilicate frit	9
Silica	30
Kaolin	5
+ Iron oxide	6

R, S/W

Fe-121
Nepheline syenite	38
Whiting	9
Barium carbonate	9
Soft borosilicate frit	9
Silica	30
Kaolin	5
+ Iron oxide	8

OX, S/W

Fe-122
Nepheline syenite	38
Whiting	9
Barium carbonate	9
Soft borosilicate frit	9
Silica	30
Kaolin	5
+ Iron oxide	10

OX, S/W

Fe-123
Nepheline syenite	38
Whiting	9
Barium carbonate	9
Soft borosilicate frit	9
Silica	30
Kaolin	5
+ Iron oxide	12

OX, S/W

Fe-124
Nepheline syenite	38
Whiting	9
Barium carbonate	9
Soft borosilicate frit	9
Silica	30
Kaolin	5
+ Iron oxide	14

OXOX, S/W

Fe-125
Nepheline syenite	38
Whiting	9
Barium carbonate	9
Soft borosilicate frit	9
Silica	30
Kaolin	5
+ Iron oxide	18

OX, S/W

Fe-126
Nepheline syenite	38
Whiting	9
Barium carbonate	9
Soft borosilicate frit	9
Silica	30
Kaolin	5
+ Iron oxide	8

R, S/W

Fe-127
Nepheline syenite	38
Whiting	9
Barium carbonate	9
Soft borosilicate frit	9
Silica	30
Kaolin	5
+ Iron oxide	10

R, S/W

Fe-128
Nepheline syenite	38
Whiting	9
Barium carbonate	9
Soft borosilicate frit	9
Silica	30
Kaolin	5
+ Iron oxide	12

R, S/W

Fe-129
Nepheline syenite	38
Whiting	9
Barium carbonate	9
Soft borosilicate frit	9
Silica	30
Kaolin	5
+ Iron oxide	14

R, S/W

Fe-130
Nepheline syenite	38
Whiting	9
Barium carbonate	9
Soft borosilicate frit	9
Silica	30
Kaolin	5
+ Iron oxide	18

R, S/W

Fe-131
Nepheline syenite	40
Whiting	20
Silica	30
Kaolin	10
+ Talc	10
+ Iron oxide	10

R, S/W: Cone 8

Fe-132
Potash feldspar	28
Whiting	24
Magnesium carbonate	9
Silica	27
Ball clay	12
+ Iron oxide	8

R, S/W: Cone 8

Fe-133
Potash feldspar	28
Whiting	24
Magnesium carbonate	9
Silica	27
Ball clay	12
+ Iron oxide	15

R, S/W: Cone 8

Fe-134
Nepheline syenite	40
Whiting	20
Silica	30
Kaolin	10
+ Iron oxide	30

R, S/W

Fe-135
Nepheline syenite	40
Bicarbonate of soda	30
Silica	20
Kaolin	10
+ Iron oxide	12

R, S/W

Fe-136
Nepheline syenite	40
Whiting	20
Silica	30
Kaolin	10
+ Talc	10
+ Iron oxide	4

R, S/W: Cone 9

Fe-137
Potash feldspar	28
Whiting	24
Magnesium carbonate	9
Silica	27
Ball clay	12
+ Iron oxide	8

R, S/W: Cone 9

Fe-138
Amblygonite	33
Zinc oxide	30
Dolomite	18
Magnesium carbonate	19
+ Iron oxide	8

R, S/W

Fe-139
Potash feldspar	63
Whiting	6
Talc	10
Bone ash	6
Silica	10
Kaolin	5
+ Talc	15
+ Iron oxide	15

R, S/W

Fe-140
Soda feldspar	63
Whiting	6
Talc	10
Bone ash	6
Silica	10
Kaolin	5
+ Iron oxide	12
+ Bone ash	8

R, S/W

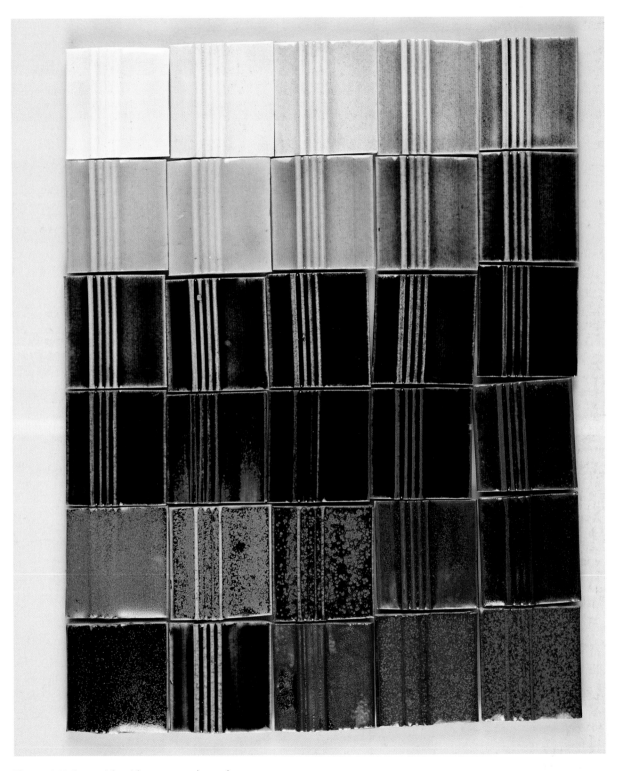

Figure 6.12. Iron oxide with stoneware base glazes.

OXIDE: Iron (Fe) Stoneware Cone 9

Fe-141		Fe-142		Fe-143		Fe-144		Fe-145	
Potash feldspar	63	Potash feldspar	63	Potash feldspar	63	Potash feldspar	63	Potash feldspar	63
Whiting	6	Whiting	6	Whiting	6	Whiting	6	Whiting	6
Talc	10	Talc	10	Talc	10	Talc	10	Talc	10
Bone ash	6	Bone ash	6	Bone ash	6	Bone ash	6	Bone ash	6
Silica	10	Silica	10	Silica	10	Silica	10	Silica	10
Kaolin	5	Kaolin	5	Kaolin	5	Kaolin	5	Kaolin	5
+ Iron oxide	1	+ Iron oxide	2	+ Iron oxide	4	+ Iron oxide	8	+ Iron oxide	12
OX, S/W		OX, S/W		OX, S/W		OX, S/W		OX, S/W	

Fe-146		Fe-147		Fe-148		Fe-149		Fe-150	
Potash feldspar	63	Potash feldspar	63	Potash feldspar	63	Potash feldspar	63	Potash feldspar	63
Whiting	6	Whiting	6	Whiting	6	Whiting	6	Whiting	6
Talc	10	Talc	10	Talc	10	Talc	10	Talc	10
Bone ash	6	Bone ash	6	Bone ash	6	Bone ash	6	Bone ash	6
Silica	10	Silica	10	Silica	10	Silica	10	Silica	10
Kaolin	5	Kaolin	5	Kaolin	5	Kaolin	5	Kaolin	5
+ Iron oxide	1	+ Iron oxide	2	+ Iron oxide	4	+ Iron oxide	8	+ Iron oxide	12
R, S/W		R, S/W		R, S/W		R, S/W		R, S/W	

Fe-151		Fe-152		Fe-153		Fe-154		Fe-155	
Potash feldspar	63	Potash feldspar	63	Potash feldspar	63	Potash feldspar	63	Potash feldspar	63
Whiting	6	Whiting	6	Whiting	6	Whiting	6	Whiting	6
Talc	10	Talc	10	Talc	10	Talc	10	Talc	10
Bone ash	6	Bone ash	6	Bone ash	6	Bone ash	6	Bone ash	6
Silica	10	Silica	10	Silica	10	Silica	10	Silica	10
Kaolin	5	Kaolin	5	Kaolin	5	Kaolin	5	Kaolin	5
+ Iron oxide	16	+ Iron oxide	20	+ Iron oxide	24	+ Iron oxide	1	+ Iron oxide	5
OX, S/W		OX, S/W		OX, S/W		+ Soft borosilicate frit	5	+ Talc	15
						+ Barium carbonate	10	OX, S/W	
						OX, S/W			

Fe-156		Fe-157		Fe-158		Fe-159		Fe-160	
Potash feldspar	63	Potash feldspar	63	Potash feldspar	63	Potash feldspar	63	Potash feldspar	63
Whiting	6	Whiting	6	Whiting	6	Whiting	6	Whiting	6
Talc	10	Talc	10	Talc	10	Talc	10	Talc	10
Bone ash	6	Bone ash	6	Bone ash	6	Bone ash	6	Bone ash	6
Silica	10	Silica	10	Silica	10	Silica	10	Silica	10
Kaolin	5	Kaolin	5	Kaolin	5	Kaolin	5	Kaolin	5
+ Iron oxide	16	+ Iron oxide	20	+ Iron oxide	24	+ Iron oxide	1	+ Iron oxide	5
R, S/W		R, S/W		R, S/W		+ Soft borosilicate frit	5	+ Talc	15
						+ Barium carbonate	10	R, S/W	
						R, S/W			

Fe-161		Fe-162		Fe-163		Fe-164		Fe-165	
Potash feldspar	63	Potash feldspar	63	Potash feldspar	63	Amblygnite	48	Spodumene	48
Whiting	6	Whiting	6	Whiting	6	Whiting	8	Whiting	8
Talc	10	Talc	10	Talc	10	Bone ash	12	Bone ash	12
Bone ash	6	Bone ash	6	Bone ash	6	Talc	10	Talc	10
Silica	10	Silica	10	Silica	10	Silicon dioxide	16	Silicon dioxide	16
Kaolin	5	Kaolin	5	Kaolin	5	Kaolin	6	Kaolin	6
+ Iron oxide	2	+ Iron oxide	10	+ Iron oxide	12	+ Iron oxide	10	+ Iron	10
+ Barium carbonate	10	OX, S/W		+ Magnesium		R, S/W		R, S/W	
OX, S/W				carbonate	15				
				OX, S/W					

Fe-166		Fe-167		Fe-168		Fe-169		Fe-170	
Potash feldspar	63	Potash feldspar	63	Potash feldspar	63	Wollastonite	48	Soda feldspar	48
Whiting	6	Whiting	6	Whiting	6	Whiting	8	Whiting	8
Talc	10	Talc	10	Talc	10	Bone ash	12	Bone ash	12
Bone ash	6	Bone ash	6	Bone ash	6	Talc	10	Talc	10
Silica	10	Silica	10	Silica	10	Silicon dioxide	16	Silicon dioxide	16
Kaolin	5	Kaolin	5	Kaolin	5	Kaolin	6	Kaolin	6
+ Iron oxide	2	+ Iron oxide	10	+ Iron oxide	12	+ Iron oxide	10	+ Iron oxide	10
+ Barium carbonate	10	R, S/W		+ Magnesium		R, S/W		R, S/W	
R, S/W				carbonate	15				
				R, S/W					

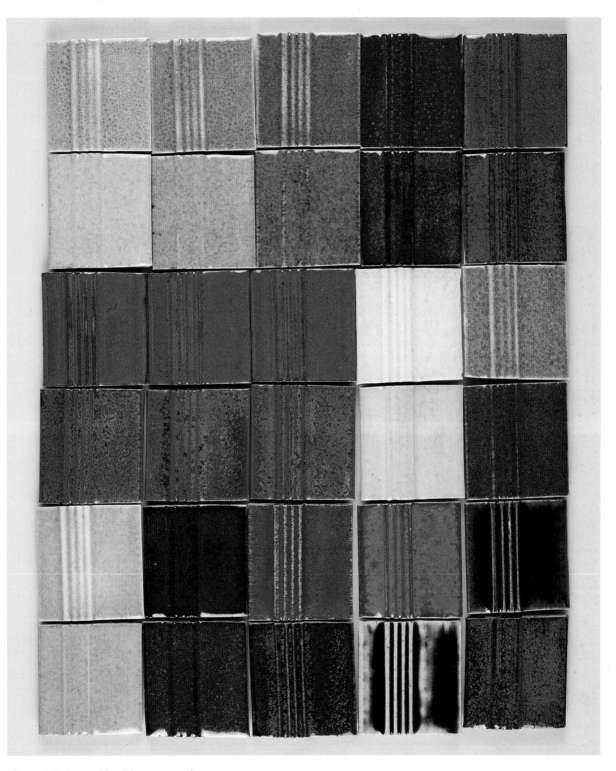

Figure 6.13. Iron oxide with stoneware bases.

Developing glazes

OXIDE: Manganese (Mn) Earthenware Cone 03, Mid-Fire Cone 5, Stoneware Cone 9

Mn-1		Mn-2		Mn-3		Mn-4		Mn-5	
Nepheline syenite	40	Nepheline syenite	38	Nepheline syenite	40	Manganese dioxide	75	Nepheline syenite	38
Whiting	20	Whiting	9	Whiting	20	Copper oxide	10	Whiting	9
Silica	30	Barium carbonate	9	Silica	30	Terracotta	15	Barium carbonate	9
Kaolin	10	Soft borosilicate frit	9	Kaolin	10	*Or*		Soft borosilicate frit	9
+ Talc	10	Silica	30	+ Manganese		Manganese dioxide	100	Silica	30
+ Manganese		Kaolin	5	dioxide	4	+ Copper oxide	10	Kaolin	5
dioxide	4	+ Manganese		R, S/W		OX, M/F		+ Manganese	
R, S/W		dioxide	4					dioxide	6
		OX, S/W						OX, S/W	

Mn-6		Mn-7		Mn-8		Mn-9		Mn-10	
Nepheline syenite	60	Potash feldspar	10	Potash feldspar	10	Nepheline syenite	38	Nepheline syenite	25
Barium	30	Whiting	40	Whiting	40	Whiting	9	Whiting	25
Lithium	5	Silica	20	Silica	20	Barium carbonate	9	Silica	25
Kaolin	5	Kaolin	30	Kaolin	30	Soft borosilicate frit	9	Kaolin	25
+ Manganese		+ Manganese		+ Manganese		Silica	30	+ Manganese	
dioxide	4	dioxide	4	dioxide	4	Kaolin	5	dioxide	4
OX, S/W		R, S/W		OX, S/W		+ Manganese		OX, S/W	
						dioxide	3		
						R, S/W			

Mn-11		Mn-12		Mn-13		Mn-14		Mn-15	
Nepheline syenite	38	Nepheline syenite	35	Nepheline syenite	20	Nepheline syenite	60	Lead bisilicate	35
Whiting	9	Whiting	18	Magnesium		Barium	30	Soft borosilicate frit	30
Barium carbonate	9	Silica	26	carbonate light	80	Lithium	5	Nepheline syenite	20
Soft borosilicate frit	9	Kaolin	8	+ Manganese		Kaolin	5	Whiting	5
Silica	30	Talc	13	dioxide	4	+ Manganese		Talc	5
Kaolin	5	+ Manganese		OX, S/W		dioxide	4	Kaolin	5
+Manganese dioxide	4	dioxide	4			OX, M/F		+ Manganese	
+ Cobalt carbonate	0.5	OX, S/W						dioxide	4
OX, S/W								OX, M/F	

Mn-16		Mn-17		Mn-18		Mn-19		Mn-20	
Nepheline syenite	60	Nepheline syenite	60	Nepheline syenite	25	Nepheline syenite	30	Hard borosilicate	50
Barium	30	Barium	30	Whiting	12	Talc	42	Zinc oxide	20
Lithium	5	Lithium	5	Calcium borosilicate	38	Lithium carbonate	18	Kaolin	30
Kaolin	5	Kaolin	5	Silica	19	Whiting	5	+ Manganese	
+ Manganese		+ Manganese		Kaolin	6	Kaolin	5	dioxide	4
dioxide	1	dioxide	2	+Manganese dioxide	4	+ Manganese		OX, M/F	
OX, M/F		OX, M/F		OX, M/F		dioxide	4		
						OX, M/F			

Mn-21		Mn-22		Mn-23		Mn-24		Mn-25	
Soft borosilicate frit	50	Soft borosilicate frit		Soft borosilicate frit	90	Soft borosilicate frit	60	Lead bisilicate	83
Gerstley borate	40	(ferro 3110/4110)	90	Silica	4	Barium carbonate	24	Silica	7
Silica	5	Silica	4	Kaolin	6	Kaolin	16	Kaolin	10
Kaolin	5	Kaolin	6	+ Manganese		+ Manganese		+ Rutile	10
+ Manganese		+ Manganese		dioxide	3	dioxide	4	+ Manganese	
dioxide	4	dioxide	4	OX, M/F		OX, M/F		dioxide	4
OX, M/F		OX, M/F						OX, M/F	

Mn-26		Mn-27		Mn-28		Mn-29		Mn-30	
Lithium carbonate	100	Lithium carbonate	100	Lead bisilicate	40	Lead bisilicate	50	Soft borosilicate frit	45
+ Manganese		+ Manganese		Lithium carbonate	60	Lithium carbonate	50	Gerstley borate	45
dioxide	4	dioxide	4	+ Manganese		+ Manganese		Silica	5
OX, M/F		OX, M/F		dioxide	4	dioxide	4	Kaolin	5
1080°C/1976°F		900°C/1652°F		OX, M/F		OX, M/F		+ Manganese dioxide	15
				900°C/1652°F		1080°C/1976°F		+ Copper oxide	4
								OX, M/F	

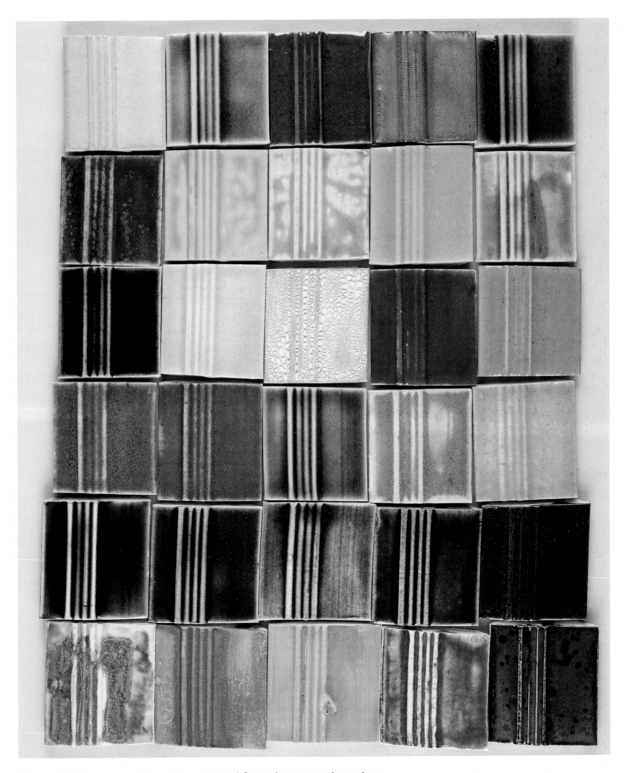

Figure 6.14. Manganese with earthenware, mid-fire and stoneware base glazes.

OXIDE: Nickel (Ni) Earthenware Cone 03, Mid-Fire Cone 5, Stoneware Cone 9

Ni-1		Ni-2		Ni-3		Ni-4		Ni-5	
Potash feldspar	42	Soda feldspar	40	Potash feldspar	40	Nepheline syenite	35	Nepheline syenite	40
Barium carbonate	40	Barium carbonate	30	Barium carbonate	30	Whiting	18	Bicarbonate of soda	30
Zinc oxide	14	Zinc oxide	20	Zinc oxide	20	Talc	13	Silica	20
Kaolin	4	Silica	5	Kaolin	10	Silica	26	Kaolin	10
+ Nickel oxide	4	Kaolin	5	+ Nickel oxide	4	Kaolin	8	+ Nickel oxide	4
OX, S/W		+ Nickel oxide	2	OX, S/W		+ Nickel oxide	2	OX, S/W	
		OX, S/W				R, S/W			

Ni-6		Ni-7		Ni-8		Ni-9		Ni-10	
Nepheline syenite	50	Nepheline syenite	50	Nepheline syenite	55	Potash feldspar	10	Potash feldspar	63
Barium carbonate	20	Barium carbonate	20	Whiting	16	Whiting	40	Whiting	6
Zinc oxide	20	Zinc oxide	20	Talc	13	Silica	30	Talc	10
Kaolin	10	Kaolin	10	Kaolin	16	Kaolin	20	Bone ash	6
+ Nickel oxide	2	+ Nickel oxide	4	+ Nickel oxide	4	+ Nickel oxide	4	Silica	10
OX, S/W		OX, S/W		OX, S/W		OX, S/W		Kaolin	5
								+ Titanium dioxide	10
								+ Nickel oxide	4
								OX, S/W	

Ni-11		Ni-12		Ni-13		Ni-14		Ni-15	
Nepheline syenite	50	Potash feldspar	50	Nepheline syenite	15	Potash feldspar	10	Nepheline syenite	40
Barium carbonate	20	Barium carbonate	20	Lead bisilicate frit	40	Whiting	40	Whiting	20
Zinc oxide	20	Zinc oxide	20	Soft borosilicate frit	30	Silica	30	Silica	30
Kaolin	10	Kaolin	10	Whiting	5	Kaolin	20	Kaolin	10
+ Nickel oxide	2	+ Nickel oxide	4	Talc	5	+ Nickel oxide	4	+ Nickel oxide	4
+ Titanium dioxide	6	OX, S/W		Kaolin	5	R, S/W		OX, S/W	
OX, S/W				+ Rutile	5				
				+ Nickel oxide	2				
				OX, M/F					

Ni-16		Ni-17		Ni-18		Ni-19		Ni-20	
Nepheline syenite	35	Nepheline syenite	15	Magnesium		Nepheline syenite	53	Hard borosilicate frit	50
Whiting	18	Lead bisilicate frit	40	carbonate (light)	80	Lead bisilicate	15	Zinc oxide	25
Talc	13	Soft borosilicate frit	30	Nepheline syenite	20	Whiting	10	Kaolin	25
Silica	26	Whiting	5	+ Nickel oxide	3	Talc	8	+ Nickel oxide	4
Kaolin	8	Talc	5	OX, S/W		Silica	9	OX, M/F	
+ Nickel oxide	2	Kaolin	5			Kaolin	5		
OX, S/W		+ Nickel oxide	2			+ Nickel oxide	4		
		OX, M/F				OX, M/F			

Ni-21		Ni-22		Ni-23		Ni-24		Ni-25	
Soft borosilicate frit	45	Nepheline syenite	30	Nepheline syenite	60	Nepheline syenite	20	Nepheline syenite	38
Lead bisilicate frit	45	Talc	42	Barium carbonate	30	Lead bisilicate frit	35	Whiting	9
Silica	4	Lithium	18	Lithium carbonate	5	Soft borosilicate frit	30	Barium carbonate	9
Kaolin	6	Whiting	5	Kaolin	5	Whiting	5	Soft borosilicate frit	9
+ Nickel oxide	4	Kaolin	5	+ Nickel oxide	4	Talc	5	Silica	30
OX, E/W		+ Nickel oxide	4	OX, M/F		Kaolin	5	Kaolin	5
		OX, M/F				+ Rutile	10	+ Nickel oxide	4
						+ Nickel oxide	4	+ Talc	15
						OX, M/F		OX, S/W	

Ni-26		Ni-27		Ni-28		Ni-29		Ni-30	
Nepheline syenite	60	Soft borosilicate frit	17	Lead bisilicate frit	83	Soft borosilicate frit	45	Soft borosilicate frit	87
Barium carbonate	30	Barium carbonate	36	Silica	7	Gerstley borate	45	Silica	4
Lithium carbonate	5	Whiting	16	Kaolin	10	Silica	5	Kaolin	9
Kaolin	5	Zinc	9	+ Nickel oxide	4	Kaolin	5	+ Nickel oxide	3
+ Nickel oxide	4	Talc	22	OX, E/W		+ Nickel oxide	4	OX, E/W	
OX, E/W		+ Nickel oxide	2			OX, E/W			
		OX, E/W							

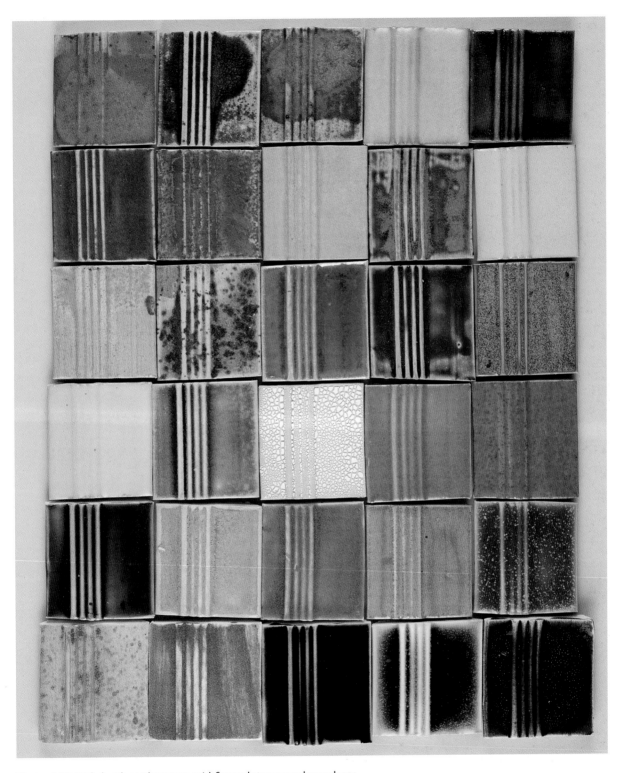

Figure 6.15. Nickel with earthenware, mid-fire and stoneware base glazes.

OXIDE: Rutile/Titanium (Ti) Earthenware Cone 03, Mid-Fire Cone 5, Stoneware Cone 9

Ti-1
Nepheline syenite	38
Whiting	9
Barium carbonate	9
Soft borosilicate frit	9
Silica	30
Kaolin	5
+ Titanium dioxide	10
OX, S/W	

Ti-2
Nepheline syenite	38
Whiting	9
Barium carbonate	9
Soft borosilicate frit	9
Silica	30
Kaolin	5
+ Titanium dioxide	10
R, S/W	

Ti-3
Nepheline syenite	38
Whiting	9
Barium carbonate	9
Soft borosilicate frit	9
Silica	30
Kaolin	5
+ Titanium dioxide	10
R, S/W	

Ti-4
Nepheline syenite	55
Whiting	16
Talc	13
Kaolin	16
+ Titanium dioxide	10
R, S/W: Cone 9	

Ti-5
Nepheline syenite	55
Whiting	16
Talc	13
Kaolin	16
+ Titanium dioxide	10
R, S/W: Cone 10	

Ti-6
Nepheline syenite	35
Whiting	18
Talc	13
Silica	26
Kaolin	8
+ Rutile	10
OX, S/W	

Ti-7
Nepheline syenite	35
Whiting	18
Talc	3
Silica	26
Kaolin	8
+ Rutile	10
R, S/W	

Ti-8
Nepheline syenite	55
Whiting	16
Talc	13
Kaolin	16
+ Rutile 10	10
OX, S/W	

Ti-9
Nepheline syenite	55
Whiting	16
Talc	13
Kaolin	16
+ Rutile 10	10
R, S/W: Cone 9	

Ti-10
Nepheline syenite	55
Whiting	16
Talc	13
Kaolin	16
+ Rutile	10
R, S/W: Cone 10	

Ti-11
Barium carbonate	60
Kaolin	40
+ Rutile	10
OX, S/W	

Ti-12
Nepheline syenite	40
Whiting	20
Silica	30
Kaolin	10
+ Rutile	10
OX, S/W	

Ti-13
Nepheline syenite	40
Whiting	20
Silica	30
Kaolin	10
+ Rutile	10
R, S/W	

Ti-14
Potash feldspar	52
Lead bisilicate frit	15
Whiting	10
Talc	8
Silica	10
Kaolin	5
+ Rutile	10
OX, M/F	

Ti-15
Hard borosilicate frit	50
Zinc oxide	25
Kaolin	25
+ Rutile	10
OX, M/F	

Ti-16
Nepheline syenite	30
Talc	42
Lithium	18
Whiting	5
Kaolin	5
+ Rutile	10
OX, M/F	

Ti-17
Nepheline syenite	30
Talc	42
Lithium	18
Whiting	5
Kaolin	5
+ Rutile	10
R, M/F	

Ti-18
Nepheline syenite	60
Barium carbonate	30
Lithium carbonate	5
Kaolin	5
+ Rutile	10
OX, M/F	

Ti-19
Nepheline syenite	15
Lead bisilicate frit	40
Soft borosilicate frit	30
Whiting	5
Talc	5
Kaolin	5
+ Rutile	10
OX, M/F	

Ti-20
Nepheline syenite	53
Lead bisilicate	15
Whiting	10
Talc	8
Silica	9
Kaolin	5
+ Rutile	10
OX, M/F	

Ti-21
Lead bisilicate frit	83
Silica	7
Kaolin	10
+ Rutile	10
OX, E/W	

Ti-22
Soft borosilicate frit	87
Silica	4
Kaolin	9
+ Rutile	10
OX, E/W	

Ti-23
Soft borosilicate frit	45
Gerstley borate	45
Silica	5
Kaolin	5
+ Rutile	10
OX, E/W	

Ti-24
Soft borosilicate frit	45
Lead bisilicate frit	45
Silica	4
Kaolin	6
+ Rutile	10
OX, E/W	

Ti-25
Soft borosilicate frit	60
Barium carbonate	24
Kaolin	16
+ Rutile	10
OX, E/W	

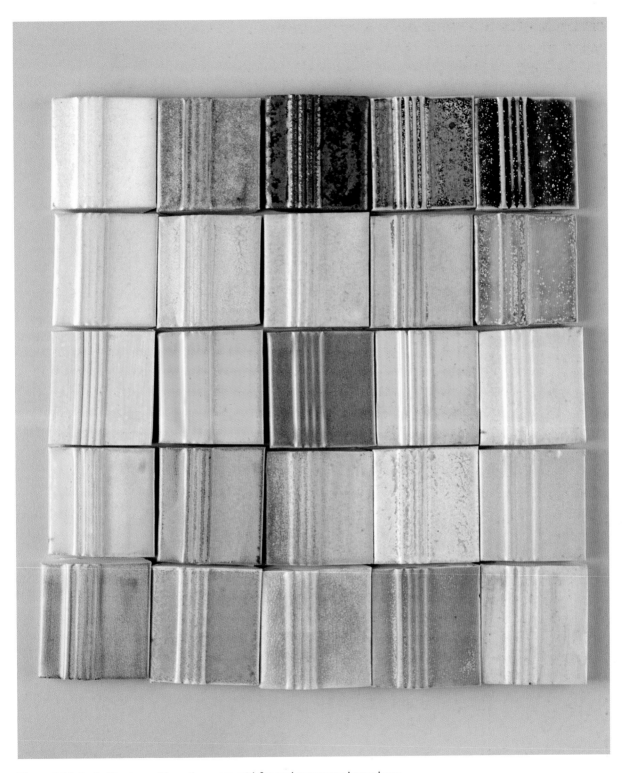

Figure 6.16. Rutile/titanium with earthenware, mid-fire and stoneware base glazes.

OXIDE: Rutile/Titanium (Ti) Earthenware Cone 03, Mid–Fire Cone 5, Stoneware Cone 9

Ti-26

Nepheline syenite	50
Barium carbonate	20
Zinc oxide	20
Kaolin	10
+ Titanium dioxide	6
+ Cobalt carbonate	1
R, S/W	

Ti-27

Nepheline syenite	50
Barium carbonate	20
Zinc oxide	20
Kaolin	10
+ Titanium dioxide	6
R, S/W	

Ti-28

Nepheline syenite	38
Whiting	9
Barium carbonate	9
Soft borosilicate frit	9
Silica	30
Kaolin	5
+ Rutile	10
+ Cobalt carbonate	1
R, S/W	

Ti-29

Nepheline syenite	38
Whiting	9
Barium carbonate	9
Soft borosilicate frit	9
Silica	30
Kaolin	5
+ Rutile	10
+ Cobalt carbonate	1
OX, S/W	

Ti-30

Nepheline syenite	55
Whiting	16
Talc	13
Kaolin	16
+ Rutile	10
+ Iron oxide	1
R, S/W	

Ti-31

Potash feldspar	48
Whiting	8
Bone ash	12
Talc	10
Silicon dioxide	16
Kaolin	6
+ Iron oxide	10
+ Titanium dioxide	8
R, S/W	

Ti-32

Nepheline syenite	55
Whiting	16
Talc	13
Kaolin	16
+ Rutile	10
+ Cobalt carbonate	3
R and OX, S/W	

Ti-33

Nepheline syenite	50
Barium carbonate	20
Zinc oxide	20
Kaolin	10
+ Titanium dioxide	10
+ Cobalt carbonate	1
OX, S/W	

Ti-34

Barium carbonate	60
Kaolin	40
+ Rutile	10
+ Cobalt carbonate	1
OX, S/W	

Ti-35

Nepheline syenite	38
Whiting	9
Barium carbonate	9
Soft borosilicate frit	9
Silica	30
Kaolin	5
+ Titanium dioxide	10
+ Iron oxide	1
OX, S/W	

Ti-36

Nepheline syenite	38
Whiting	9
Barium carbonate	9
Soft borosilicate frit	9
Silica	30
Kaolin	5
+ Titanium dioxide	10
+ Iron oxide	4
R, S/W	

Ti-37

Nepheline syenite	55
Whiting	16
Talc	13
Kaolin	16
+ Rutile	10
+ Iron oxide	3
OX, S/W	

Ti-38

Nepheline syenite	
Soft borosilicate frit	44
Whiting	17
Talc	12
Silica	5
Kaolin	16
+ Copper carbonate	6
+ Tin oxide	0.25
+ Rutile	1
R, S/W	3

Ti-39

Barium carbonate	60
Kaolin	40
+ Rutile	10
+ Iron oxide	2
OX, S/W	

Ti-40

Nepheline syenite	38
Whiting	9
Barium carbonate	9
Soft borosilicate frit	9
Silica	30
Kaolin	5
+ Titanium dioxide	10
+ Iron oxide	1
R, S/W	

Ti-41

Nepheline syenite	38
Whiting	9
Barium carbonate	9
Soft borosilicate frit	9
Silica	30
Kaolin	5
+ Nickel oxide	4
+ Rutile	10
OX, S/W	

Ti-42

Nepheline syenite	55
Whiting	16
Talc	13
Kaolin	16
+ Cobalt carbonate	2
+ Rutile	10
R, S/W	

Ti-43

Nepheline syenite	15
Lead bisilicate frit	40
Soft borosilicate frit	30
Whiting	5
Talc	5
Kaolin	5
+ Iron oxide	2
+ Rutile	10
OX, M/F	

Ti-44

Potash feldspar	52
Lead bisilicate frit	15
Whiting	10
Talc	8
Silica	10
Kaolin	5
+ Copper carbonate	4
+ Rutile	10
OX, M/F	

Ti-45

Nepheline syenite	15
Lead bisilicate frit	40
Soft borosilicate frit	30
Whiting	5
Talc	5
Kaolin	5
+ Rutile	10
+ Nickel oxide	4
OX, M/F	

Ti-46

Lead bisilicate frit	83
Silica	7
Kaolin	10
+ Iron oxide	4
+ Rutile	10
OX, E/W	

Ti-47

Lead bisilicate frit	75
Potash feldspar	10
Silica	5
Kaolin	10
+ Rutile	3
+ Cobalt carbonate	
OX, E/W	

Ti-48

Nepheline syenite	53
Lead bisilicate	15
Whiting	10
Talc	8
Silica	9
Kaolin	5
+ Rutile	5
+ Copper carbonate	2
OX, M/F	

Ti-49

Nepheline syenite	53
Lead bisilicate	15
Whiting	10
Talc	8
Silica	9
Kaolin	5
+ Rutile	10
+ Cobalt carbonate	1
OX, M/F	

Ti-50

Nepheline syenite	15
Lead bisilicate frit	40
Soft borosilicate frit	30
Whiting	5
Talc	5
Kaolin	5
+ Rutile	10
+ Iron oxide	2
OX, M/F	

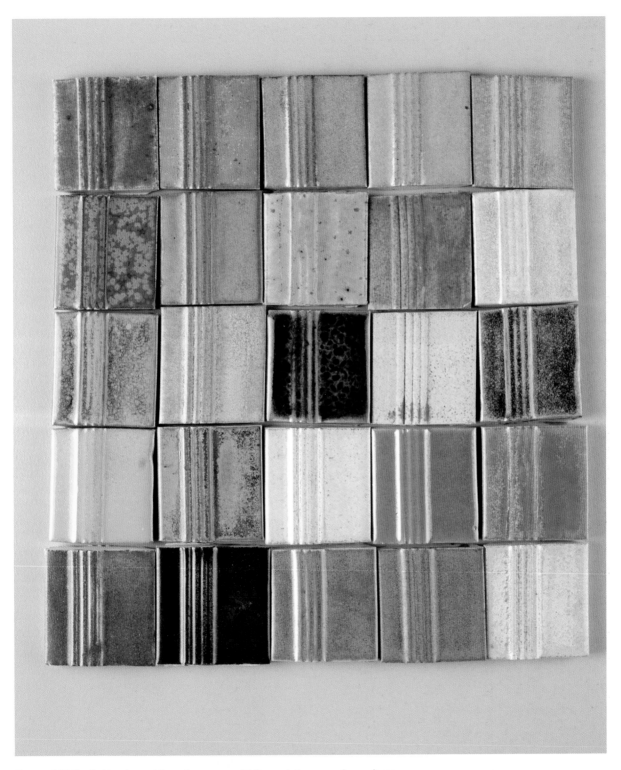

Figure 6.17. Rutile/titanium with earthenware, mid-fire and stoneware base glazes.

Ingredient conversions

Frits

Frit	UK	USA	Australia
Soft borosilicate frit	37214	3110	4110
Hard borosilicate	3124	3124-2	4113
Lead bisilicate	VTR29	3403 (No longer available)	3531

First try using the frits you already have in your studio.

Notes on other ingredients

Potash feldspar: US equivalents are Custer feldspar and G200HP feldspar

Soda feldspar: US equivalents include Minspar 200 and Kona F4 Feldpsar.

Magnesium carbonate 'light': A material easily obtained in Australia and the UK through ceramic suppliers. Available in the US from ACS Chemical, Inc. (acsrenee@verizon.net). Magnesium heavy can be used as a substitute, but some of the surface effects, like crawled and cracked surface, will not happen.

Cobalt nitrate: This is a soluble salt and not readily available. Cobalt nitrate needs to be sourced through chemical suppliers. US Pigment (www.uspigment.com) sells cobalt sulphate, which can be used instead of cobalt nitrate.

Cullet: Crushed glass, used in the glass industry, and readily available.

Amblygonite: Composed of lithium, sodium, aluminium, phosphate, fluoride and hydroxide. It is not used in any glazes in this book, but only as a raw materials test.

Bicarbonate of soda: A soda frit can be used as an alternative, but bicarbonate of soda is widely available and cheap. It also doesn't crystallise out in a mix, like soda ash would. In high amounts in a glaze recipe, it will not be soluble, as water can't dissolve more than 9g per 100ml of water.

Lead: Any of the glazes containing lead bisilicate frit should only be used for decorative glazes on vases and sculptural work, and not on domestic tableware. In the US it isn't recommended that lead in any form be used in a glaze. However, lead bisilicate, formulated to make lead safer to handle, is available in Australia and in the UK. In this form, the lead has been fused with silica to create a glass, and then ground.

Suppliers

UK

Bath Potters Supplies
Radstock, Nr Bath
Tel: 01761 411077
www.bathpotters.co.uk

Ceramatech
London
Tel: 0208 885 4492
www.ceramatech.co.uk

Clayman
Chichester, West Sussex
Tel: 01243 265845
info@claymansupplies.co.uk

CTM Potters' Supplies
Woodbury Salterton, Exeter
Tel: 01395 233077
www.ctmpotterssupplies.co.uk

Potterycrafts
Stoke-on-Trent, Staffordshire
Tel: 01782 745000
www.potterycraft.co.uk

Scarva Pottery Supplies
County Down, Northern Ireland
Tel: 028 406 69699
www.scarvapottery.com

Top Pot Supplies
Newport, Shropshire
Tel: 01952813203
www.toppotsupplies.co.uk

USA

Amaco Brent
Indianapolis, IN
Tel: 317-244-6871
www.amaco.com

Bailey Ceramic Supplies
Kingston, NY
Tel: 845-339-3721
www.baileypottery.com

Bracker's Good Earth Clays
Lawrence, KS
Tel: 785-841-4750
www.brackers.com

Clay Planet
Santa Clara, CA
Tel: 800-443-2529
www.clay-planet.com

Columbus Clay Co.
Columbus, OH
Tel: 866-410-2529
www.columbusclay.com

Georgies
Portland, OR
Tel: 503-283-1353
www.georgies.com

Hammill & Gillespie
Livingstone, NJ
Tel: 800-454-8846
www.hamgil.com

Laguna Clay Co.
City of Industry, CA
Tel: 800-452-4862
www.lagunaclay.com

Mile Hi Ceramics
Denver, CO
Tel: 303-825-4570
www.milehiceramics.com

Minnesota Clay Co.
Edina, MN
Tel: 952-884-9101
www.minnesotaclayusa.com

US Pigments
South Elgin, IL
Tel: 630-893-9217
Fax: 630-339-2644
info@uspigment.com

AUSTRALIA

Clayworks
Dandenong, VIC, 3175
Tel: (03) 9791 6749
www.walkerceramics.com.au

Feeney's Clay
West Ipswich, QLD, 4305
Tel: (03) 8761 6322

**Jackson's Drawing Supplies
(Ceramics)**
Balcatta, WA, 6021
Tel: (08) 6241 6400
www.jacksons.com.au

Pottery Supplies
Milton, QLD, 4064
Tel: (07) 3368 2877
Homebush West, NSW, 2140
Tel: (02) 8756 5900
www.potterysupplies.com.au

Walker Ceramics
Croydon, VIC, 3136
Tel: (03) 8761 6322
sales@walkerceramics.com.au
Fyshwick, ACT, 2609
Tel: (02) 6280 5700
act@walkerceramics.com.au

Index

alumina 6–9, 13, 14, 34, 35, 39, 45, 49, 56–7, 75, 77, 79
amblygonite 13, 36, 38, 39, 40
application 26–7, 30–2, 34, 67, 72, 78, 81

balanced glaze 6, 8
ball clay 7, 13, 16, 64
barium 7, 10, 13, 17, 27, 30, 36, 40, 46, 49, 58, 61, 63, 66, 67, 68, 70, 75, 76, 77
basalt 7, 13, 36, 38, 49, 50, 51
bisque 25, 26, 34
bone ash 13, 16, 17, 30, 36, 82, 84, 89
borax 7, 22, 36, 38, 74, 75, 76
boric acid 7, 74, 75, 76

calcium 7, 9, 15, 30, 36, 38, 46, 49, 64, 75, 76, 77, 87, 126
celadon 21, 22, 49, 52
chrome 7, 13, 27, 36, 43, 59, 60, 70, 74, 75, 76, 77, 79, 85, 91
clay body 13, 16, 17, 25, 27, 28, 38, 49
cobalt 7, 13, 21, 36, 38, 43, 46, 52, 53, 57, 63, 70, 74, 75, 76, 77, 78, 79, 82, 85, 87, 91
colour blend 28, 78–89, 91
cone bending 18, 19, 34
copper carbonate 13, 27, 33, 36, 46, 54, 55, 58, 63, 66, 70, 74, 77, 79, 82, 85, 87, 88, 89
copper red 6, 11, 12, 14, 15, 21, 22, 23, 24, 25, 27, 28, 54, 57, 58, 64, 66, 84, 89, 91

earthenware 5, 6, 21, 25, 26, 34, 36, 38, 43, 46, 47, 54, 55, 61, 63, 64, 68, 69, 85, 91
eutectic 9, 10

fireclay 11, 17
flashing 68
flow test 14, 15, 61
food dye 81

grid test 72–3

heat work 18, 19

iron oxide 12, 13, 16, 17, 20, 21, 36, 46, 49, 52, 63, 74, 77, 79, 82, 85, 87, 88

Jun glazes 14, 15, 22, 64

kaolin 7, 8, 12, 13, 14, 16, 20, 24, 27, 28, 34, 36, 40, 44, 45, 46, 49, 50, 52, 53, 54, 55, 56, 58, 60, 62, 63, 64, 66, 67, 70, 85, 87, 89
kiln atmosphere 21–4
kiln burner 11, 12, 21, 23, 24, 25,
kiln fuel 21, 22, 23, 24
kiln shelves 11, 23, 34
kiln type 13, 21

lead 9, 10, 13, 14, 22, 30, 35, 36, 43, 44, 59, 60, 62, 61, 64, 68, 74, 75, 76, 77, 85, 91, 126
line blend 8, 9, 35, 46, 49–64, 63, 75, 80
lithium 7, 13, 36, 38, 40, 44, 45, 46, 53, 59, 60, 68, 74, 75, 76

magnesium 7, 21, 31, 36, 38, 39, 40, 41, 59, 60, 75, 76, 77, 80, 84
manganese 7, 36, 63, 74, 75, 76, 77, 79, 82, 119
Material Safety Data Sheets (MSDS). 30, 91
matt glaze 6, 8, 9, 16, 27, 35, 38, 39, 54, 61, 64, 69, 72, 75, 76
maturing temperature/maturation temperature 15, 20, 61, 64
melt test 14
mesh size 13, 15, 30
mid–fire 26, 34, 38, 43, 46, 47, 54, 63, 64, 68, 69, 84, 86, 91
mines 14
mixing 26, 28, 29, 30–4, 48, 57, 78, 80–84, 91

nepheline syenite 7, 12, 13, 14, 17, 18, 27, 28, 35, 36, 40, 44, 45, 46, 52, 53, 54, 56, 58, 62, 64, 66, 67, 68, 70, 75, 77, 87, 88
nickel 7, 36, 43, 46, 63, 74, 76, 77, 82, 91

oil–spot glaze 20
opaque glaze 8, 16, 18, 39, 75
Orton cones 19
oxidation 11, 12, 19, 20, 21–4, 25, 34, 39, 61, 78, 91
oxide response 42, 43, 44, 45, 75, 77

porcelain 14, 16, 17, 36, 38, 49, 50, 53
potash feldspar 7, 8, 14, 17, 18, 20, 24, 36, 40, 44, 45, 46, 49, 50, 51

potassium 7, 36, 49, 63, 74, 75, 76, 82
pyrometer 18, 19, 24

quadraxial blend see square blend

random glazes 6, 39–48,
raw materials test 35–8
reduction 12, 19, 21, 22, 24–5, 34, 52, 54, 55, 78, 86, 91
refractory material 57, 77
rutile 13, 17, 27, 36, 42, 43, 46, 57, 58, 63, 64, 66, 79, 82, 84, 85, 91

safety 30, 91
saggar 22
satin glaze 8, 5, 6, 9, 11, 15, 18, 35, 38, 39, 54, 61, 64, 66, 69, 72, 75, 77, 78
Seger formula 7, 14, 61
shino 6, 22
silica 6–12, 13, 16, 24, 30, 33, 38, 39, 40, 43, 45, 46, 49, 52, 53, 54, 55, 58, 60, 66, 69, 70, 75–7, 85, 87, 88, 91
soda feldspar 7, 35, 36, 40, 42, 58, 70, 89
square blend 35, 67–71, 75
stoneware 5, 6, 8, 11, 14, 17, 18, 22, 24, 25, 26, 28, 34, 35, 36, 38, 43, 46, 49, 52, 54, 61, 64, 69, 84, 88, 91
strontium 7, 59, 40, 59, 60, 75, 77
suppliers 14, 16, 127

talc 11, 13, 16, 17, 20, 25, 27, 28, 36, 40, 42, 44, 45, 46, 49, 61, 62, 64, 66, 82, 84, 87, 88
tin oxide 13, 17, 36, 54, 55, 58, 66, 70, 81, 82, 87, 88
titanium dioxide 7, 13, 21, 22, 35, 36, 38, 74, 77, 78, 79, 82, 84, 87, 88, 89, 91
triaxial blends 35, 57, 64–6, 75

weighing 28, 29–30, 32, 48, 52, 80, 84, 91
whiting 8, 9, 12, 13, 15, 16, 17, 20, 24, 27, 28, 36, 40, 42, 44, 45, 46, 49, 50, 52, 53, 54, 55, 58, 59, 60, 62, 64, 66, 68, 69, 70, 75, 76, 77, 87, 88, 89
wood ash 7, 13

zinc oxide 7, 13, 36, 38, 39, 40, 75, 76, 77, 79, 82, 84